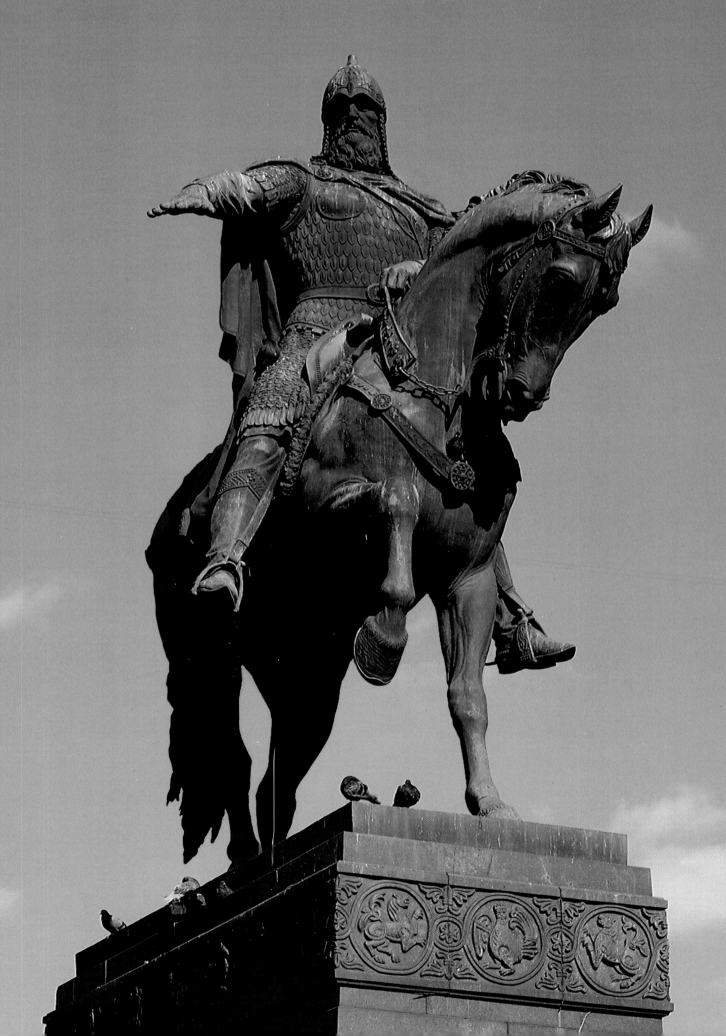

Aurora Art Publishers • *St Petersburg*

Selection and sectional texts by Yury Alexandrov

Introduction by Yury Limonov

Translated from the Russian by Paul Williams

Design and layout by Yury Krylov

MOSCOW

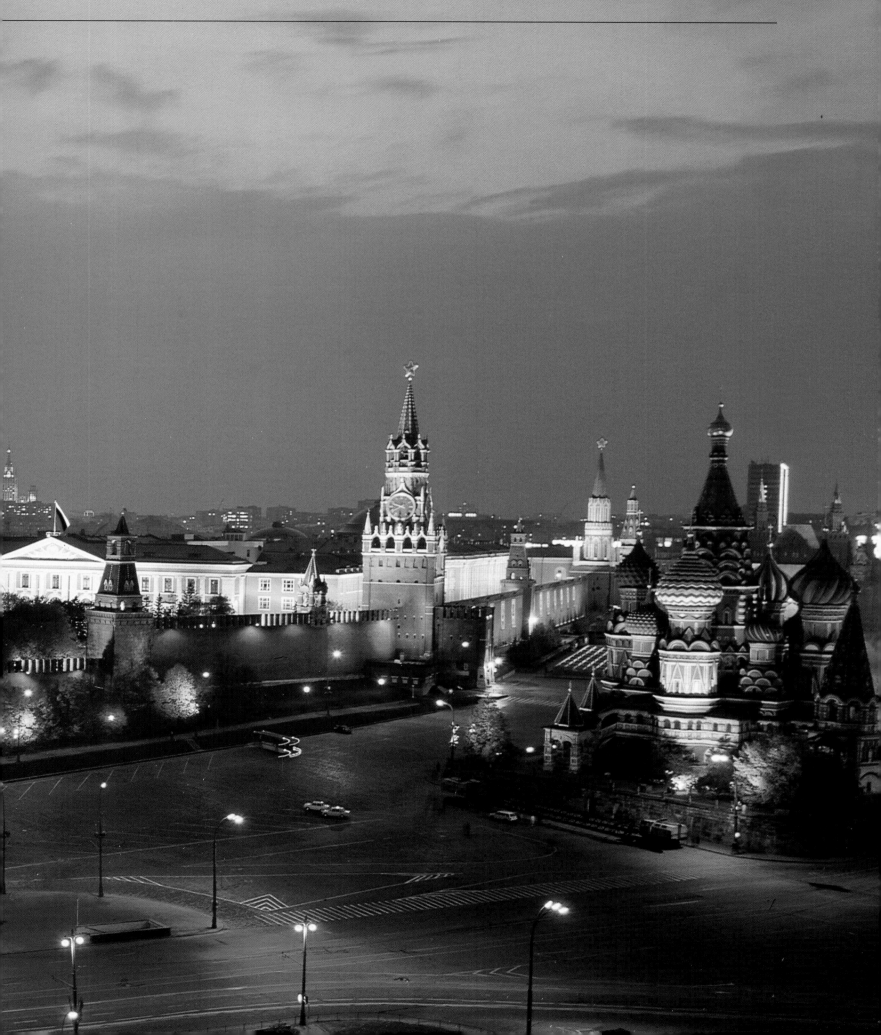

EIGHT CENTURIES OF MOSCOW

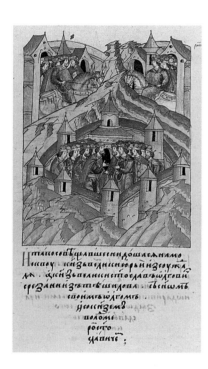

On page 1:
Monument to Yury Dolgoruky
1954, sculptors Sergei Orlov, Anatoly Antropov, Nikolai Stamm; architect Victor Andreyev

The first mention of Moscow in the chronicles
Miniature from the 16th-century "Illustrated Chronicle"

The story of how Moscow originated differs little from that of the majority of European cities whose sites were determined primarily by considerations of security. In the early Middle Ages water provided the best defence and many settlements sprang up on islands or peninsulas, which had only one narrow approach route by land. That is why the core of the future Russian capital came to be located on the triangle of high ground formed by the River Neglinnaya and the River Moskva as the one joined the other. The site was not an uninhabited one: the new town evidently absorbed several small settlements on the bank of the River Moskva, with which it shares its name. The old Russian *Ipatyev Chronicle* records the invitation which Prince Yury Dolgoruky, the powerful ruler of north-western Russia, sent to Prince Sviatoslav of Chernigov to visit him "at his manor of Moscow". This first recorded mention of the future capital was made in 1147. That year has come to be considered the date of Moscow's foundation and Yury Dolgoruky — whose surname, meaning "long-armed", came from his habit of interfering in the affairs of distant territories — its founder.

The origin of the city is also linked with a romantic legend about a rich boyar (high aristocrat) named Stepan Kuchka. The story goes that Yury Dolgoruky developed a passion for the boyar's wife. Once, when the Prince was on campaign, Kuchka imprisoned his wife, while he himself prepared to seek refuge with his overlord's enemies. When he found out, Yury Dolgoruky came back, freed his mistress and executed his disloyal and jealous vassal. The Prince married Kuchka's daughter to his own son, Andrei, and made the boyar's sons serve him. On the site of Kuchka's fortified manor, Yury Dolgoruky founded the new town of Moscow. The truth of this legend seems to be supported by certain historical facts. Up until quite recently there was an area of Moscow known as Kuchkovo Pole — "Kuchka's Field". Among the aristocratic participants in the 1174 conspiracy which led to the murder of Yury Dolgoruky's son Andrei Bogoliubsky, the Russian chronicles name the sons of the boyar Kuchka. Finally, both the chronicles and the archaeological evidence make it possible to assert that the town fortifications of Moscow were indeed constructed in about 1153, that is to say during the reign of Yury Dolgoruky.

Soon a fortress or citadel appeared in the centre of the town, which subsequently became known as the Kremlin. Still today it is the symbol of the Russian capital and the physical expression of the highest power in the state. Various explanations have been given for the word "kremlin" (*kreml* in Russian). The most widely accepted connects it with a word *kremen* meaning stone or fortification, hence *kreml* — a fortified place. In olden days the work *kreml* was also used to refer to building timber. At the time the fortress was being constructed, it was surrounded by a dense, near-impenetrable pine-forest (*bor* in Russian) which became the source of building material for Moscow. The forest was remembered in place names. For example, the Kremlin to this day has a Borovitsky Gate. In olden times the word also appeared in the names of the Church of the Saviour "na Boru" ("on the site of the forest") inside the Kremlin, Borovaya Square, one of the earliest in the city, and Borovitskaya Street.

In the thirteenth century the whole civilized world was faced by a new, terrible threat — the Tatar-Mongol hordes. The devastation caused by the nomad armies of Genghis Khan and Batu Khan was greater than anything previously known, except perhaps the worst excesses of the Huns. A wave of devastation swept from the shores of the Pacific and the Great Wall of China through Central Asia, Persia and the Middle East down as far as Egypt and across Europe through Russia and the Balkans as far as Germany, Bohemia and the Venetian Adriatic. Moscow was directly affected. In the winter of 1238, having already conquered the Russian lands to the east, the Tatars approached the future capital. They surrounded the city and took it by storm, slaughtering the defenders and the ordinary people alike. Prince Vladimir, the son of Grand Prince Yury Vsevolodovich, was taken prisoner. All the buildings and churches of Moscow, the outlying monasteries and neighbouring villages were wrecked and set on fire. For a long period all the Russian lands had to pay a heavy tribute to the Tatars and, even later, they lived under constant threat of further devastating raids.

Soon, however, Moscow began to be rebuilt. It formed part of the territory under the direct rule of the Grand Prince, the highest member of the feudal hierarchy in old Russia. In the middle of the thirteenth century it belonged to Prince Alexander Nevsky, an inspired military commander who twice saved Russia from serious aggression, by the Swedes and by the German knights of the Teutonic Order.

His virtue, courage and self-sacrifice made him one of the most positive figures of the age and earned him lasting veneration as one of Russia's native saints. In many ways he resembled his Western European contemporary, another military leader later canonized: King Louis IX of France.

In 1272, Moscow became the capital of its own principality. Throughout almost all its history the city was closely connected with the Eastern Orthodox variety of Christianity. In the early fourteenth century Moscow became the residence of the head of the Russian Orthodox Church (originally the metropolitan, then, from the late sixteenth century, the patriarch). As the religious capital of Russia, the city acquired immense authority which extended to the other lands with Orthodox believers. This authority in many ways contributed to the success of the policy pursued by successive grand princes of Moscow — the unification of the Russian lands and principalities around Moscow. Probably the most colourful figure in the early period of "gathering lands" was Prince Ivan Kalita in the first half of the fourteenth century. He was radically different in character and behaviour from the type of ruler then common in Russia and in Western Europe — the warrior-prince imbued with aristocratic concepts of honour and duty who considered the most weighty arguments in any dispute to be bloody battles and the clash of swords. Against this background Ivan Kalita was something extraordinary. He achieved his ends through diplomatic negotiations, marriage ties, family inheritances and, above all, gold. A merchant-prince accumulating capital, that was Ivan I of Moscow. And his nickname — Kalita meaning "money-bag" — reflected the fact. Energetic, intelligent, devious and miserly, he did not seek grandeur and was not tempted by an outward display of power. Even his personal appearance, the modest dress of an ordinary city-dweller and his strong Christian humility, put one in mind of another figure in European history. I am thinking here of Louis XI, another ruler far removed from the ideal of the warrior-king, who did so much to unite the French lands around Paris. Both Ivan Kalita and Louis XI clashed with men who were by nature their opposites. Both Alexander, the Prince of Tver, and Charles the Bold, Duke of Burgundy, were real knights, fearless and irreproachable, and both died as a result of the intrigues of their enemies.

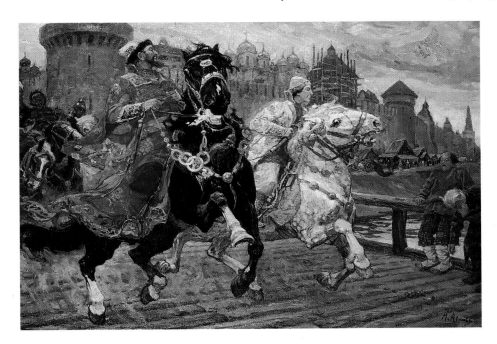

Moscow grew considerably during Ivan I's reign (1328–40). The Kremlin, which remained the inner citadel of the city, was enclosed by a stone wall. The commercial area known as the Posad appeared and grew. This part of the city, located alongside the Kremlin, was inhabited by merchants, craftsmen, administrative officials and fighting men. It was enclosed by a fairly complex set of fortifications, in an effort to provide protection against continuing Tatar raids.

A fair amount of building in stone was now taking place in Moscow. By the 1330s several churches had been put up in the Kremlin, but the only remnants of them today are fragments incorporated into later religious structures. A whole ensemble of state administrative and ecclesiastical buildings began to form in the Kremlin. It included the chief place of worship in the city — the Dormition Cathedral, which was also its patronal church. Alongside stood the Grand Prince's residence with its domestic church. Close by were the palace of the metropolitan and the homes of the Grand Prince's relatives and courtiers. The tall Church of St John Climacus also served as a watchtower. Soon two other churches were completed: the Cathedral of Our Saviour "na Boru" and the Cathedral of the Archangel Michael. When in 1367, during the reign of Grand Prince Dmitry Donskoi, white stone walls were built around the Kremlin, the complex had reached roughly the size and shape that it has today.

Moscow played a great role in the struggle against the Tatar oppressors. The city, the Grand Prince and the Orthodox Church jointly rose up in defiance of the conquerors. In 1380, a major blow was inflicted against the Tatars in the upper reaches of the River Don. Almost all the Russian lands took part in the battle, but Moscow played the leading role in the alliance and Grand Prince Dmitry was the overall commander. This victory at Kulikovo Field earned the head of the Russian forces the surname Donskoi — "of the Don".

The Russian Orthodox Church also made a major contribution in encouraging the Russian lands to unite in the struggle against outsiders and increasing patriotic feeling. Metropolitan Alexei and Sergei of Radonezh, the founder of the Trinity–St Sergius Monastery, inspired believers to fight for their country and its liberation.

In the fifteenth century, Moscow became of paramount importance for the whole of Russia as the focus of secular and religious power, the economic and cultural centre of the country. Under Ivan III, the grandson of Dmitry Donskoi, the office of grand prince took on a new significance. The unification of the Russian lands under the aegis of Moscow turned its ruler into an autocrat. He became the sole

Mikhail Avilov. 1882–1954
Tsarevich Ivan Out Riding. 1913

legitimate sovereign for the whole of Russia and Moscow was the seat of his power. Ivan III also became a significant player on the international stage. The Grand Prince established diplomatic, trading and cultural relations with many countries in Europe and Asia. In 1472, Ivan III married Sophia (Zoe) Palaeologus, the niece of the last Emperor of Byzantium. After the fall of Constantinople to the Turks in 1453 she had lived with her relatives in Rome under the protection of the Pope. That marriage enabled Ivan III to claim the right of being the heir to the Byzantine Empire. Nevertheless, Moscow decisively rejected the Holy Roman Emperor's suggestion that Ivan accept the title of king. The Grand Prince himself formulated his refusal quite simply: he was "sovereign in his realm" from the outset, by birthright, and he never had wanted any titles and still did not. In official documents Ivan III styled himself "lord of all Russia" and even "tsar" (a title derived from the Latin "caesar"). The exalted position of the Grand Prince of Moscow, and now successor to the Byzantine emperors, found expression in more elaborate court etiquette and even changes to the ruler's official dress. On formal occasions the Grand Prince wore a magnificent collar, the *barmy,* and a kind of crown known as the Cap of Monomakh. According to legend this crown had been sent from Constantinople as a present to Ivan III's ancestor Vladimir Monomakh by the Byzantine Emperor Constantine. In the late fifteenth century Muscovites witnessed the coronation of Ivan III's grandson Dmitry in accordance with the Byzantine rites. At the same time as the new court etiquette, Russia also acquired a new state coat-of-arms. St George on a horse killing the dragon was replaced by the two-headed eagle — the Byzantine imperial device.

In the fifteenth and sixteenth centuries Italian influence penetrated into all aspects of European culture. At the courts of Elizabeth I of England and Mary, Queen of Scots not only fabrics, clothes, utensils and jewellery were highly prized, but also Italian music, poetry and painting. In Paris too Italians were working at court as artists, architects and decorators. Italian culture, Italian art and the Italian language were in fashion across the whole of Europe. Distant Muscovy was no exception from this general fascination with Italy. In Moscow too Italian architects, artists and metal-workers were busy. They were involved in the grand construction projects which were realized in the capital at that time. In 1479 the Bolognese architect and engineer Aristotle Fioravanti created the celebrated Dormition Cathedral; in 1508 his compatriot, known in Russia as Aleviz Novy, constructed the Archangel Cathedral.

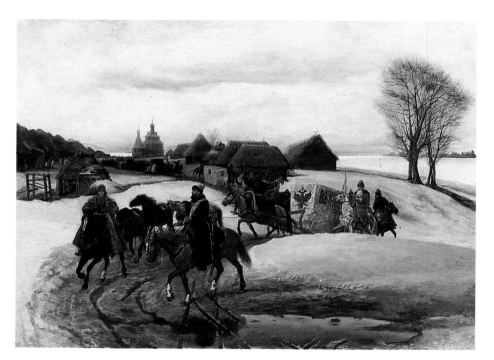

Viacheslav Schwarz. 1838–1869
The Tsarina's Springtime Pilgrimage in the Reign of Tsar Alexei Mikhailovich. 1868

What was Moscow like in the time of Ivan III? How did the people live? What economic ties did the Russian capital have? Answers to all these questions can be found in the writings of Western European travellers who visited the city. Several people left their impressions of the Moscow of the 1470s. One of them was the Venetian ambassador Ambrogio Contarini. He attended receptions given by Grand Prince Ivan III and by his wife Sophia Palaeologus. His brief jottings are extremely interesting. He writes of Ivan: "The sovereign is about 35 years of age; he is tall and lean; all in all he is a very handsome man." Contarini also recorded some impressions of the capital and its inhabitants. The Russians struck the ambassador as "very attractive, both the men and the women", but they were "a coarse people". "The city of Moscow is situated on a small hill... the River Mosco flows through it. On the one side is the castle and a part of the city; on the other the remaining part of the city. There are many bridges over the river which people use to cross from one bank to another. This capital is the residence of the Grand Prince himself. Around the city there are great forests — in general there are very many of them in the country... The region is exceptionally rich in all manner of cereal crops."

Contarini left us some details of the everyday lives of the citizens, including their daily routine. Craftsmen worked and merchants traded from morning until lunchtime. After lunch the Muscovites rested. The ambassador observed with surprise that later "it is impossible to engage them in any business." The inquisitive traveller noted several times that wine and fruit were a great rarity in Moscow, but the people "consume a drink made from honey, to which hop leaves are added. This drink is not at all bad, if it has aged." Nevertheless, as early as the late fifteenth century restrictions were imposed on the production of such mead by private individuals.

Grand Prince Ivan III and his successor Vasily III completed the process of gathering the Russian lands under the rule of Moscow. In 1478 Novgorod, one of the greatest cities in the country, became part of the Muscovite state; in 1485 Tver, the capital of a once-mighty principality was annexed. Vasily III also positively pursued the policy of unification in an intelligent and energetic manner. In 1510 he achieved the incorporation into the Russian state of Pskov, a major centre of international trade, and in 1514 acquired Smolensk, a strategically important stronghold on the western border, while in 1512 he

became the master of Riazan, the last independent Russian principality. This marked the completion of the core of the Russian nation state.

The Russian sovereign's achievements were quite well known in the West. For many European rulers Vasily III became an exemplary figure – a statesman conducting an effective policy at home and abroad. But Vasily was extremely unfortunate in his personal life. In his youth he married a beauty from the aristocratic Saburov family. The Grand Prince and his wife, Solomonia, lived together for twenty years, but never had children. This personal problem inevitably became a concern for the whole state: the main line of the dynasty might lose its hold on the throne and power. Urged by the Church and his supporters, Vasily resolved to divorce Solomonia on the grounds of her infertility and to marry again. A suitable bride had already been found – Elena Glinskaya, an attractive girl from a Polish family. Solomonia, an intelligent and energetic woman, was opposed to the divorce and the balance of sympathy in Moscow society favoured the Grand Princess. None the less, in the summer of 1525 Solomonia was seized during a service at the Convent of the Nativity and forced to become a nun. She was banished to a convent in the city of Suzdal not far from Moscow. The Grand Prince soon married his second wife. Meanwhile, fantastic rumours began to emerge from Suzdal. The Grand Princess was said to have given birth to a son on her arrival at the convent. The boy was baptized Georgy. The rumours disquieted the Grand Prince and he ordered an investigation. The legend claims that Solomonia gave the child to loyal people and then put it about that the boy had died and was buried in the convent.

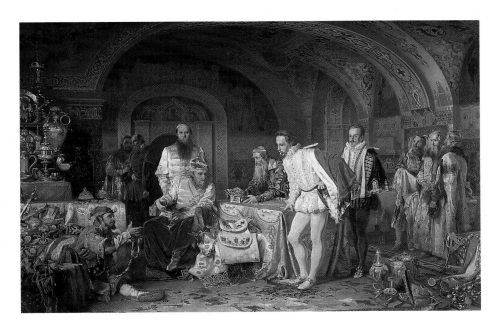

According to other tales, the boy grew up to become the famous robber Kudeyar, who took from the rich and helped the poor. This quick-witted, cruel, yet generous outlaw, was tremendously popular among the poor of Moscow, something like a Russian Robin Hood.

The story of Solomonia's son would be no more than a romantic legend, were it not for a discovery which flung historians into confusion. In 1934, when the Intercession Cathedral in Suzdal was being reconstructed, several graves were opened. A stone slab was found alongside Solomonia's tomb. Lying in a small coffin beneath it was a bundle of rags made to look like an infant. This doll was dressed in an expensive silk robe and wrapped in swaddling-clothes sewn with large pearls. Apart from the obvious conclusion that the burial had been staged and the child replaced by a doll, such a find naturally gave rise to a number of perplexing questions. Was the pregnant Grand Princess divorced and made a nun in breach of all the legal and ecclesiastical rules? If so, did the Grand Prince know about this "fateful error" or was he the victim of a deception? Further, is it possible that the legendary robber Kudeyar, the son of Solomonia, and Ivan the Terrible, the son of Elena Glinskaya, were half-brothers? Did the Tsar know about it? In any event, at the start of Ivan IV's reign all the documents relating to the case of Solomonia and her barrenness were requested from the archives and never returned! Judging by appearances, the Tsar destroyed them. But why? This story is wreathed in mystery, like many other occurrences in European history where the succession to the throne or the continuity of power was at stake.

In the sixteenth century Moscow became one of the largest cities not only in Russia, but anywhere in Europe. By the middle of the century over 100,000 people lived in the capital. It was twice the size of Prague, bigger than London and its suburbs. The Italian bishop Paolo Giovio wrote in his book about Russia that the city was "built along the bank of the River Moskva for a distance of five miles and the houses there are generally wooden, but not too low and fairly spacious inside. Each of them is usually divided into three rooms: a parlour, a bedroom and a kitchen. They bring logs from the forest, trim them straight using a cord, put them one on top of another and fasten the ends. In that way they build walls which are exceptionally strong, cheap and quick." He goes on to explain why the overall size of the city is so great: "Almost every house has its own garden serving for the owner's pleasure and at same time supplying him with enough vegetables to meet his needs; that is why the city seems unusually extensive. Almost every block has its own church." Inside the city too, as in almost every city in mediaeval Europe, there were mills to grind corn. "Within the city the small River Neglinnaya flows into the Moskva, providing power for a large number of mills." Not one of the travellers who left reminiscences of sixteenth-century Moscow failed to express admiration for the Kremlin. Paolo Giovio described it as "a highly attractive castle with towers and loopholes built by Italian architects". His opinion was seconded by the Austrian envoy Sigismund von Herberstein: "The fortress is so large that, apart from the very large and splendid stone-built royal apartments, it contains the apartments of the metropolitan, and also of the sovereign's brothers, great lords and very many other people. Moreover, there are many churches in the fortress, so that in extent it almost reminds one of a town."

Alexander Litovchenko. 1835–1890
Tsar Ivan the Terrible Showing His Treasures to the English Ambassador Jerome Horsey

All foreigners noted the advantages of Moscow's geographical position. One fifteenth-century writer stated: "Moscow by virtue of its favourable situation, better than that of all other cities, deserves to be the capital, because it was constructed by its wise founder in the most populous country, in the centre of the state. It is bounded by rivers, fortified by a castle and, in the opinion of many, will never lose its primacy."

Moscow was becoming a very important trading centre. The capital was an enormous marketplace for the whole of Russia. Agricultural produce, furs, craftsmen's wares and manufactured goods were brought here from all parts of the country. Moscow was the focus of commerce with the countries of Western Europe and the East. As early as 1553 an English trading expedition sailed into the Northern Dvina. The English adventurers made their way to Moscow and were granted an audience with Ivan the Terrible. From that time onwards, English, and later Dutch and German merchants regularly made the long sea journey to northern Russia. In 1584 the city of Archangel was founded on the Northern Dvina. Western Europeans brought many goods to Moscow: woollen cloth from England and Holland, expensive fabrics from Italy, wine from France, tin and lead from Bohemia and Germany. Eastern merchants brought fabrics, spices, rice and precious stones.

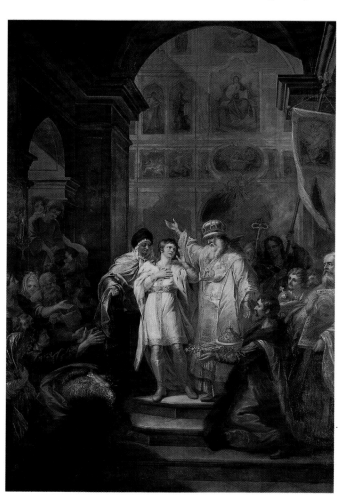

Moscow in the reign of Ivan the Terrible (1533–1584) was not only the economic, but also the political centre of the Russian state. It was the residence of the Grand Prince (in 1547 he began calling himself "Tsar of All Russia") and the meeting-place of the Boyar Duma, the highest collective body in the country with which the ruler was supposed to consult. Moreover, it was the meeting-place for the national assemblies known as *Zemskiye Sobory* which had the power to legislate. Admittedly, such gatherings were not summoned on a regular basis, but rather in exceptional situations. In function these assemblies were very similar to the French Estates-General of the seventeenth century. Russia was developing into a monarchy with representation of the estates. Executive organs also appeared in Moscow — the *prikazy* which were forerunners of the present-day ministries. The Posolsky Prikaz dealt with foreign affairs, the Streletsky Prikaz administered the armed forces, while the Razboiny and Zemsky Prikazy had police functions. This system of administration helped to consolidate the centralized state.

The appearance of "ministries" gave rise to a new category among the citizens of Moscow — civil servants. By the end of the seventeenth century they represented a considerable section of the capital's population.

In the middle of the sixteenth century, with the full support of Ivan the Terrible, Zemskiye Sobory approved several very important reforms. One was the organization of special units of *streltsy*, or fusiliers, to guard the Tsar. A similar thing took place in France a few decades later when Cardinal Richelieu created the musketeers. The assemblies restricted the Church's rights to acquire land. And finally, here, in Moscow, for the first time plans were put forward for the creation of national Russian schools.

Above all, though, Ivan the Terrible is associated in people's minds with the *oprichnina*, a division of the state and the nobility into two camps with the aim of weakening the influence of the great boyar landowners who opposed the centralized state and the Tsar. The plan was to give the boyars' land to the lesser nobility who supported Ivan. The boyars responded by conspiring against the government. They attempted to reverse all the Tsar's undertakings, to dispose of Ivan himself and even to collaborate with the external enemies of the Russian state. Ivan IV responded to the actions of the opposition with a campaign of repression. Many boyars who took part in conspiracies were executed. A large number of churchmen also paid for their hostility to the Tsar. Moscow witnessed the public execution of great lords and their followers. It was this merciless annihilation of the most powerful and wealthy aristocratic families which earned Ivan the popular by-name "the Terrible". This period of the formation of nation-states, religious and civil wars was marked in Western Europe too by a sea of blood. Suffice it to recall the numerous executions of Henry VIII's reign in England, the burning of heretics under Spain's Philip II or the Massacre of St Bartholemew when the French King Charles IX acceded to the killing of thousands simply because they were Huguenots.

But these bloody episodes did not stop the general progress of culture and enlightenment among the peoples of Europe. As early as the first half of the sixteenth century learning began to spread among the inhabitants of Moscow, particularly the well-to-do. Textbooks appeared, giving guidance in grammar and arithmetic. "Encyclopaedic" dictionaries — anthologies in which the most varied items of knowledge, scientific and practical, were arranged in alphabetical order — became popular. Muscovites' contacts with foreigners and journeys abroad by diplomats, officials and merchants forced them to master European languages, notably German and Polish. Many Muscovites, especially churchmen, knew Greek and Latin and were acquainted with works of Classical literature.

Grigory Ugriumov. 1764–1823
The Election of Mikhail Romanov as Tsar on 14 March 1613

One event of immense cultural and historical importance was the development of printing in Moscow. The first printed book in Russia, the *Apostolos,* was produced in April 1564 from a print-shop run by the government secretary Ivan Fiodorov (a monument to him was put up in the capital in the twentieth century). Tsar Ivan was personally involved in the creation of that print-shop. Book-printing helped to promote official political ideas, and so strengthened the centralized state, as well as the spiritual enlightenment of the people.

From the sixteenth century, Moscow became a centre of technical and cultural learning. Splendid historical chronicles were created, richly illustrated with colourful miniatures — monuments of public thought reflecting attempts to resolve a number of social and political problems. Ivan the Terrible himself was an outstanding polemicist. We also still have letters he wrote to Queen Elizabeth of England and King Eric XIV of Sweden. Metropolitan Macarius of Moscow and his assistants created an enormous illustrated anthology of ecclesiastical literature — the *Chetyi-minei,* Menologies or readings for every month.

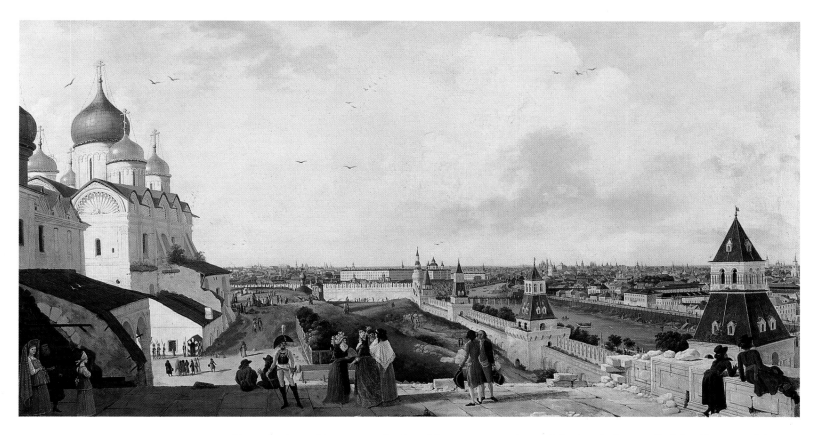

Gérard de La Barthe.
Late 18th – early 19th centuries
*View of Moscow from the Balcony
of the Kremlin Palace.* 1790s

The prominent Moscow archpriest Silvester created an original anthology called the *Domostroi.* It contained a vast range of rules and recommendations to help the reader to be a conscientious Christian, a careful householder and a good family man.

The painter's art flourished in sixteenth-century Moscow — in icons, frescoes and book miniatures. Mention must also be made of Muscovite applied art, especially jewellery. Sometimes as a sign of particular favour — the work of Russian craftsmen was greatly prized in the West — the Tsar would present a diplomat with a piece of jewellery.

An important addition to the architectural appearance of Moscow was St Basil's — properly the Intercession Cathedral — on Red Square. It was constructed in 1555–61 by the Russian master-builders Barma and Postnik to commemorate the capture of Kazan.

The early seventeenth century was a time of great trials and no small amount of tragedy for Russia and for Moscow. This was the time of Tsar Boris Godunov, the upheaval caused by several pretenders to the throne, a popular uprising and occupation by Polish, Lithuanian and Swedish forces. A highly important event for the country was the election to the throne in 1613 of Mikhail Romanov, the first ruler of a new dynasty.

Moscow under the first Romanovs was a large capital city, the administrative, political, cultural and economic centre of life in a Russia that extended from the shores of the Baltic to the Pacific. The Tsar resided in the Kremlin and there he consulted with the Boyar Duma. All the administrative *prikazy* were also located in the city. As in the previous century, the population of Moscow consisted of craftsmen, merchants, soldiers, civil servants and members of the nobility.

In this period Russia established permanent contacts with many foreign countries — England, Holland, the Holy Roman Empire and France. Much was being written about Russia and about Moscow in Western Europe. Travellers' journals were published. Some of the best works about Moscow were produced by the French captain Margeret and the Jesuit de la Neuville. Moscow had economic ties with

almost all the countries of Europe and Asia and maintained diplomatic relations with the most important states in the world.

The seventeenth century transformed the face of Moscow. It was a time of intensive construction and many new masonry buildings — secular and religious — adorned the cityscape. The Kremlin acquired the three-storey Terem Palace and the Patriarch's Chambers. The latter included the Cross Hall, a great vaulted room without piers.

A few kilometres away from the Kremlin towers rose around the New Maiden Convent, the Don and Simonov Monasteries in the suburbs.

What made Moscow particularly distinctive, however, was its wooden buildings with their fanciful carved decoration and brightly painted walls, window frames and doors. The same kind of showiness could be found in the Muscovites' clothing which was adorned with embroidery, lace, fur and silk. The brilliant examples of applied art created by Moscow craftsmen in this period — richly decorated weapons, jewellery, caskets and various traditional forms of vessel — were greatly valued not only throughout Russia, but in Western Europe too.

Moscow in the seventeenth century was the centre of enlightenment for Russia. Books were published in huge numbers for popular consumption. In the second half of the 1600s alone the Moscow Printing Yard (the largest establishment of its kind in the country) produced more than 500,000 primers and educational psalters. In the mid-century it had more than 11,500 printed books in its stores. The first bookstore opened in Moscow in 1672. The same period saw the publication, under the auspices of the court, of one of the first newspapers in Europe — the *Vesti-Kuranty.* Although handwritten, it differed little in content from the newspapers produced in Hamburg or Paris.

Russian literature continued to develop in the seventeenth century. Many of the notable works were written in Moscow itself.

In Europe at that time the theatre and related forms of public spectacle were tremendously popular. Russia again was no exception. Moscow had its own "folk theatre". At religious festivals and other popular celebrations, citizens performed scenes from Russian history or the Bible and whole dramatic or satirical shows on contemporary themes. In 1672 a true theatre in the modern sense of the word appeared in Moscow. It was run by a German Pastor named Johann Gottfried Gregory. Performances were given in the Kremlin for the Tsar, his relatives and courtiers. The company's repertoire consisted mainly of plays on biblical subjects.

By that time there were many educated people in Moscow — not only monks and priests, but laymen as well. In the middle of the seventeenth century schools attached to monasteries were a common feature. There future priests and civil servants studied Russian, Greek and Latin. Private schools also began to appear. In 1667 the first parish school opened at the Church of St John the Divine in Kitai-Gorod; in 1680 a specialized school attached to the Printing Yard; and in 1687 the Slavo-Graeco-Latin Academy, the first higher educational establishment in Russia. The academy was supposed to provide education for people "of any rank, class or age" and produce highly qualified graduates to meet the needs of the Church and the state.

In the seventeenth century Moscow contributed much to Russian history, politics, economy and culture. It was in the capital that the pressing need for reforms and a reconstruction of Russian society became most obvious. The first ruler to introduce sweeping changes was Peter the Great, who in the early eighteenth century transferred the capital to the newly-founded city of St Petersburg on the Baltic Sea. The innovations which the Tsar introduced were disliked by many social groups. Sometimes opposition to the reforms spilled over into active resistance. In the late seventeenth century the *streltsy,* fusiliers who served as a kind of court guard, mutinied in Moscow. The Tsar cruelly put down the revolt. The *streltsy* were executed and Peter continued with his reforms.

Although it had lost its status as the capital, Moscow did not lose its significance in the minds, lives and traditions of the Russian people. It remained a hive of trade and crafts, and later developed into a major industrial city. Moscow was still a highly important cultural centre. In 1755 Moscow University was founded. Its teaching programme was based to a large extent on the views of the French Enlighteners. Moscow was a centre for the press, producing the newspaper *Moskovskiye vedomosti,* periodicals and almanacs. The city accommodated many printing-shops and publishing-houses of various tendencies from the clerical to the most liberal. Translations of Western European, and especially French, books were turned out in large print-runs. They included the then-fashionable novels of Nicolas Restif de La Bretonne, the works of Voltaire and those of the Encyclopaedists and other writers of the Age

Unknown artist
*Sleigh Races in
the Petrovsky Park.* 1840s

of Enlightenment — Denis Diderot, Jean Le Rond d'Alembert, Jean-François Marmontel, Jean-Jacques Rousseau and others.

The tremendous world-shattering events of the late eighteenth and early nineteenth centuries — the French Revolution and the Napoleonic Wars — directly affected Russia and Moscow. *Moskovskiye vedomosti* reported in detail on the course of the revolution in Paris and the provinces. Bookstores in Moscow sold French newspapers, magazines and engravings devoted to the ideas of "Liberté, Egalité, Fraternité". The government of Russia and Catherine II personally were in favour of the preservation of the monarchy in France, nevertheless, Russian troops were not dispatched to help put down the revolution. The anti-French coalition of Austria, Britain and the German states was defeated. Objectively, one might say that Russia helped the French Revolution to survive.

In 1812, however, Napoleon invaded Russia and captured the old capital. Moscow was almost completely destroyed by fire. Explosive charges were laid in the Kremlin on the French Emperor's orders and luck alone prevented them from going off. His retreat from Moscow led to the destruction of the Grande Armée, Elba, the "Hundred Days", Waterloo and, finally, St Helena. In the "Patriotic War" of 1812, Moscow became for all Russians a patriotic symbol, a bulwark in the struggle against the invaders. More than that, the name of the old capital became a synonym for the whole of Russia. In the minds of the people of that time Moscow would remain the embodiment of a sense of national independence.

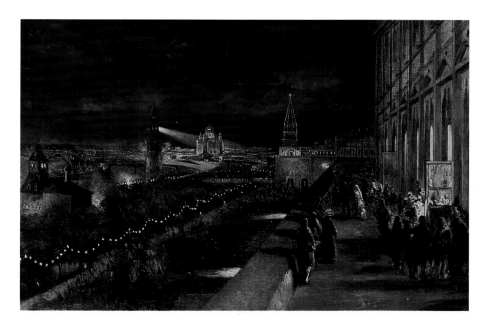

In Moscow's Dormition Cathedral in 1894 the last Tsar, Nicholas II, was crowned ruler of all Russia.

In March 1918 Moscow again became a capital, first of Soviet Russia, then of the Soviet Union, and now of the Russian Federation.

During the Second World War Moscow played a major role in the victory of the international alliance against Hitler's aggression. A patriotic spirit of self-sacrifice made the city once again a symbol for the defence of Russia.

Like many of the world's great cities, Moscow changed its appearance in the twentieth century. The patriarchal atmosphere and spontaneity of the old, cosy city, so dear to the hearts of many Russians, vanished. They were replaced by severe functionality and conceptual rigidity of a metropolis with blocks of modern standardized housing, wide avenues, numerous high-speed intersections and complex underground pipes and tunnels.

Moscow at the end of the twentieth century is a major centre for machine-building, metal-working, precise mechanics and the chemical industry. It is the location of the country's governmental institutions and the seat of its parliament. It is home to the Russian Academy of Sciences and the residence of the Patriarch, the head of the Russian Orthodox Church. The capital contains more than 70 higher educational institutions, some of the largest libraries in the country and several dozen theatres and museums.

Today Moscow is a vast city, the capital and economic, political, cultural and religious centre of a great country.

Nikolai Makovsky. 1842–1886
*Illuminations in Moscow
on the Occasion of the Coronation
of Alexander III.* 1883

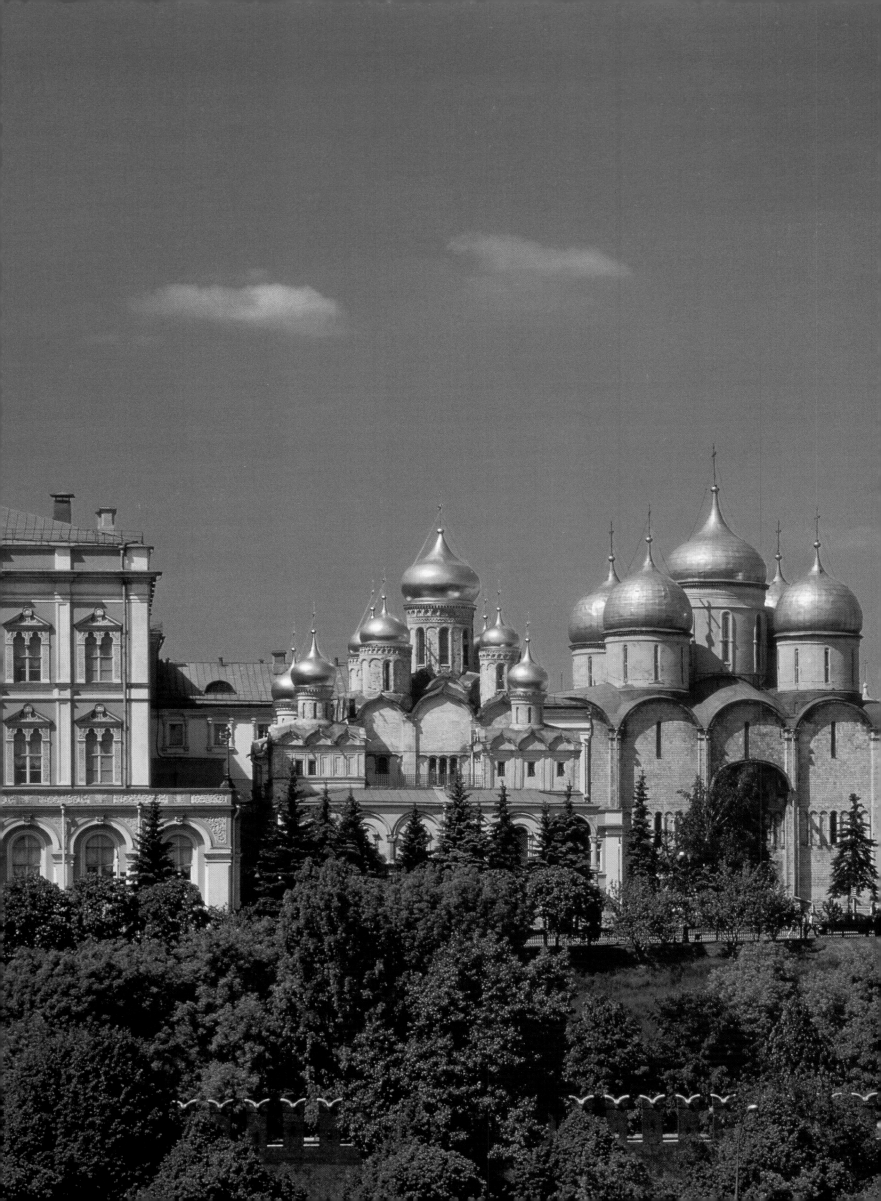

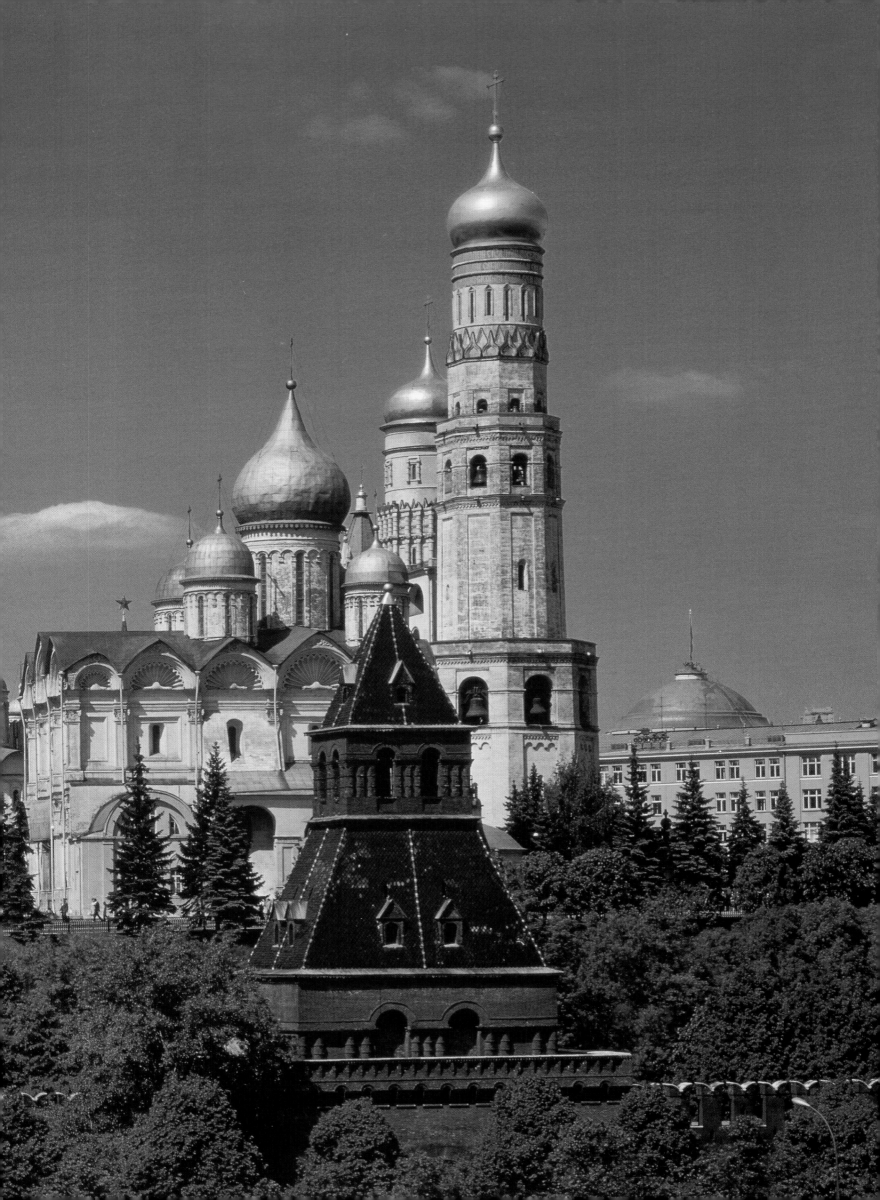

THE KREMLIN

In 1156, on the orders of Prince Yury Dolgoruky, a fortress of pine logs — the original Kremlin or citadel of Moscow — was erected on Borovitsky Hill. In 1339, under Grand Prince Ivan Kalita of Moscow, an "oaken city" was constructed. Not long afterwards, in 1367, Grand Prince Dmitry Donskoi ordered the oak walls replaced with white stone ones. And a little over a century later, when Moscow had become the capital of the unified Russian lands, Ivan III, gave orders for the Kremlin to be enclosed by the walls and towers (1485–95) which still stand today. Austere and impregnable, protected by water on all sides, the Kremlin was a sort of Capitol for Moscow — "the third and last Rome", as the city came to be called after the fall of Byzantium, the second Rome, to the Turks.

For the first time in Russian defensive architecture a kremlin was constructed in brick. Its ground-plan, in the form of an irregular triangle, has survived without any substantial changes. This shape was determined by the location: the River Neglinnaya (piped underground in the 19th century) flowed around the west of the fortified eminence, the River Moskva ran along the south side. On the north-west side a broad ditch was dug out which filled with water.

The Kremlin walls link 20 towers, whose tent-shaped roofs were added at a later date. The three round towers are the strongest and provided a particularly large field of fire. Five of the towers have gates in them, while one — the Kutafya Tower — stands apart from the walls, protecting the outer end of the old bridge across the Neglinnaya. The earliest to be built was the Tainitskaya (Secret) Tower which had a secret passage down to the River Moskva beneath it; the latest — and, at 80 metres, the tallest — was the Trinity Tower. The main, Saviour Tower, originally the Frolov Tower, got its present name from an icon of Christ which was placed above the gateway in the 17th century. In that same period a striking clock was installed in the tower. The present chimes date from the late 18th century.

The Kremlin walls slope out at the bottom. Their thickness varies between 3 and 5 metres and their height between 6 and 17 metres, depending on the underlying relief. The total length of the walls is 2,235 metres. They are crowned with swallow-tailed merlins typical of Milanese fortresses, reminding us that they were designed by Italian architects.

The architectural centre of the Kremlin is Cathedral Square. On its north side stands the majestic Cathedral of the Dormition (or Assumption), the chief place of worship for Muscovite Russia. Here state decrees were proclaimed, lesser princes swore fealty to Moscow and, later, Russian grand princes and tsars were crowned (even after Moscow ceased to be the capital). Here too the metropolitans and patriarchs of All Russia were invested and buried.

The Cathedral of the Annunciation (1489) served as the domestic church for the rulers of Moscow. After reconstruction in the mid-16th century, the cathedral acquired nine domes.

Next to that cathedral is the oldest secular building in Moscow — the Palace of Facets. It gets its name from the faceted stones that adorn its façade. In the past this building was the venue for the reception of ambassadors and the meeting place of important assemblies. Here Ivan the Terrible celebrated the incorporation of Kazan into the Russian state and Peter the Great his victory over Charles XII of Sweden at Poltava in 1709. In 1995 the Red Porch adjoining the Palace of Facets was reconstructed.

The Cathedral of the Archangel Michael was the burial place of Moscow princes and Russian tsars. (After the capital was transferred in 1712, the Russian rulers, from Peter the Great onwards, were buried in St Petersburg.) This is the oldest necropolis in the city.

The Cathedral Square ensemble includes the single-domed Church of the Deposition of the Robe, built in memory of Moscow's deliverance from an attack by the Tatars.

The most dominant architectural landmark in the Kremlin is the bell-tower known as "Ivan the Great", one of the tallest structures in old Moscow (81 metres). A decree issued by Tsar Mikhail Fiodorovich forbade the construction of churches taller than it.

At the foot of the tower stands the Tsar-Bell, one of the largest in the world. It measures 6.6 metres across the base and weighs 200 tonnes. The bell was cast by Ivan and Mikhail Motorin in 1733–35, but left in the pit. Two years later there was a great fire. The hot bell cracked when water fell on it and an 11.5-tonne piece broke off. In 1836 the bell was finally raised and placed on a pedestal.

Another outstanding example of Russian casting is the Tsar-Cannon. It has a bore of 890 mm, a barrel length of 5.34 metres and a weight of 40 tonnes, and was intended to protect the Saviour Gate.

The Poteshny (Amusement) Palace was constructed in 1652 for the boyar Miloslavsky. After his death, it passed to the state. Under Tsar Alexei Mikhailovich theatrical performances were staged there.

Opposite the Arsenal is the thoroughly reconstructed Senate building, now the residence of the President of Russia, an example of Moscow Classical style.

The Great Kremlin Palace forms a single complex with the Terem Palace and the Palace of Facets. There are about 700 rooms in the building. A suite of rooms on the lower floor formed the private apartments of the Emperor and Empress. The state rooms of the second storey were dedicated to the various Russian orders, the most famous of which is the Order of St George.

The Armoury, one of the oldest museums in the country, houses works of Russian, Western European and Eastern decorative and applied art: old arms and armour, unique items made of gold, silver and precious stones, state regalia, a collection of thrones, and ambassadorial gifts.

1. View of the Kremlin cathedrals

2. The Saviour Tower
 1491, architect Pietro Antonio Solari;
 1624–25, architect Bazhen Ogurtsov,
 clock-maker Christopher Galloway

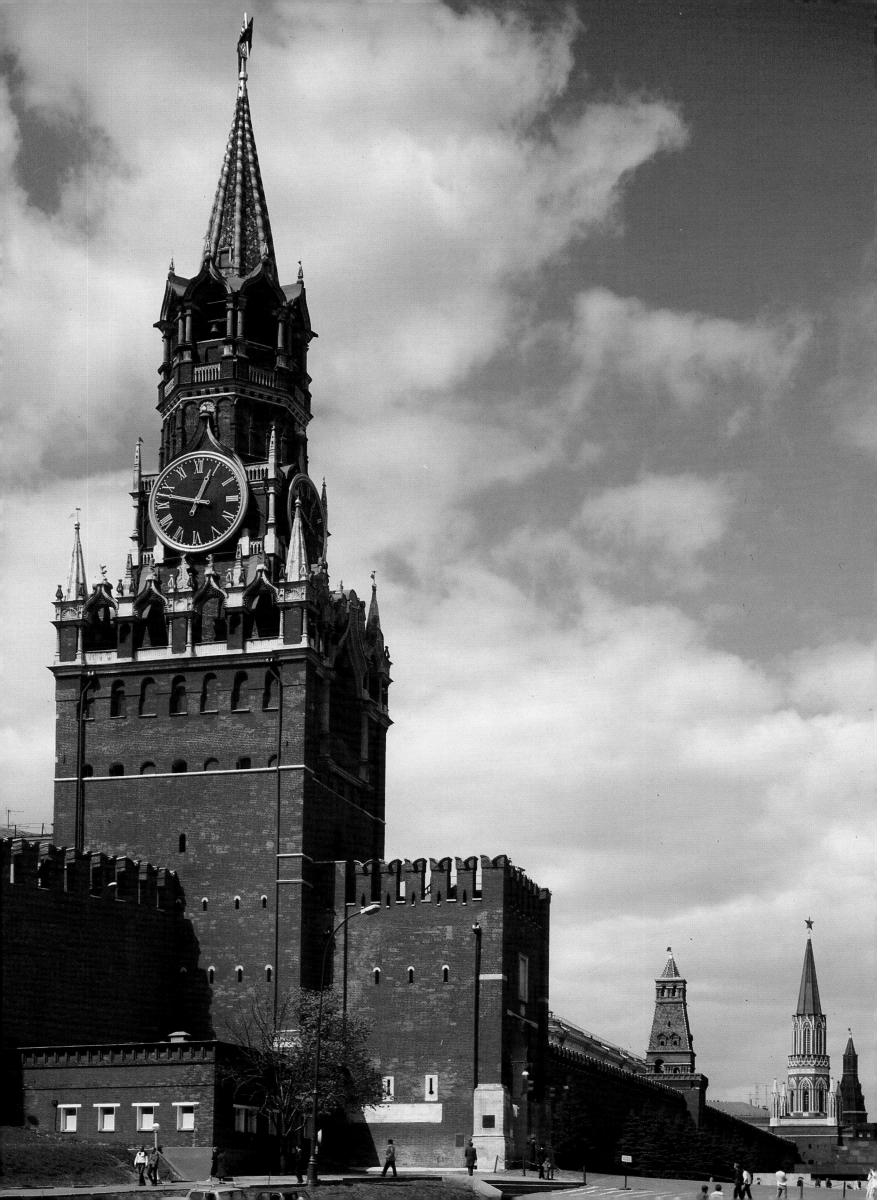

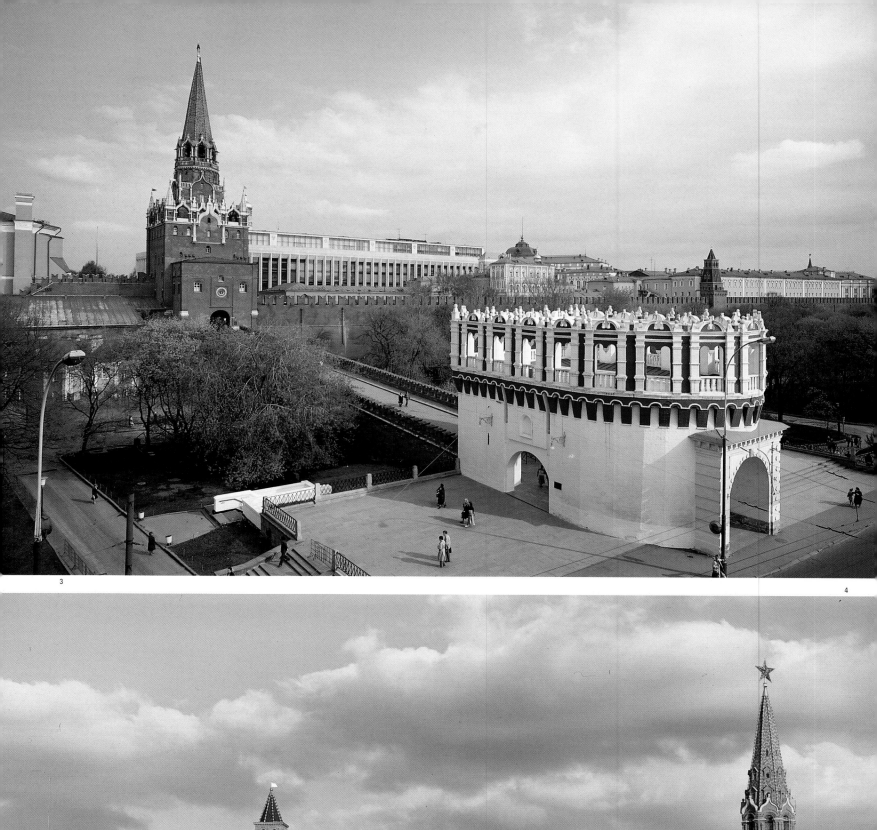

3

4

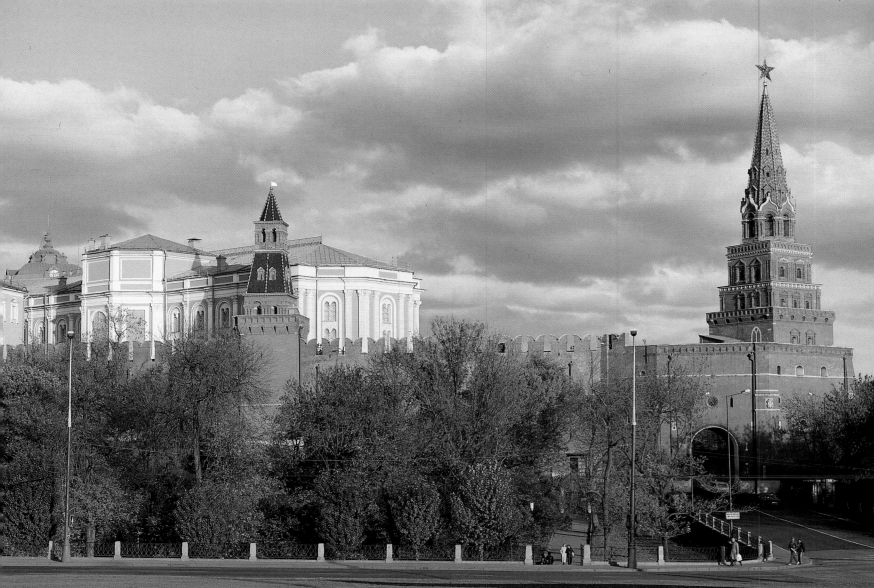

5

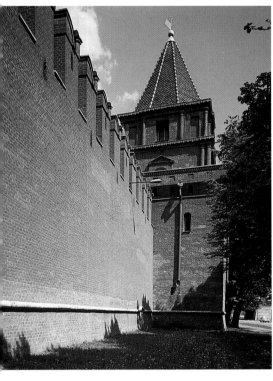

6

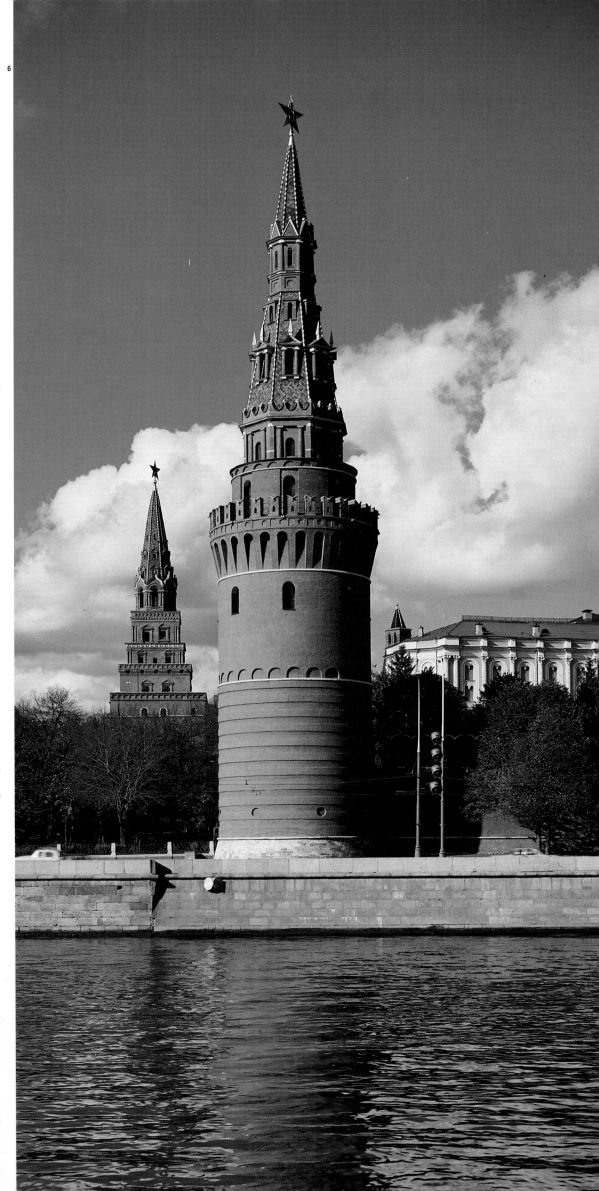

7

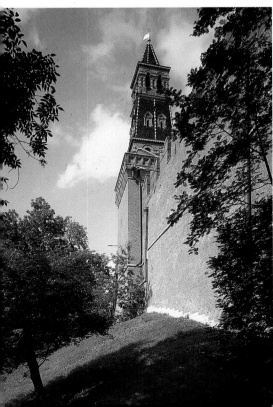

8

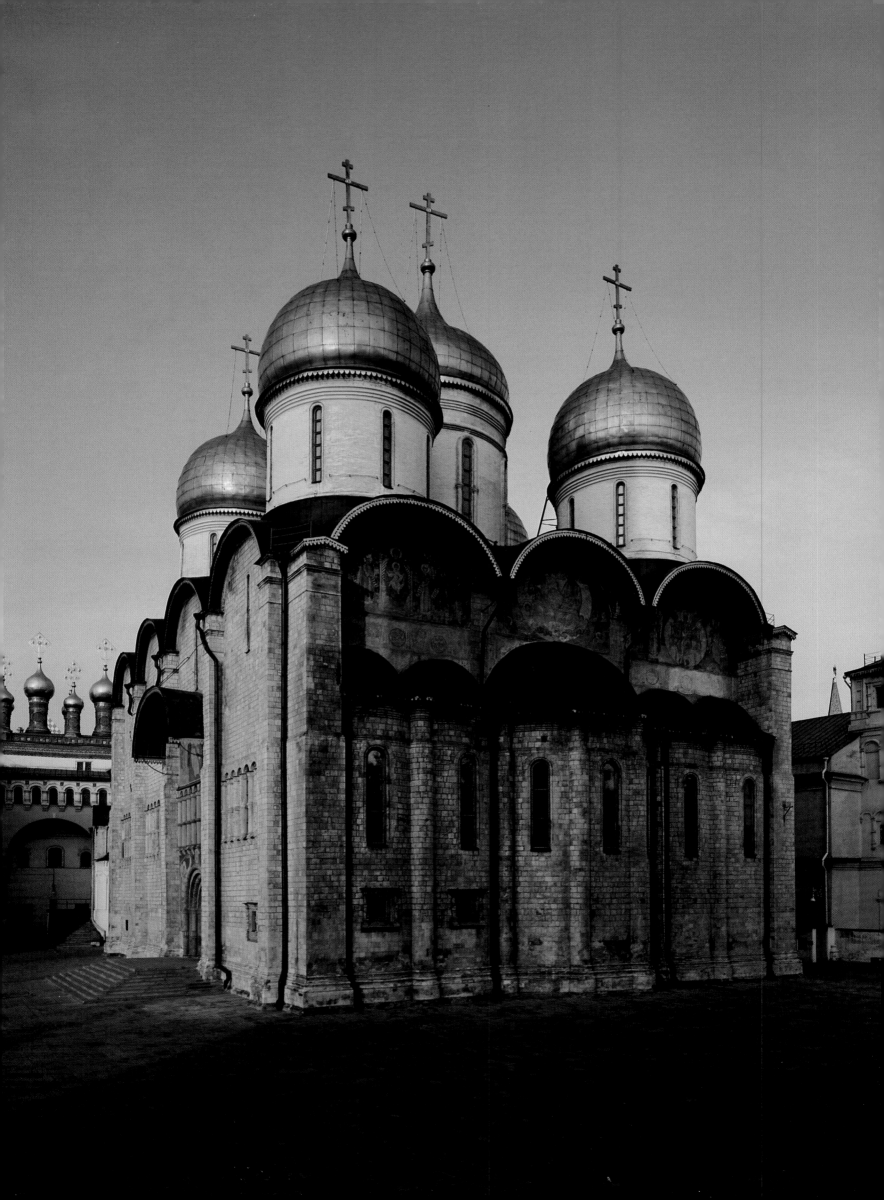

10

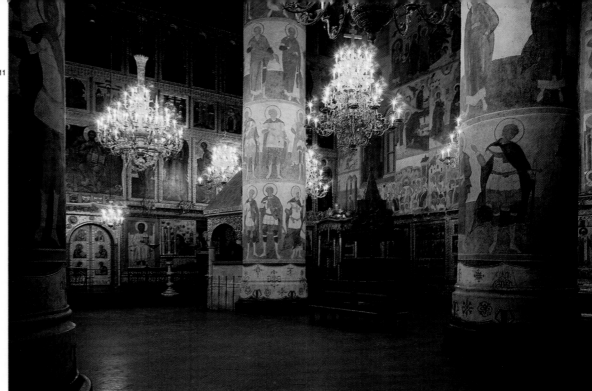

11

12

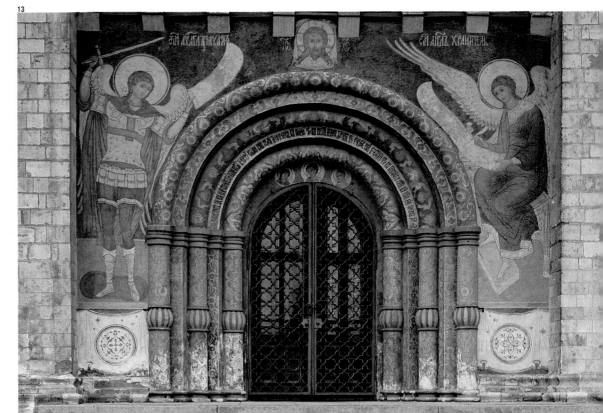

13

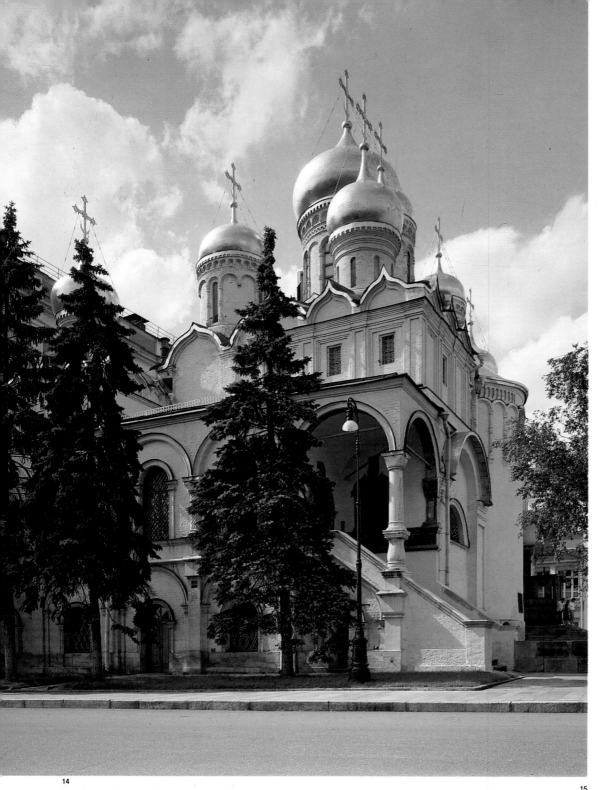

14

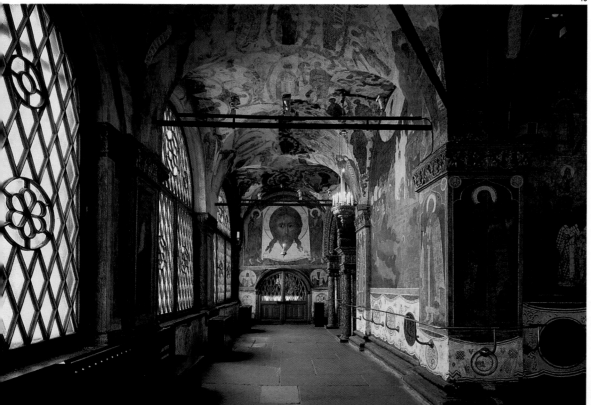

15

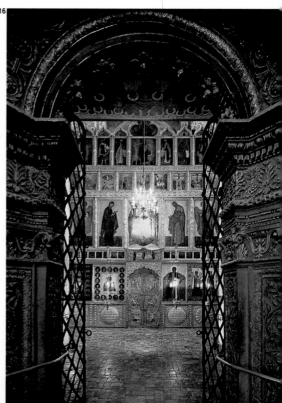

16

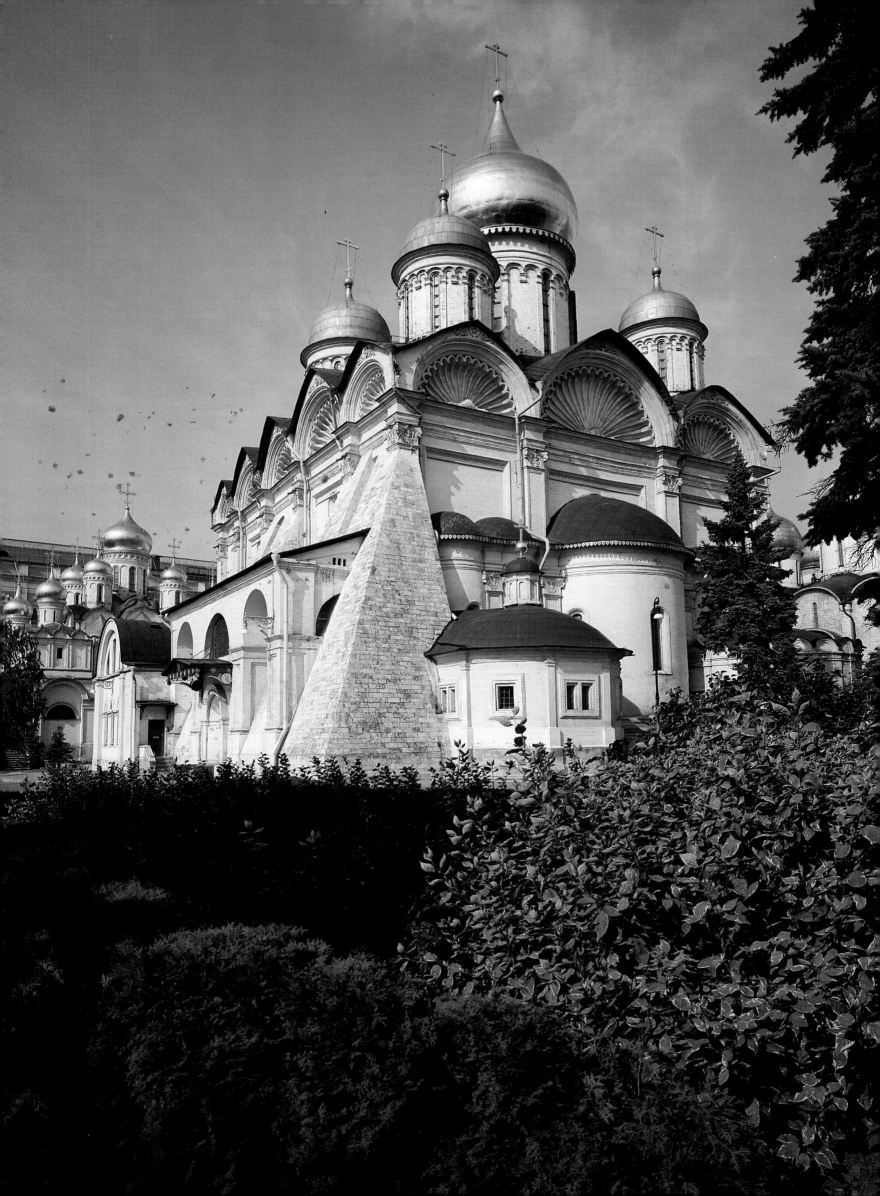

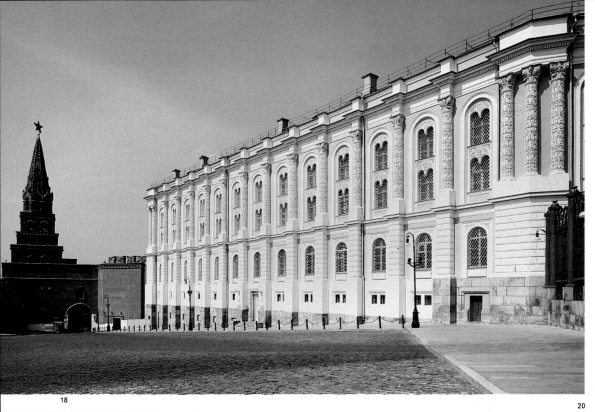

18

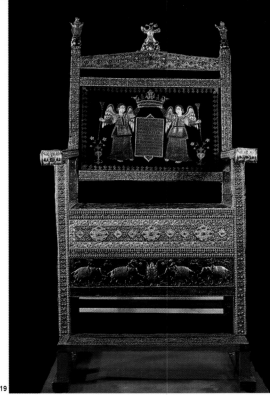

19

20

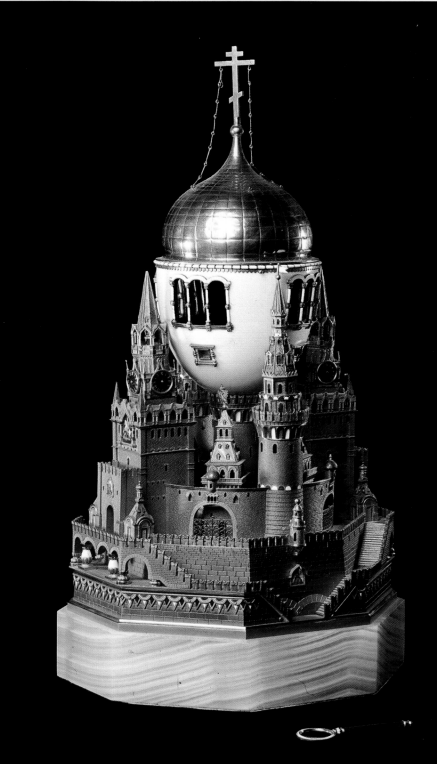

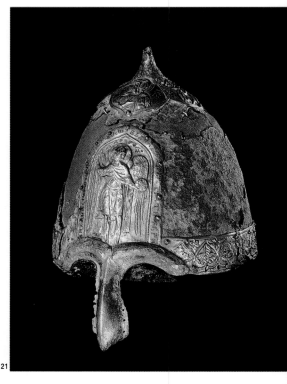

21

22

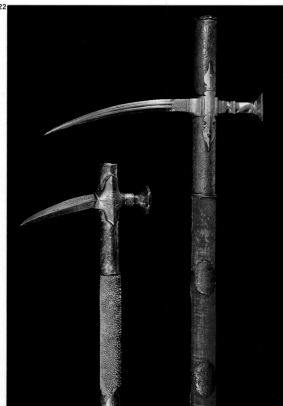

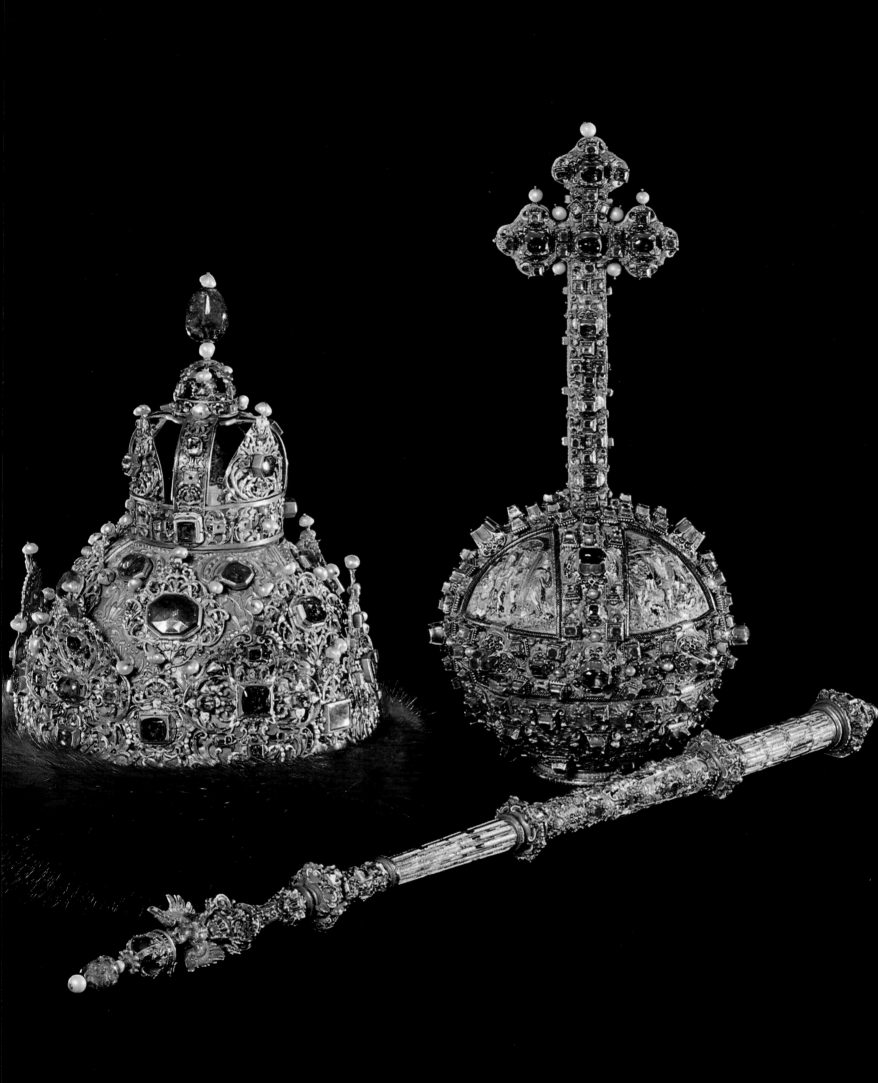

24

25

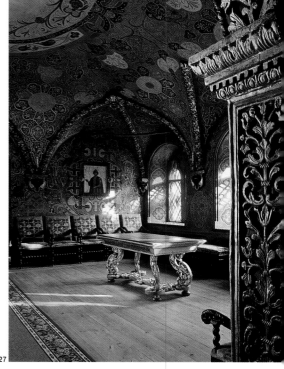

26

27

28

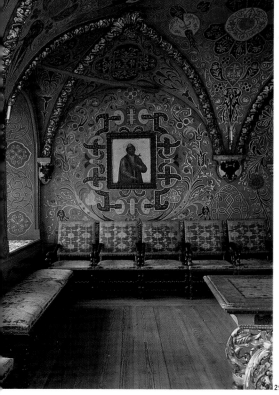

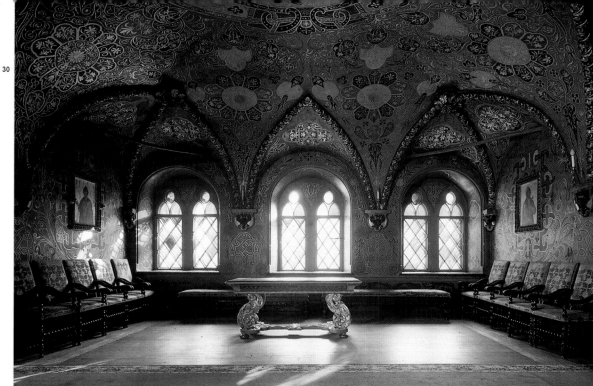

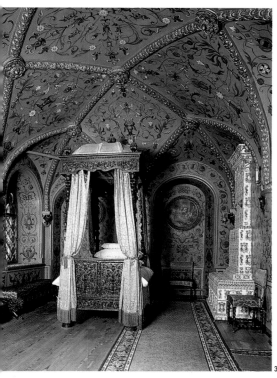

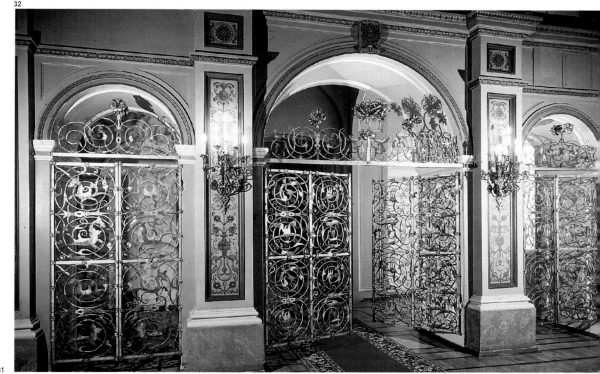

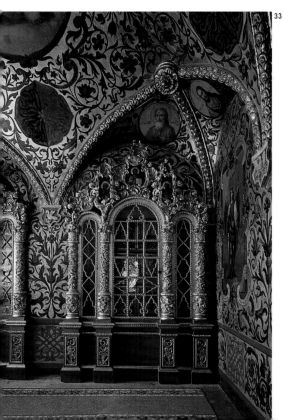

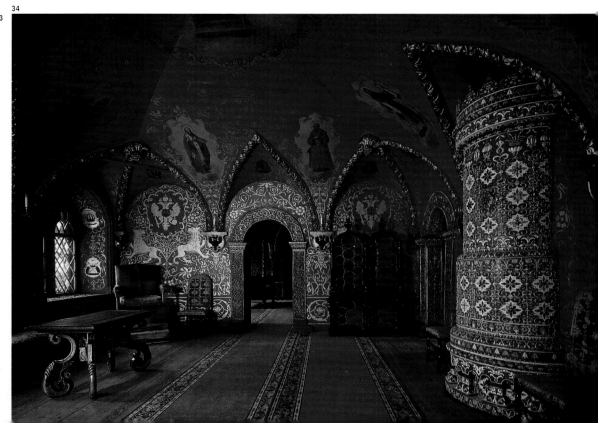

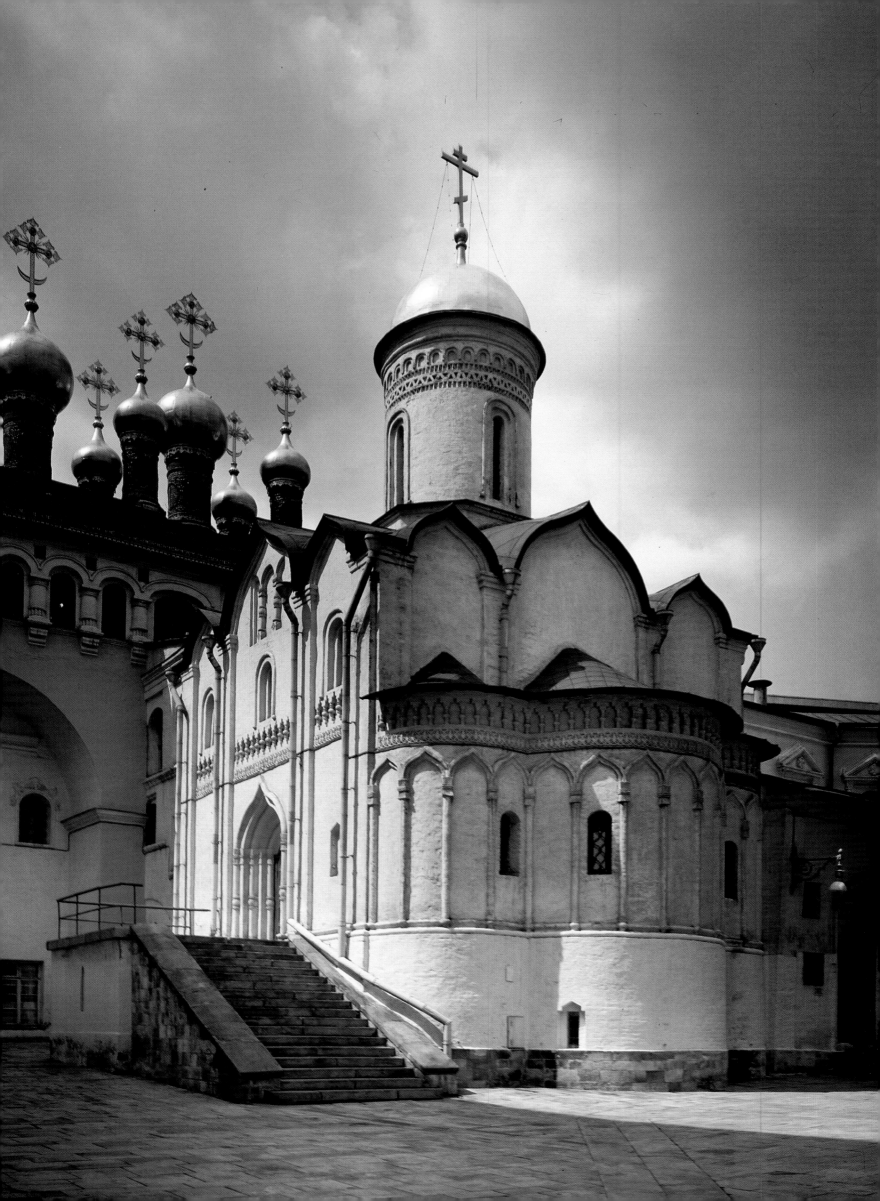

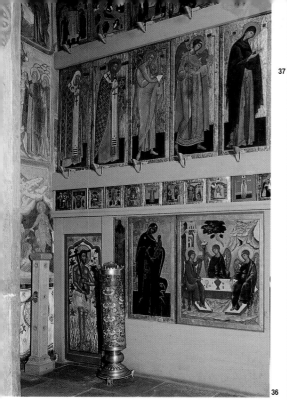

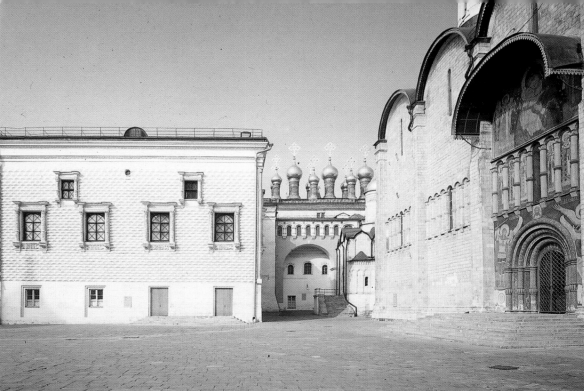

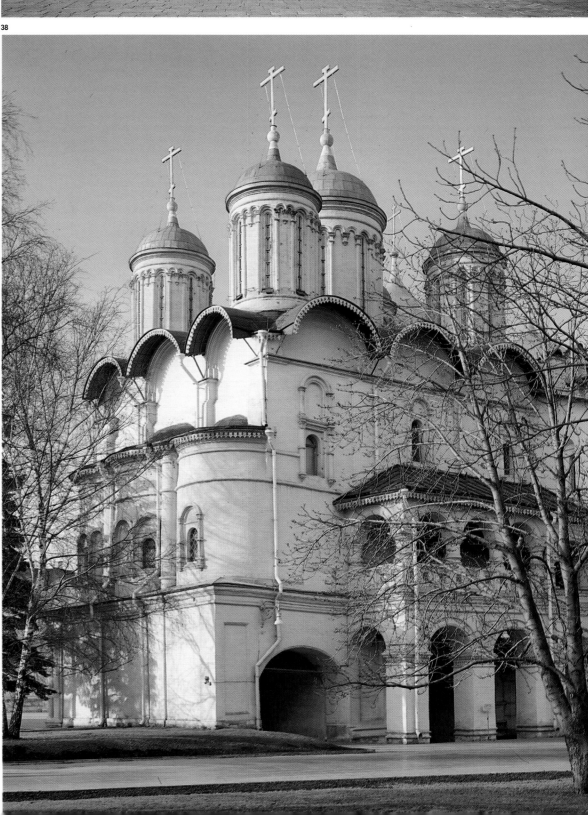

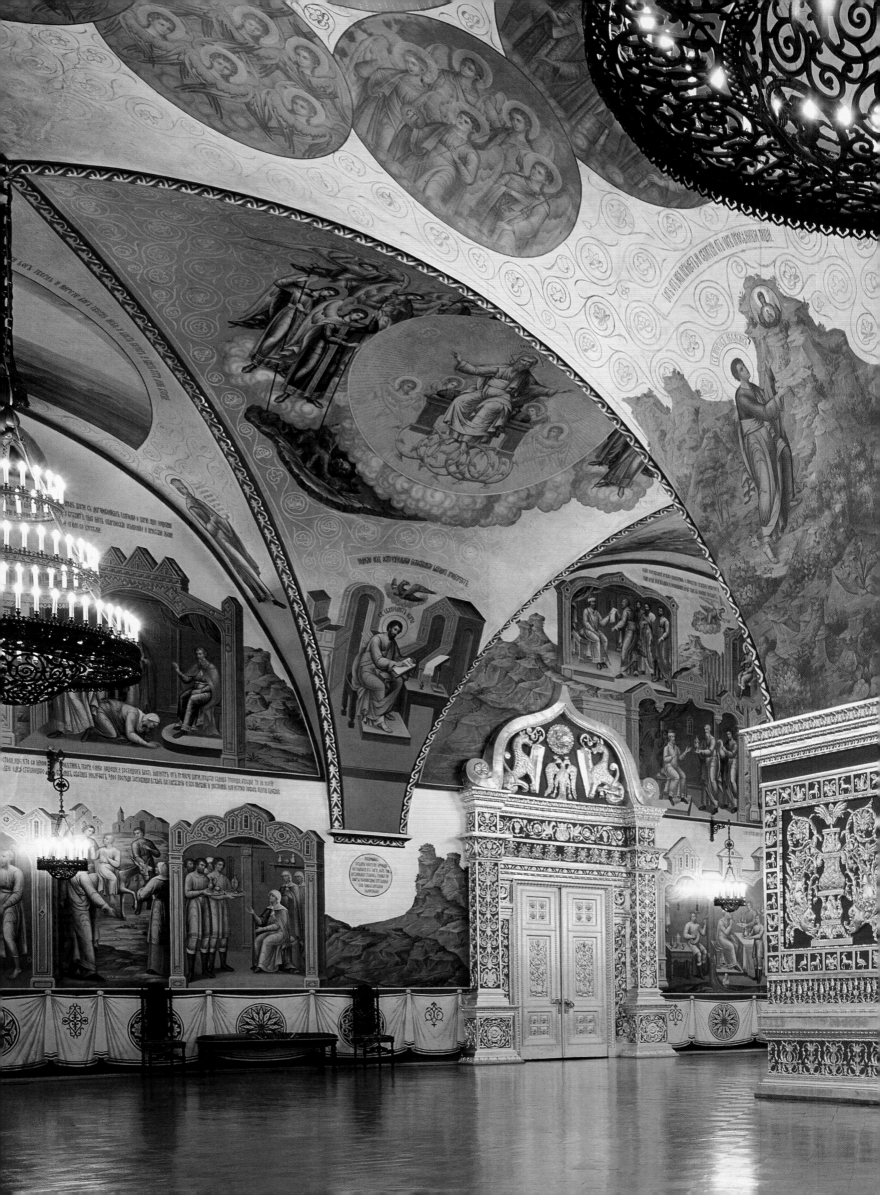

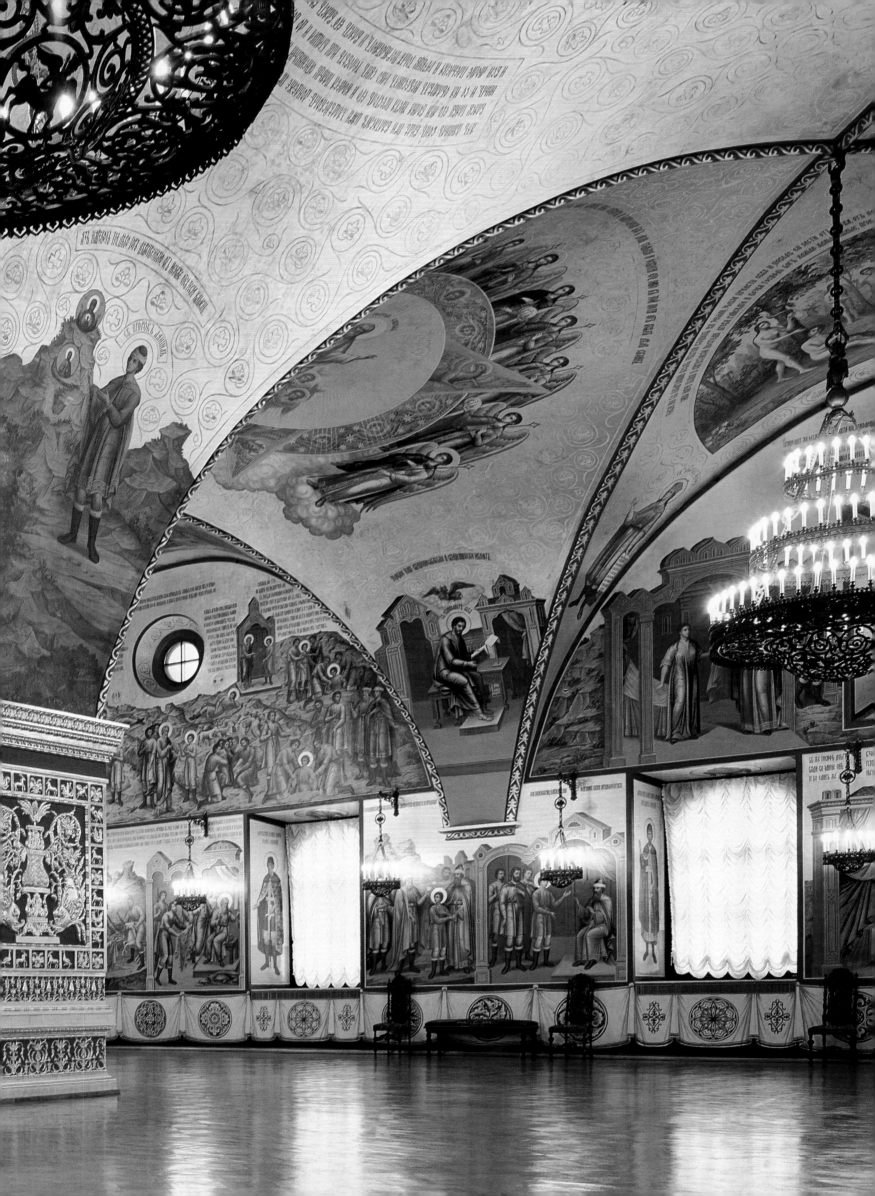

40

41

42

43

44

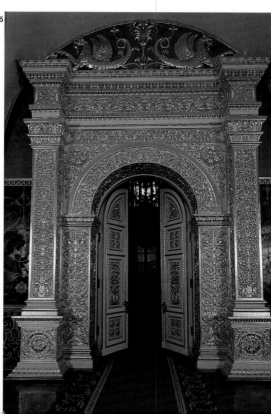

45

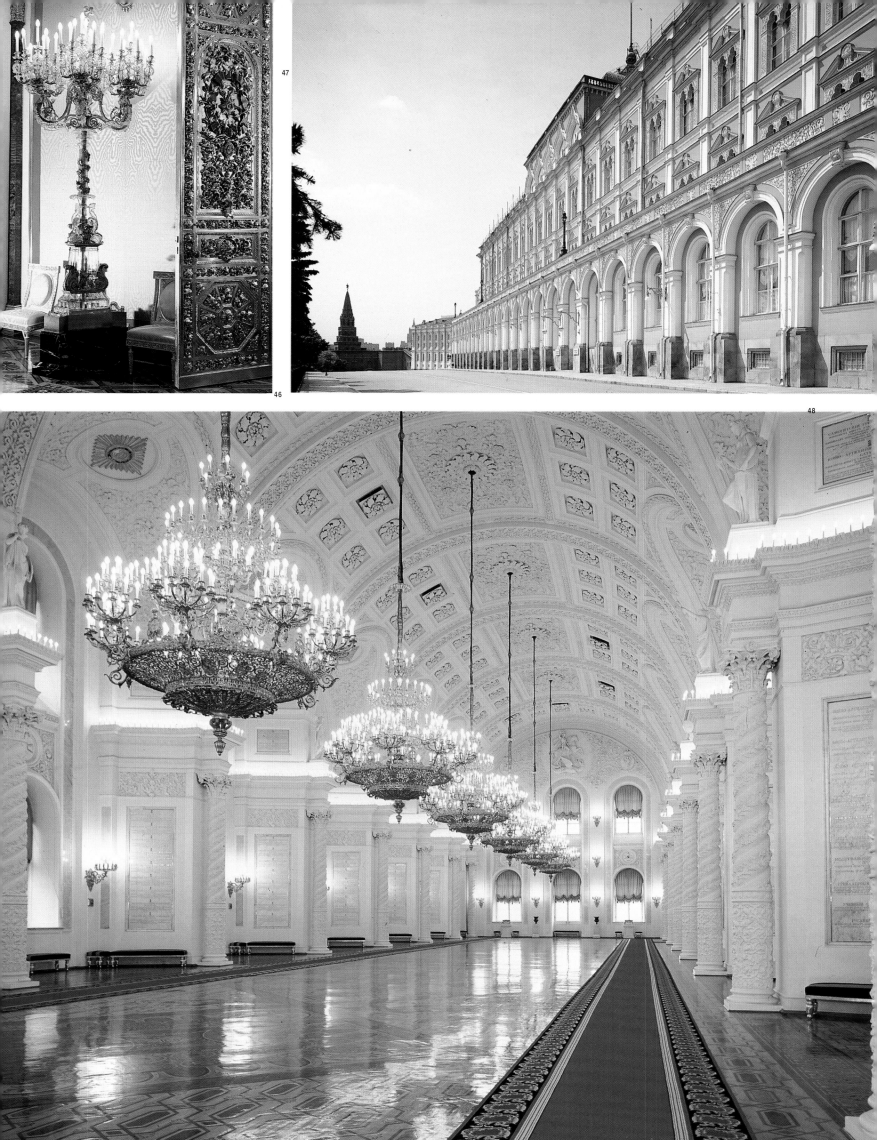

46

47

48

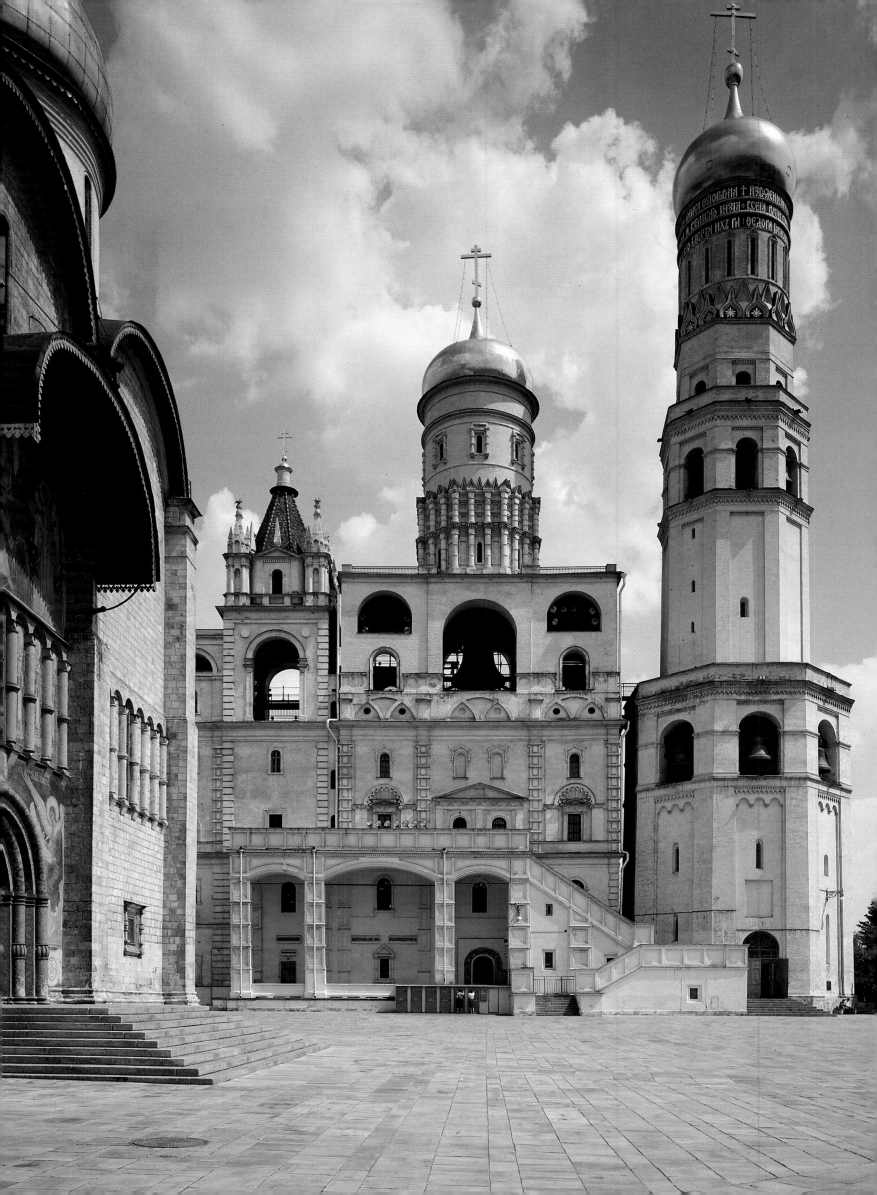

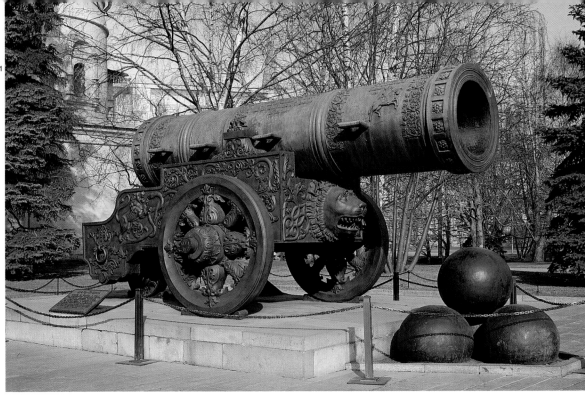

51

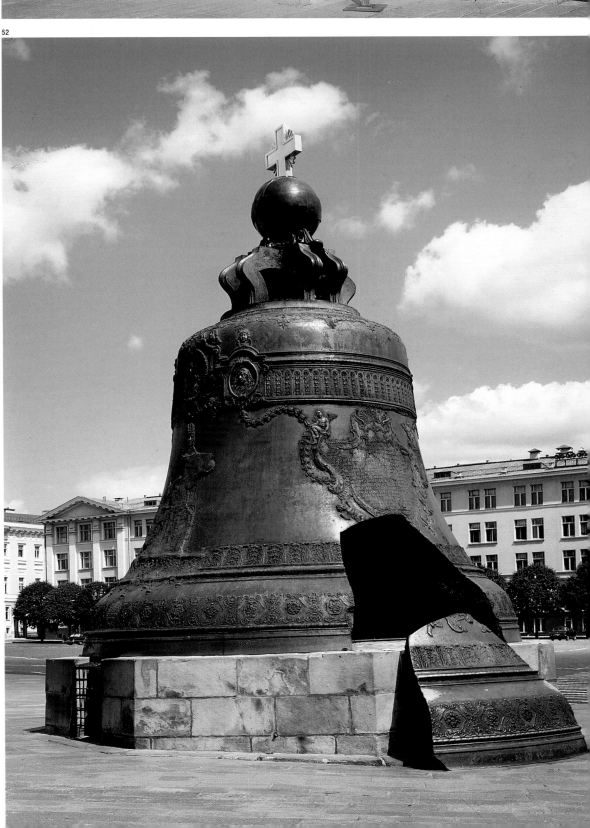

50

52

Red Square, the main square in Moscow (length 695 metres, width 130 metres), is dominated by the Kremlin. Its architectural composition is based on the contrast between the horizontal line of the fortified wall and the upward thrust of its towers and of the many-domed Cathedral of the Intercession of the Virgin (1555–61), better known as St Basil's Cathedral after a celebrated holy-fool who was buried by its wall some time later. The cathedral was created as a monument to a great Russian military victory, the defeat of the Khanate of Kazan. It was popularly considered to be a memorial to all the heroes who fell in the centuries-long struggle against the Tatar-Mongol yoke. On Ivan the Terrible's orders, the project was entrusted to the Russian master-builders Barma and Postnik. The cathedral was supposed to be made up of eight separate chapels, dedicated to the religious festivals and saints on whose feast-days major victories were gained in the Kazan campaign, but on their own initiative the builders added a ninth, achieving a powerful, harmonious symmetry in all the apparent variety.

An important element in the square is the monument to the early-17th-century heroes Kuzma Minin and Dmitry Pozharsky who led the army which liberated Moscow from the Poles. This work was the first sculptural monument in Moscow. It was unveiled in 1818 and reflects the patriotic and civic sentiments of the period when Moscow was being reconstructed after the war and fire of 1812. The monument was funded by public subscription. In 1931 it was moved from outside the Upper Trading Rows (GUM) to a site near St Basil's.

Opposite St Basil's, on the north side of the square, stands the building of the History Museum. Constructed in 1875–81 to the design of Vladimir Sherwood, it played a considerable role in the development of architecture in Moscow towards the turn of the 20th century, marking the beginning of reconstruction in the centre of the city. Its creator, an architect and artist, intended the museum to become a sort of visual embodiment of Russia and accordingly strove to design an edifice with a distinctively national character. The decoration exactly reproduced elements from notable architectural monuments around the country, making the building itself a sort of exhibit.

In the 1780s a stone chapel was erected by the Resurrection Gate for the icon of the Virgin of Iberia, which came from the Iberian Monastery on Mount Athos in Greece. In 1931 that historic building was destroyed and the holy image venerated in old Moscow disappeared. On 26 October 1995, the feast-day of the Virgin of Iberia, the Resurrection Gate, recreated on the old foundations, was formally reopened and the new Iberian Chapel consecrated.

The nearby Kazan Cathedral — a monument to the victory of 1612 when Polish and Lithuanian forces were driven out of Moscow — was rebuilt in 1993. The cathedral, consecrated in 1636, had been barbarously destroyed 300 years later. And so a lost corner of old Moscow has recently been returned to life.

The appearance of Red Square was significantly altered by the construction of the Lenin Mausoleum (present building, 1930) and the moving of the monument to Minin and Pozharsky. The architect Alexei Shchusev sought to make the Mausoleum the compositional centre of the square, by making it large and placing it on the highest point. The Mausoleum was, however, constructed partially below ground so as not to destroy the harmony of a unique architectural ensemble.

A stone's throw from Red Square, by the Kremlin wall in the Alexander Garden, is the Tomb of the Unknown Soldier, a memorial to all those who gave their lives for their country in the war years of 1941–45.

53. The Intercession Cathedral
(St Basil's)
1555–61, architects Barma and Postnik

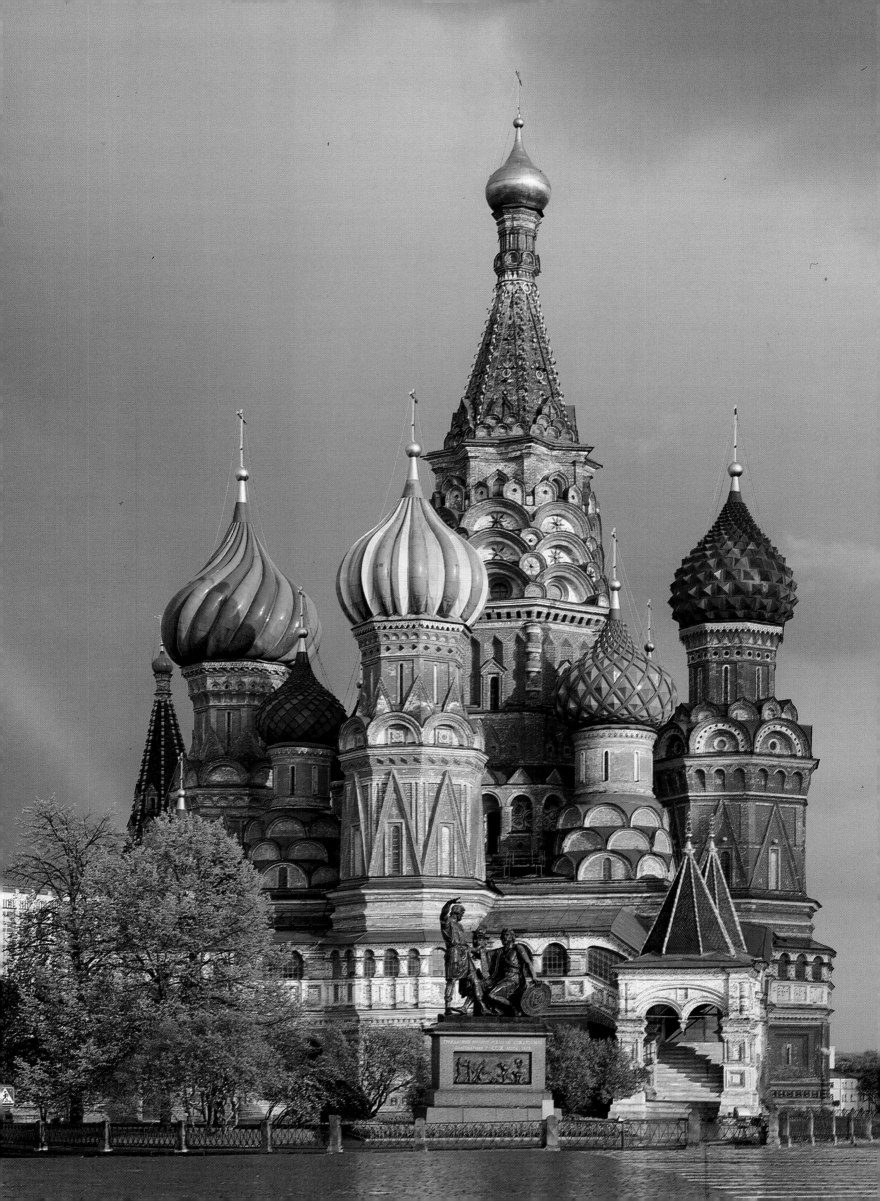

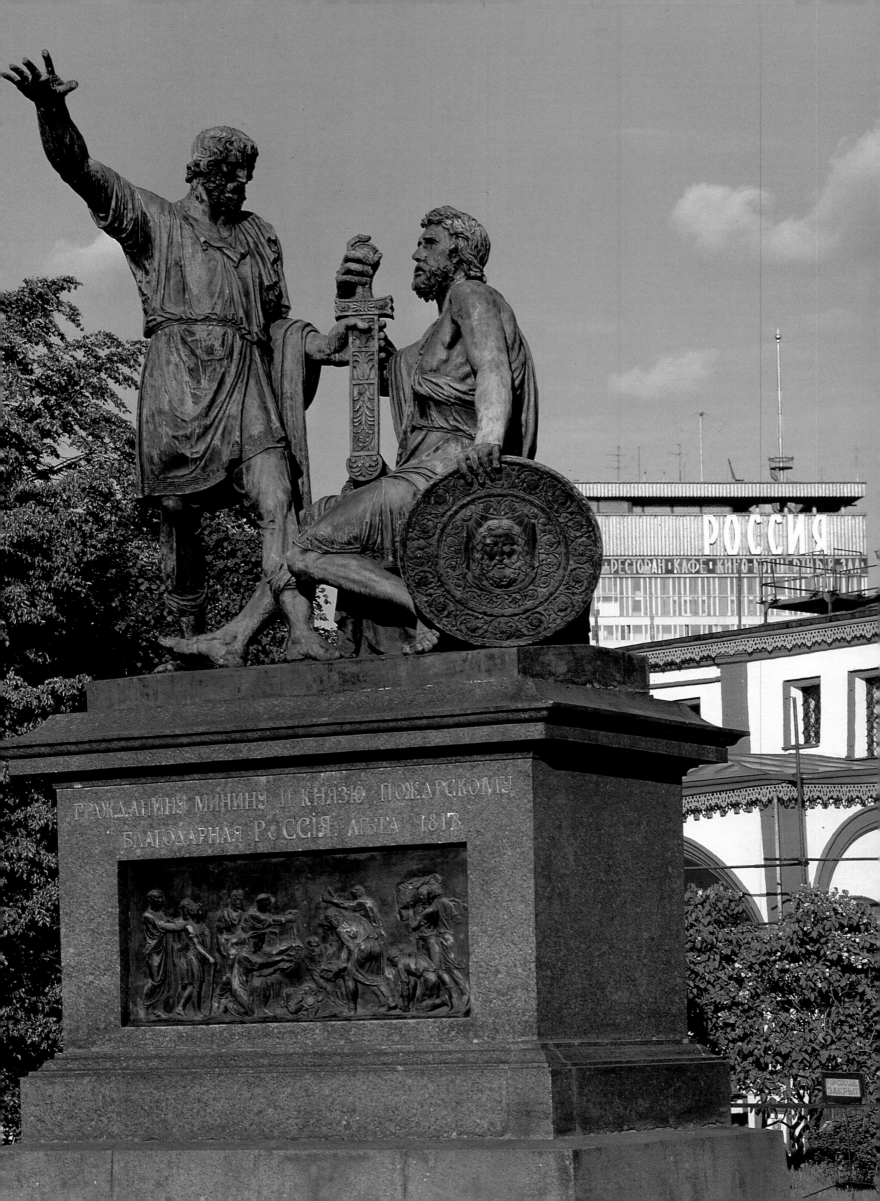

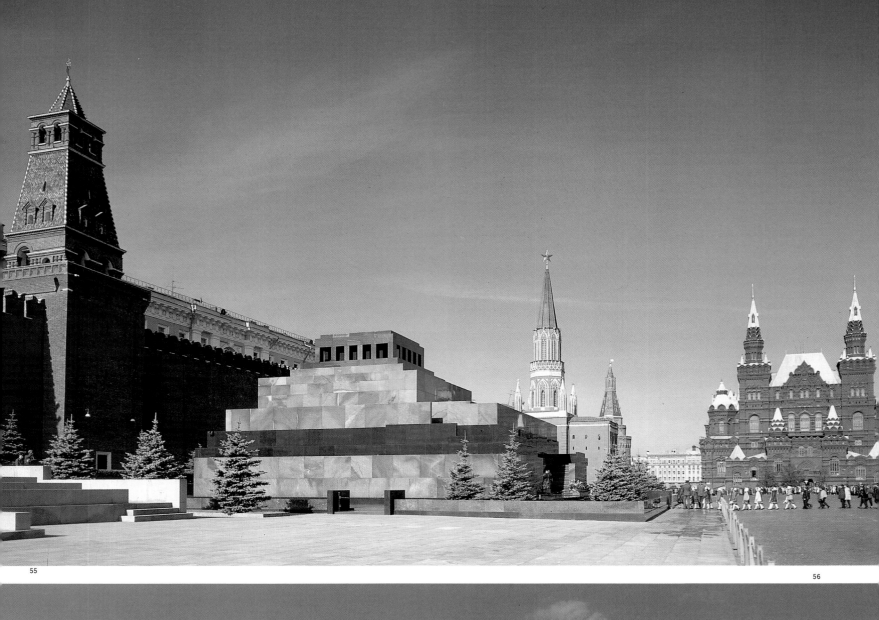

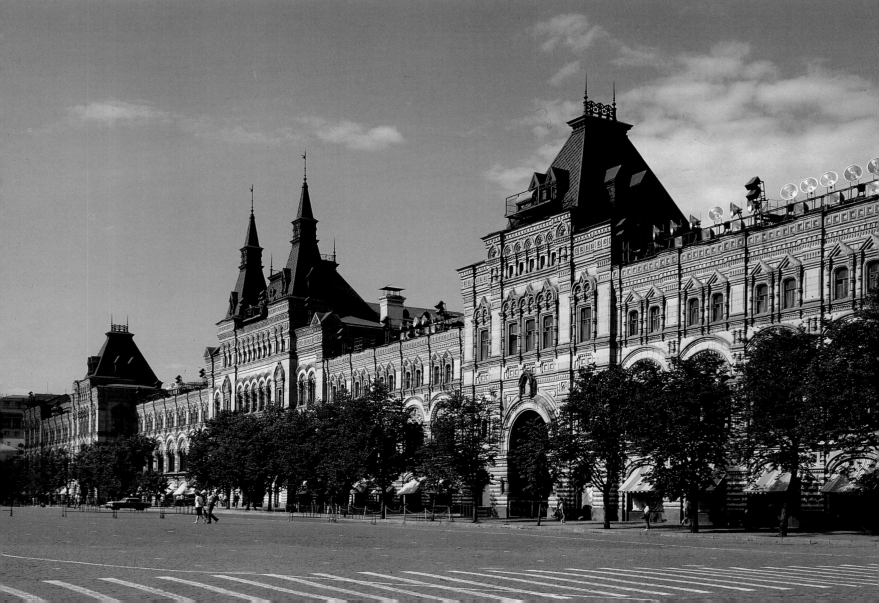

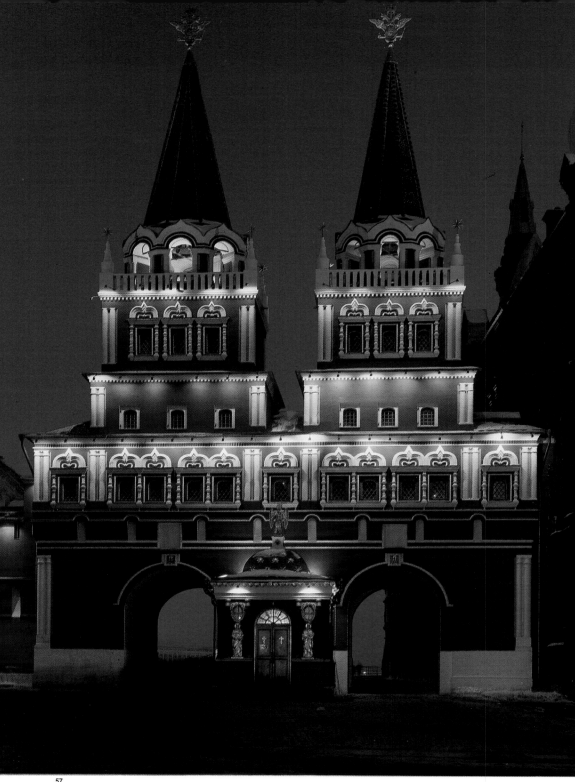

57

58

59

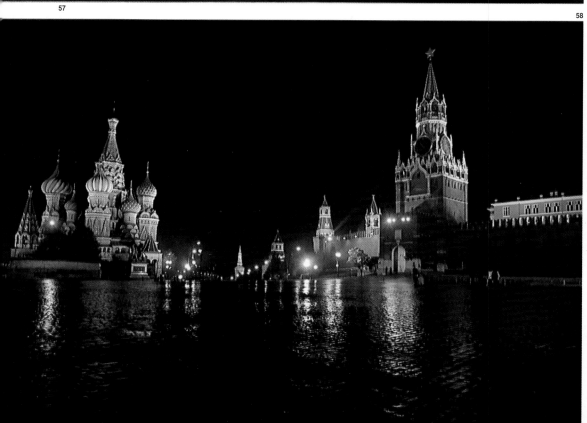

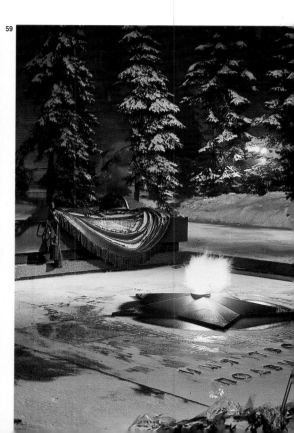

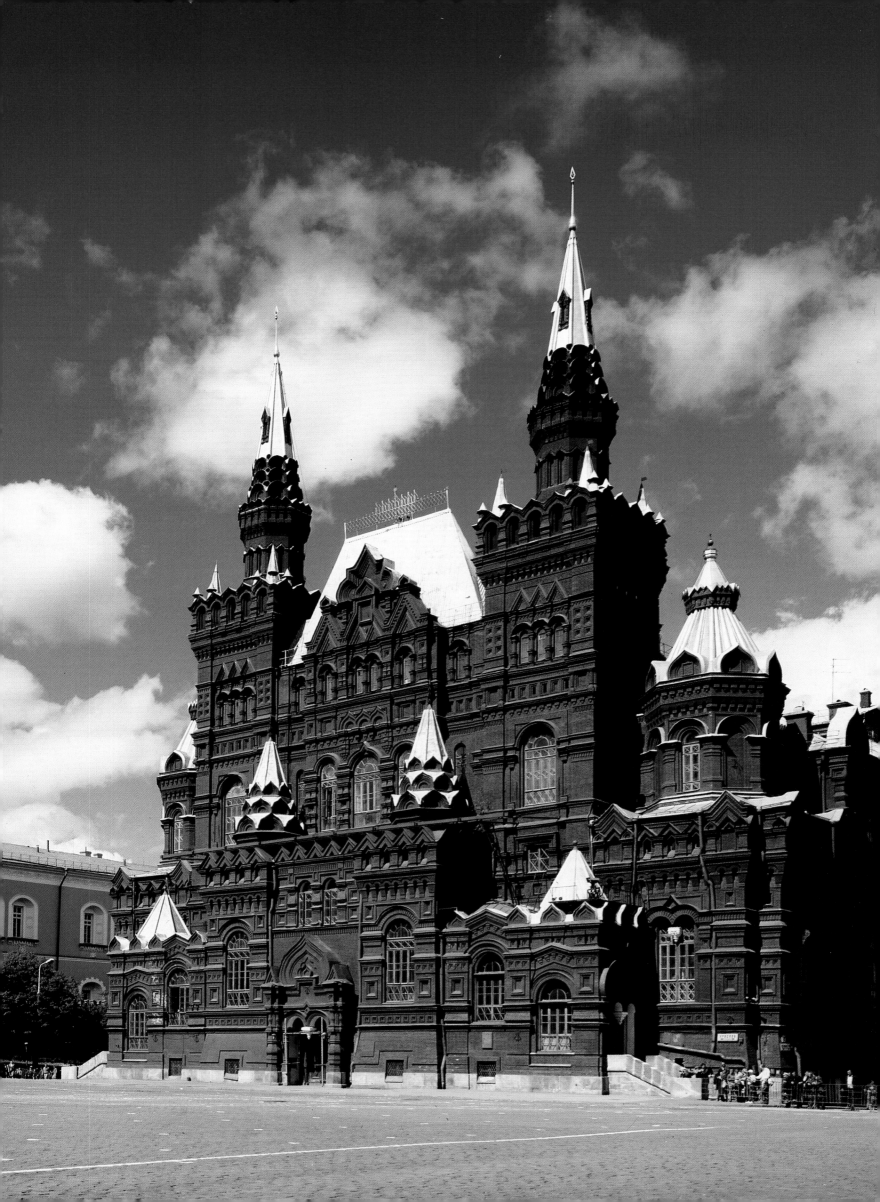

Kitai-Gorod is one of the oldest parts of Moscow. The origin of the name remains a mystery. The first part has been linked to various words: *kita* – a mesh of branches, supposedly used to produce particularly strong walls; *kity* – earthwork fortifications; and others. The most convincing explanation, however, is that the name consists of two words, one Mongol, one Early Russian, and means "middle fortress". Kitai-Gorod was indeed located between two other sets of fortifications – the Kremlin and the White City.

Kitai-Gorod is almost as old as the Kremlin. It was enclosed by strong fortifications in the mid-16th century. The new fortress met all the demands for defensive architecture at that time, and, although the fortifications were constructed soon after those of the Kremlin, they were considerably superior. Almost as long as the Kremlin walls, they were lower, but thicker. Today we can still see fragments of the Kitai-Gorod fortifications: part of the wall in Revolution Square, a tower in Theatrical Lane, and a larger restored section of wall in Kitai-Gorod Lane.

One of the interesting features of Kitai-Gorod is its layout. The three main streets of the district, Varvarka, Ilyinka and Nikolskaya Street, which fan out from Red Square sprang up along important roads leading out of the city.

On Varvarka is the southern façade of the Old Gostiny Dvor, a trading complex which in its time supplied not only Moscow, but the whole of Russia with commodities. This monumental building was constructed in the heyday of Classicism.

Alongside St Barbara's Church (which gave the street its name) stands the "English Court" of the 16th and 17th centuries. Originally the building belonged to a rich foreign merchant called Yushka. When he died, Ivan the Terrible gave this well-appointed residence with its grand reception rooms, living quarters and storage premises to the English merchants of the Muscovy Company. The north façade, towards the street, retains distinctive features of 16th-century architecture. The main, southern, façade, with pilaster strips, an elaborate cornice and a belt of recessed decorative squares, was created later, in the early 17th century.

The ensemble of the Monastery of the Sign formed between 1678 and 1684. It comprises a massive five-domed cathedral with bell-tower, chapter-house and a building containing the monks' cells. The complex is dominated by the cathedral which was built of brick in 1679–84 by a team of serf peasants led by Fiodor Grigoryev and Grigory Anisimov.

Closer to the River Moskva is the small Church of the Conception of St Anne "in the Corner" (at one time it stood in the angle of the Kitai-Gorod wall) – one of the oldest buildings in this district. It was constructed in brick by unknown builders at the turn of the 16th century.

Not far from Varvarka, in Nikitnikov Lane, is a celebrated example of the Russian decorative style – the Church of the Holy Trinity. It was built in 1631–34, paid for by the wealthy merchant Grigory Nikitnikov, a native of Yaroslavl, and served as both a family and a parish church. The south chapel, dedicated to St Nicetas the Warrior, acted as the family vault. Lavish plant ornament and depictions of fabulous birds cover the limestone window and door surrounds. The side-chapels, tent-roofed bell-tower, porch and refectory combine to create a picturesque, asymmetrical silhouette. The south side of the building, which faces the street, is the most richly decorated. The church's murals and 17th-century icons, including works by the celebrated Simon Ushakov, are of great artistic value.

Among the most interesting historical and architectural monuments on Nikolskaya Street is the Royal Print Yard, which played a great role in the advance of learning in this country. Here Ivan Fiodorov and Piotr Mstislavets printed the first dated Russian book, the *Apostolos* of 1564. According to one scholar, the Moscow Print Yard produced more books in Cyrillic script than all the rest of the world together. The territory that it occupied is now concealed behind the unusual building of the former Synodal Printing-House. Its main façade is in the "Russian Gothic" manner, although the compositional structure is typical of Classicism. Today the building is occupied by the Russian State University of the Humanities. In 1875 the architect-restorer Nikolai Artleben restored the Proof-Reading Chamber which stood alongside the Kitai-Gorod wall and added a grand porch to it.

61. The Church of the Holy Trinity
in Nikitniki
1631–34; 1653–56

40

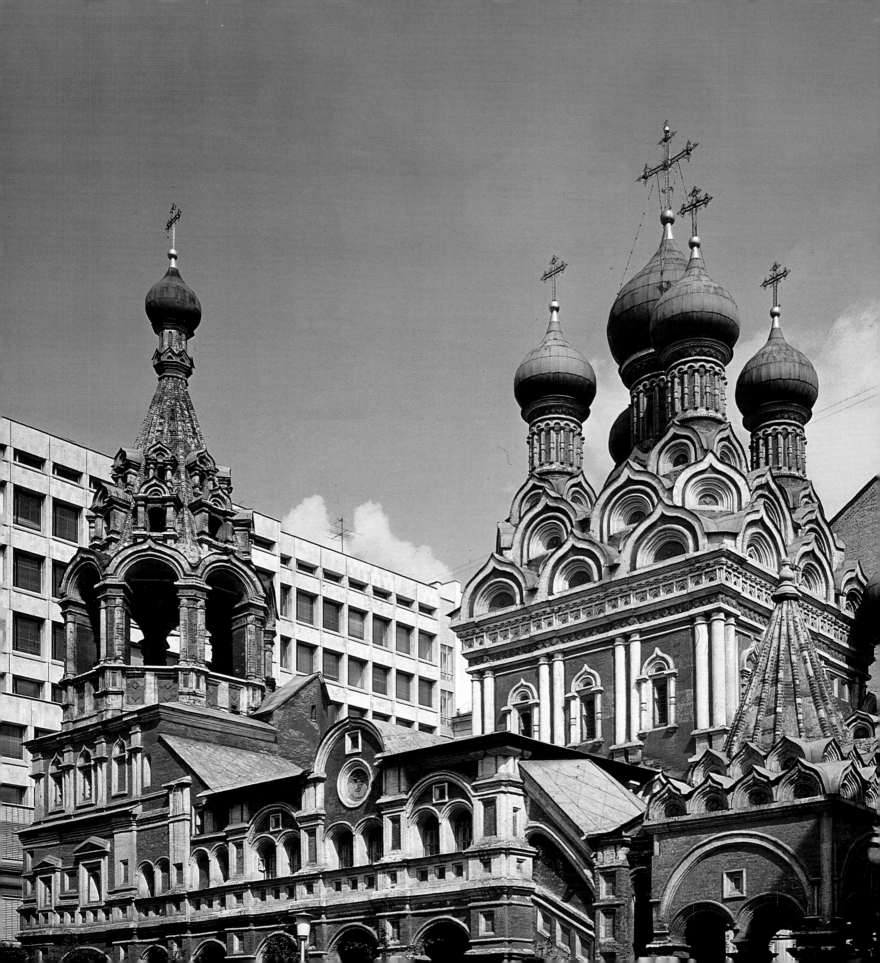

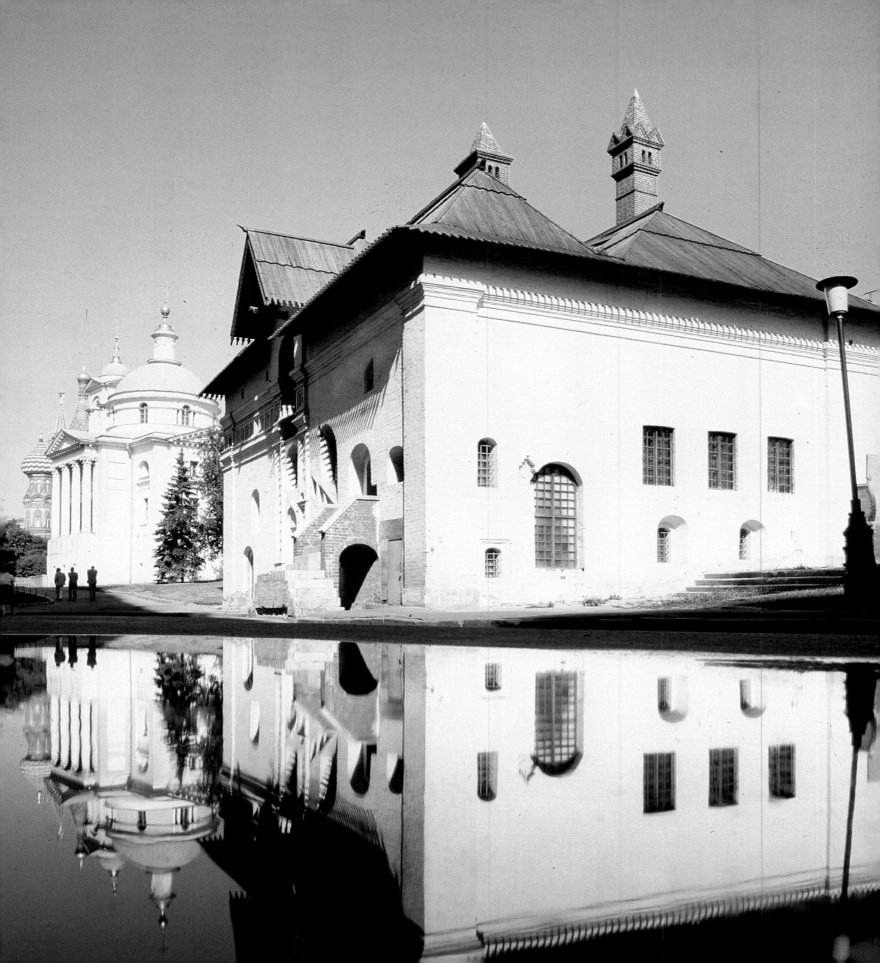

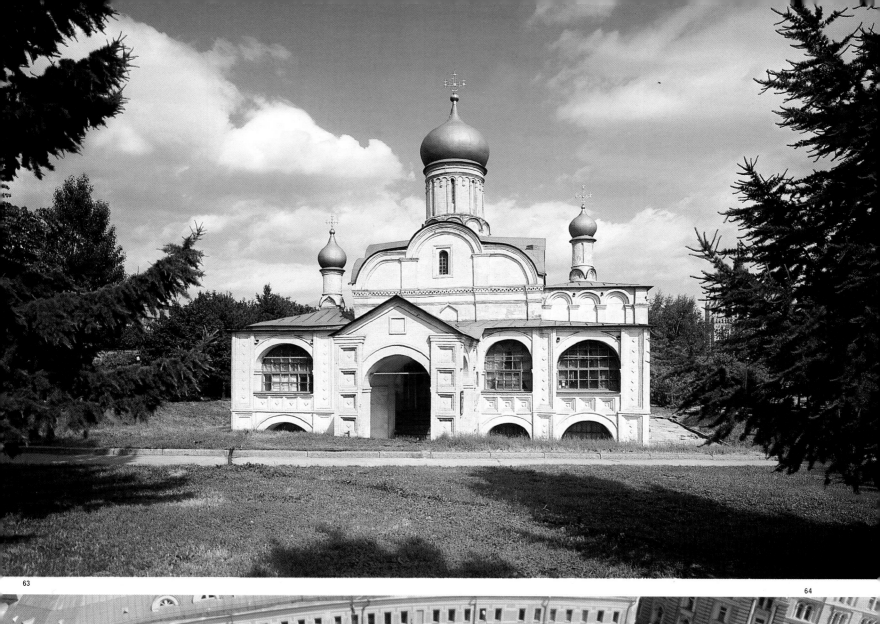

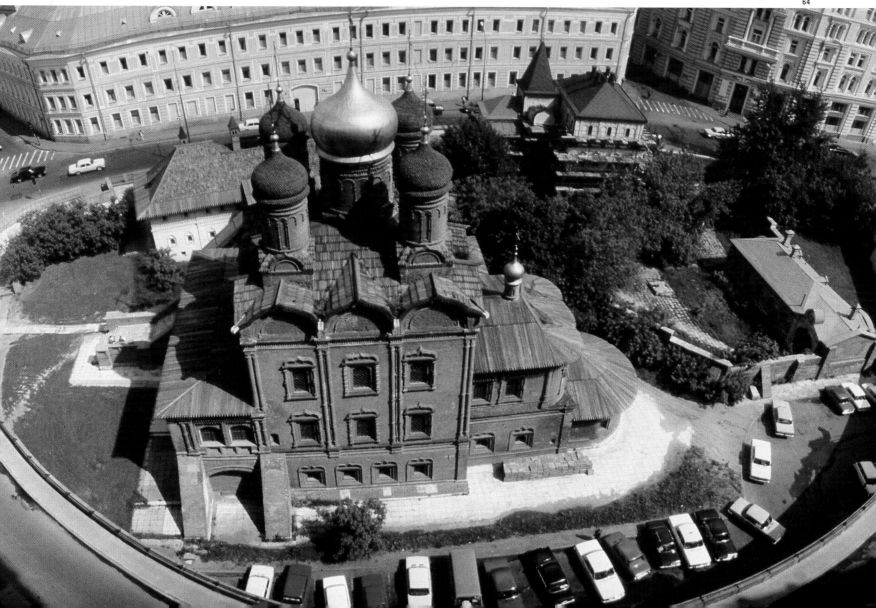

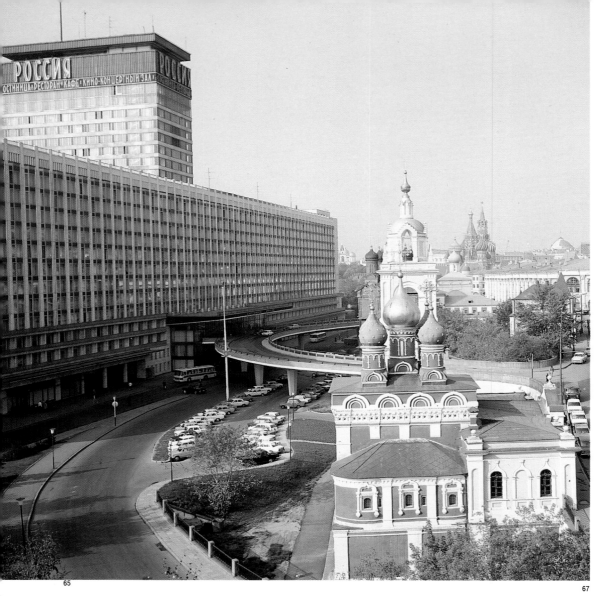

65

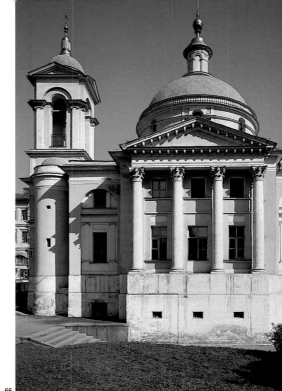

66

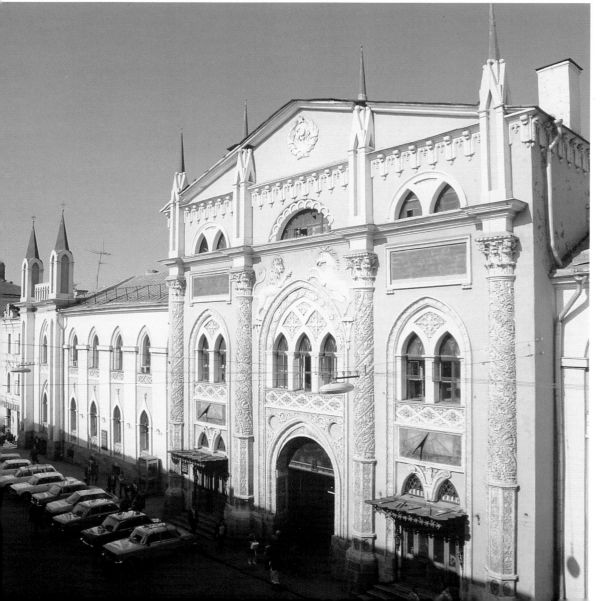

67

The area between Kitai-Gorod, the boundary of which is now marked by the arc of central squares, and the present-day Boulevard Ring came by the end of the 16th century to be known as the White City.
In the late 16th century Fiodor Kon directed the construction of tremendous sweep of wall from the Vodovzvodnaya Tower at the south-western corner of the Kremlin to the mouth of the River Yauza out to the east. This incomplete circle, over 9.5 kilometres long, provided protection for a long-established area of Moscow which had incorporated some ancient localities. The name White City most probably arose because these areas were "white" in the sense of being exempted from taxes.
In early times, the territory that became the White City contained the Grand Prince's suburban residence, the estates of many boyars, monasteries and convents and the Cannon Yard. In the 18th century the White City was mainly inhabited by the nobility and their urban mansions sprang up across the area. By that time the White City wall had lost its defensive significance and in the second half of the century it was dismantled, to be replaced by a series of boulevards. The laying out and construction of the boulevards was completed in the course of the restoration of Moscow after the fire of 1812. As a result a splendid "green horseshoe" of tree-lined avenues came into being.
The rich history of the White City and its important role in the life of Moscow is reflected in the number of architectural and historical monuments to be found there. In the western part of the area, the street called Volkhonka leads to the Pushkin Museum of Fine Arts (1898–1912, architect Roman Klein), one of the largest of its kind in the world. Some elements of the building were borrowed from the Erechtheion and the Parthenon in Athens. The original core of the museum was a number of casts from ancient statues collected by its founder, Professor Ivan Tsvetayev. Today it is the second largest collection of art in the country (after the Hermitage in St Petersburg).
On Mokhovaya Street, which leads into the chain of central squares embracing Kitai-Gorod, stands a famous monument of Classical architecture — the Pashkov House. Today it forms part of the State Library of Russia complex of buildings which occupies the whole block between Znamenka and Vozdvizhenka Streets. The new building of the library displays features of the period of transition between ascetic Constructivism and the pompous "Neo-Classicism" of the Stalin era. A large amount of monumental decorative sculpture adorns the façade, with bas-reliefs depicting scholars, writers and thinkers, cast in the bronze of bells taken from Moscow churches, placed between the piers.
Arseny Morozov's mansion on Znamenka was built in the late 19th century. That rich merchant had spent some time in Portugal and decided to reproduce a mediaeval castle that had attracted him there in the very heart of Moscow. He had a luxurious mansion built in a pseudo-Mauritanian style with lace-topped towers, ironwork on the balcony, a massive portal for an entrance and walls dotted with sea-shells.
On the corner of Okhotny Riad (Hunters' Row) and Bolshaya Dmitrovka stands a splendid example of Classical architecture, now known as the House of Unions. It was originally created in 1775 by Matvei Kazakov for the governor-general, Prince Dolgoruky-Krymsky. After the Moscow nobility acquired the building for use as a their club, the same architect enlarged it and added the famous Hall of Columns in which a sense of grand festiveness combines with the cosiness of a private residence. The balls held here drew up to 5,000 people. Among those who attended, at different times, were Lermontov, Griboyedov, Tolstoi and Pushkin. In 1880, when the monument to Pushkin was unveiled on Strastnaya (now Pushkin) Square, Turgenev and Dostoyevsky made speeches in his honour in the Club of the Nobility.
The vista along Petrovka ends with the stone lacework of the bell-tower in the Upper Monastery of St Peter, from which the street got its name. The monastery was founded in the 1300s, but the buildings which survive today date mainly from the late 17th century. They were paid for by the Naryshkins, the aristocratic family of Peter the Great's mother Natalia.
On the slopes of Sretensky Hill there is an area known as Kuchkovo Field after the semi-legendary boyar Kuchka who was killed by Yury Dolgoruky. The Convent of the Nativity of the Virgin, founded there in 1386, is one of the oldest in Moscow. The present ensemble of buildings date from between the 16th and 19th centuries.
Among the architectural monuments of Peter the Great's time is the Church of the Archangel Gabriel built on the estate of the Tsar's close associate Prince Alexander Menshikov and better known as the Menshikov Tower. The Prince intended his edifice to be higher than the Ivan the Great bell-tower in the Kremlin, and for a time it was the tallest structure in Moscow. Nicknamed "the sister of Ivan the Great", it was constructed in the manner of Naryshkin Baroque churches, but the decoration and treatment of form already belonged to Peter's age. An unaccustomed innovation was the addition of a wooden spire crowned with a gilded copper sculpture of an archangel. The fate of the tower to some extent paralleled that of the Prince himself with abrupt changes in fortune. The commoner Menshikov's giddy rise to the heights of statesmanship ended in disgrace and banishment to Siberia. His tower's glory was also short-lived. In 1723 the spire was struck by lightning and badly damaged by the resultant fire. It was restored, in modified form, only towards the end of the century.

70. Monument to the poet
Alexander Pushkin
1880, sculptor Alexander Opekushin

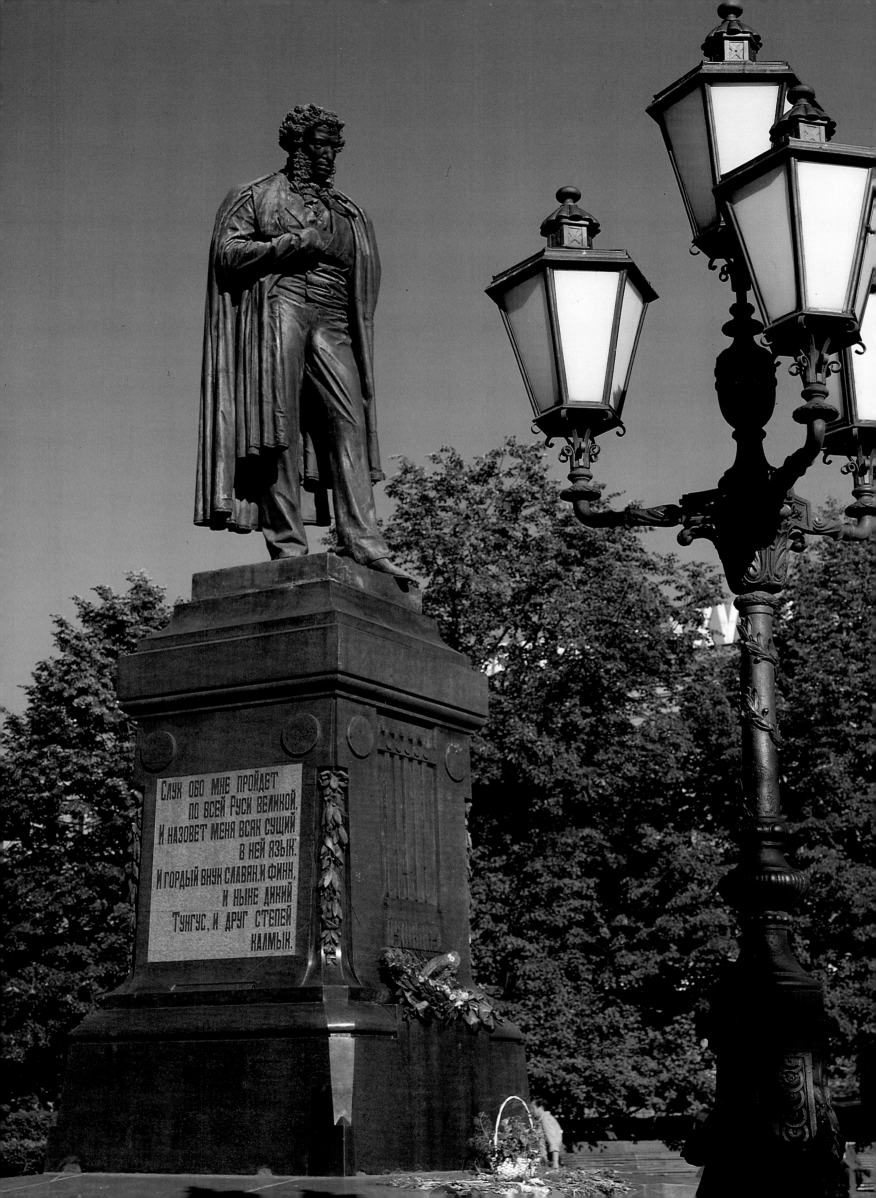

71

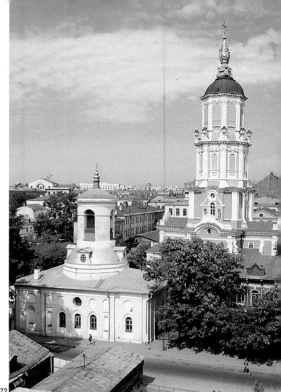

72

73

74

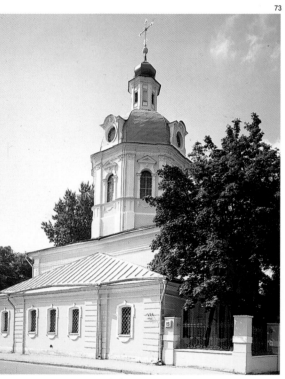

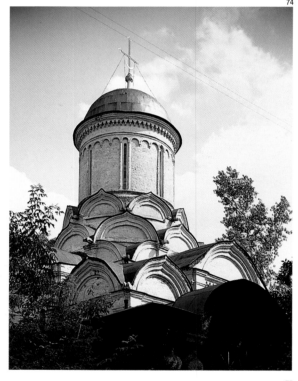

75

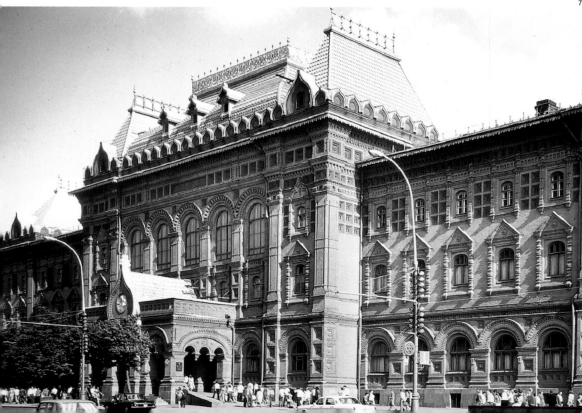

71. The Naryshkin Palace *(1690)* and the bell-tow
of the Upper Monastery of St Peter *(1694)*

72. The Church of St Theodore the Stratilate
(now the representation of the Patriarchate
of Antioch)
1806, architect Ivan Yegotov

The Church of the Archangel Gabriel
(the "Menshikov Tower")
1704–07, architect Ivan Zarudny

73. The Church of St Nicholas in Zvonari
*1762–81, architect Karl Blank; refectory
and bell-tower: 19th century*

74. The Cathedral of the Nativity of the Virgin in t
Convent of the Nativity
1501–05

75. The City Duma building
1890–92, architect Dmitry Chichagov

76. Hotel National
1903, architect Alexander Ivanov

77. Tverskaya Street (formerly Gorky Street)

78. Manezhnaya (Manège) Square

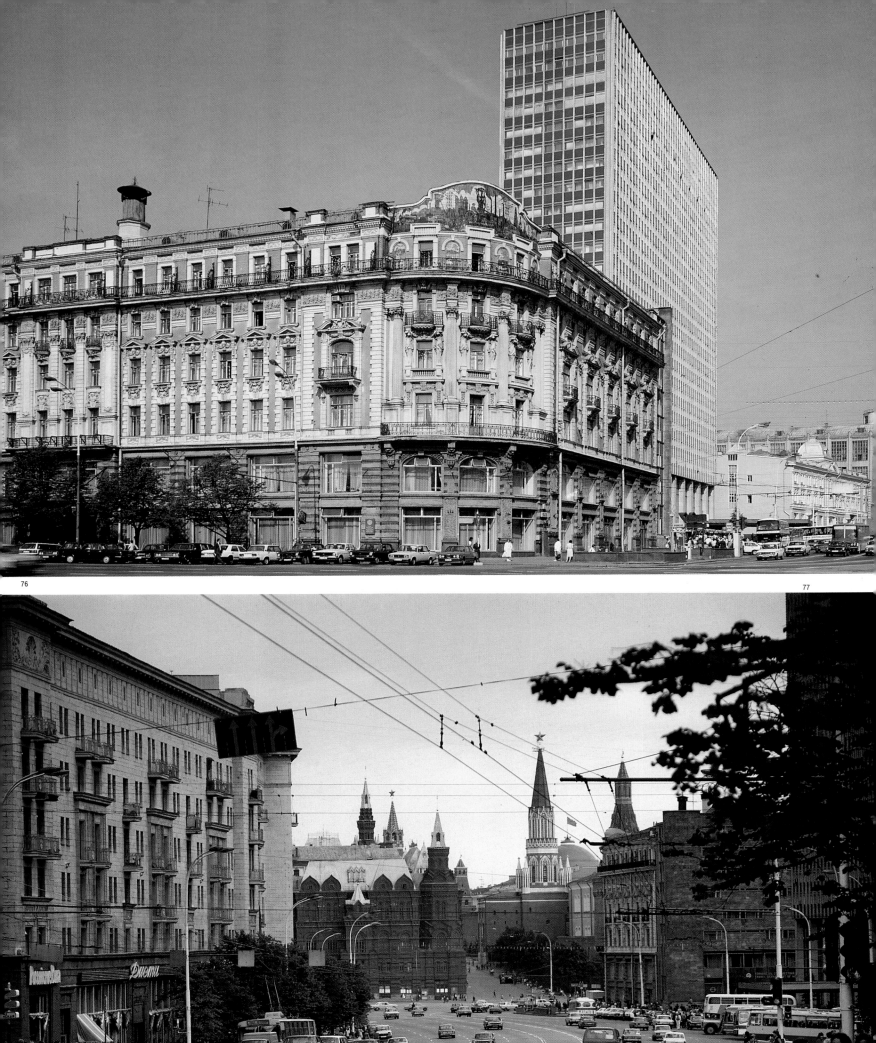

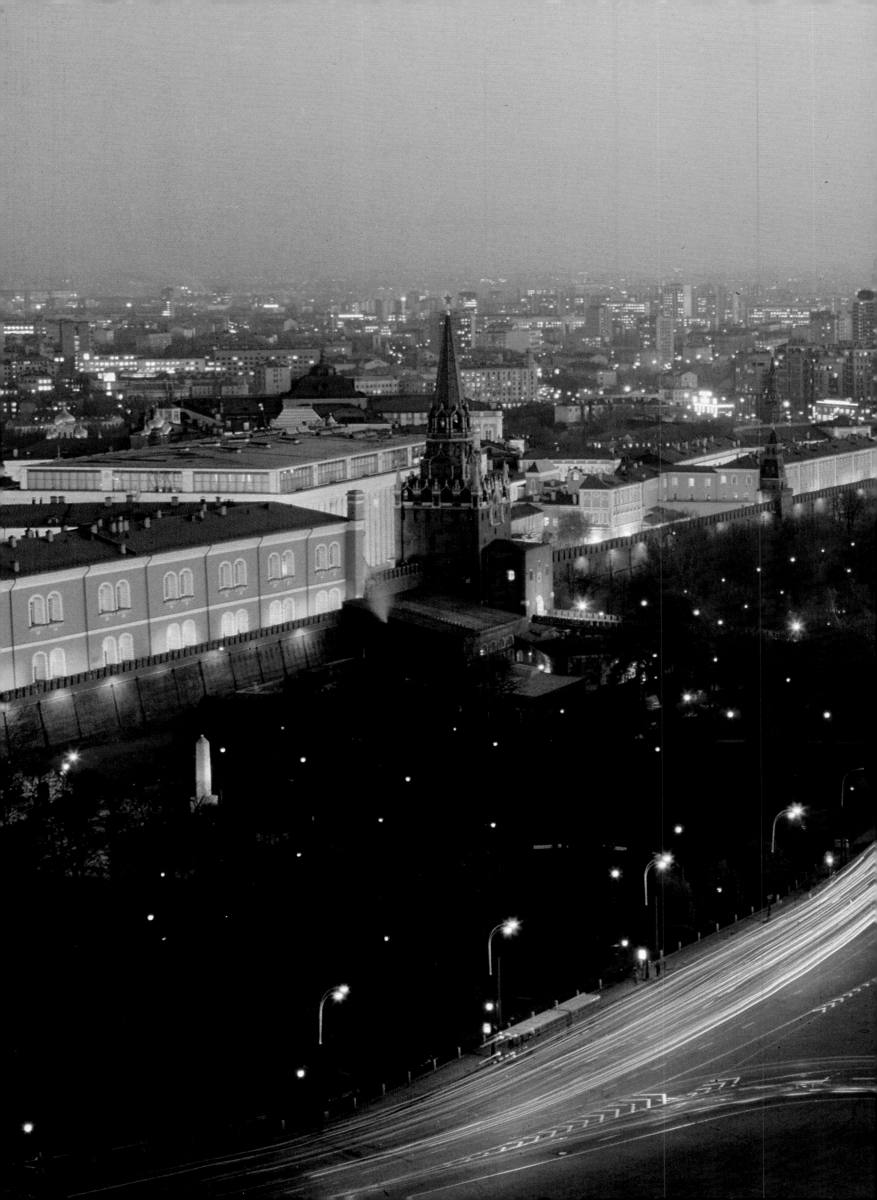

79

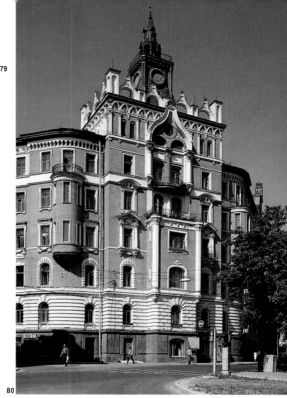

80

81

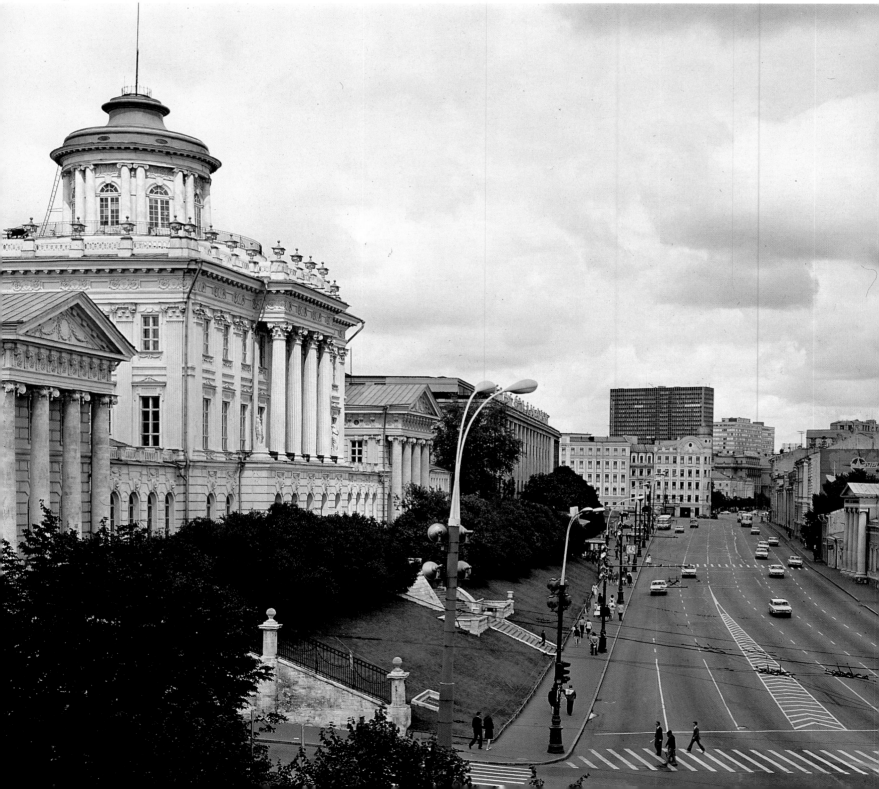

82

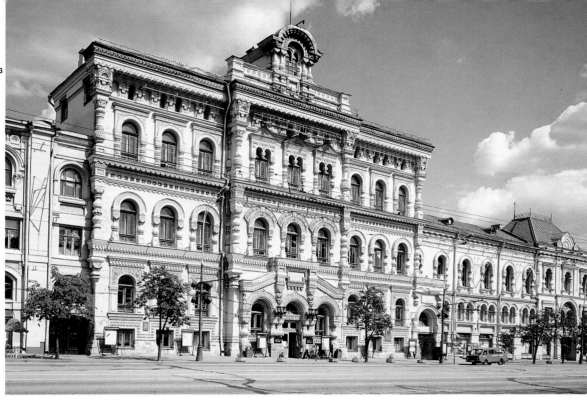

83

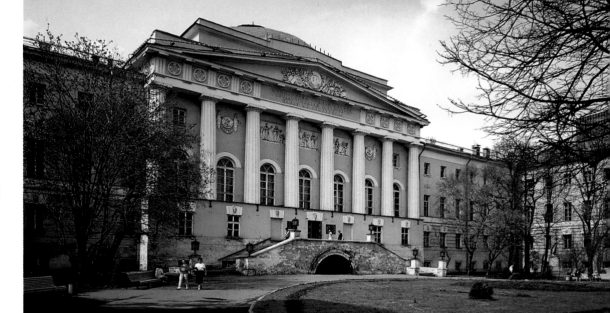

84

79. Club of the Moscow Nobility (House of Unions)
1775, 1784–87, architect Matvei Kazakov

80. Apartment house built for the Rossiya
insurance company
1899–1902, architect Nikolai Proskurnin

81. The Pashkov House
1784–86, architect Vasily Bazhenov

82. The Muir and Merrilees department store
(now TsUM)
1906–08, architect Roman Klein

83. The Polytechnical Museum
*1874–77, architect Ippolit Monighetti;
1896, architect Nikolai Shokhin;
1907, architects Vladimir Voyeikov,
Vasily Yeramishantsev*

84. The "old building" of Moscow University
*1786–93, architect Matvei Kazakov;
1817–19, architects Domenico Giliardi,
Afanasy Grigoryev*

85. The mansion of Arseny Morozov
(now the House of Friendship with
the Peoples of Foreign Countries)
1895–99, architect Victor Mazyrin

86. The Bolshoi Theatre
*1821–24, architects Osip Bove, Andrei Mikhailov;
1855–56, architect Albert Cavos*

87. A scene from a performance at the Bolshoi

88. The auditorium of the Bolshoi Theatre

85

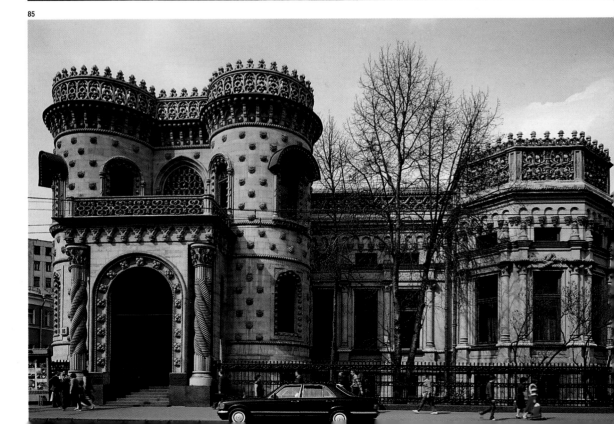

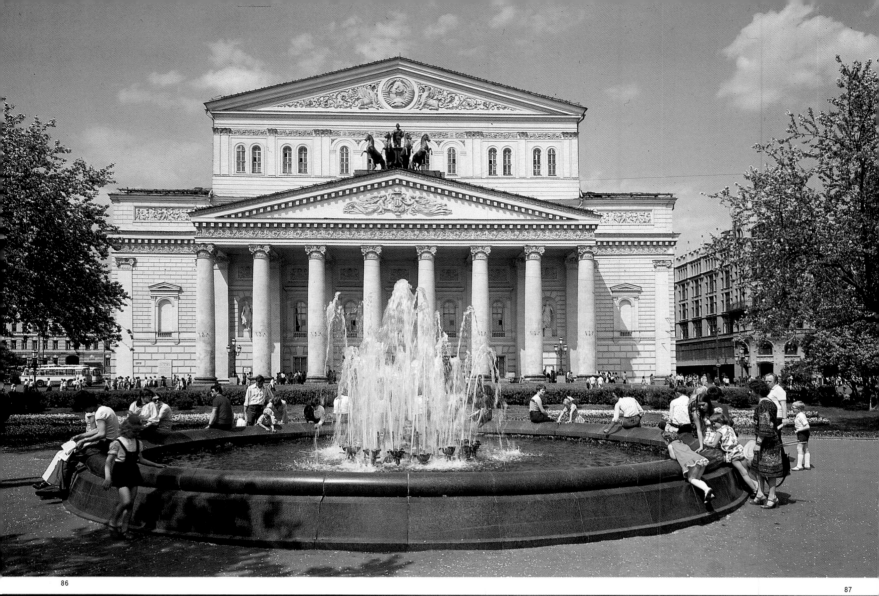

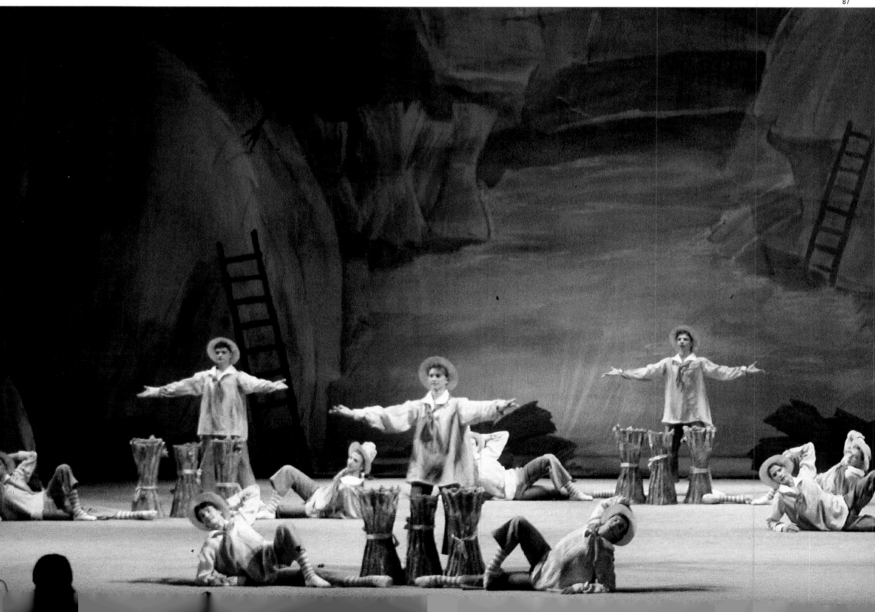

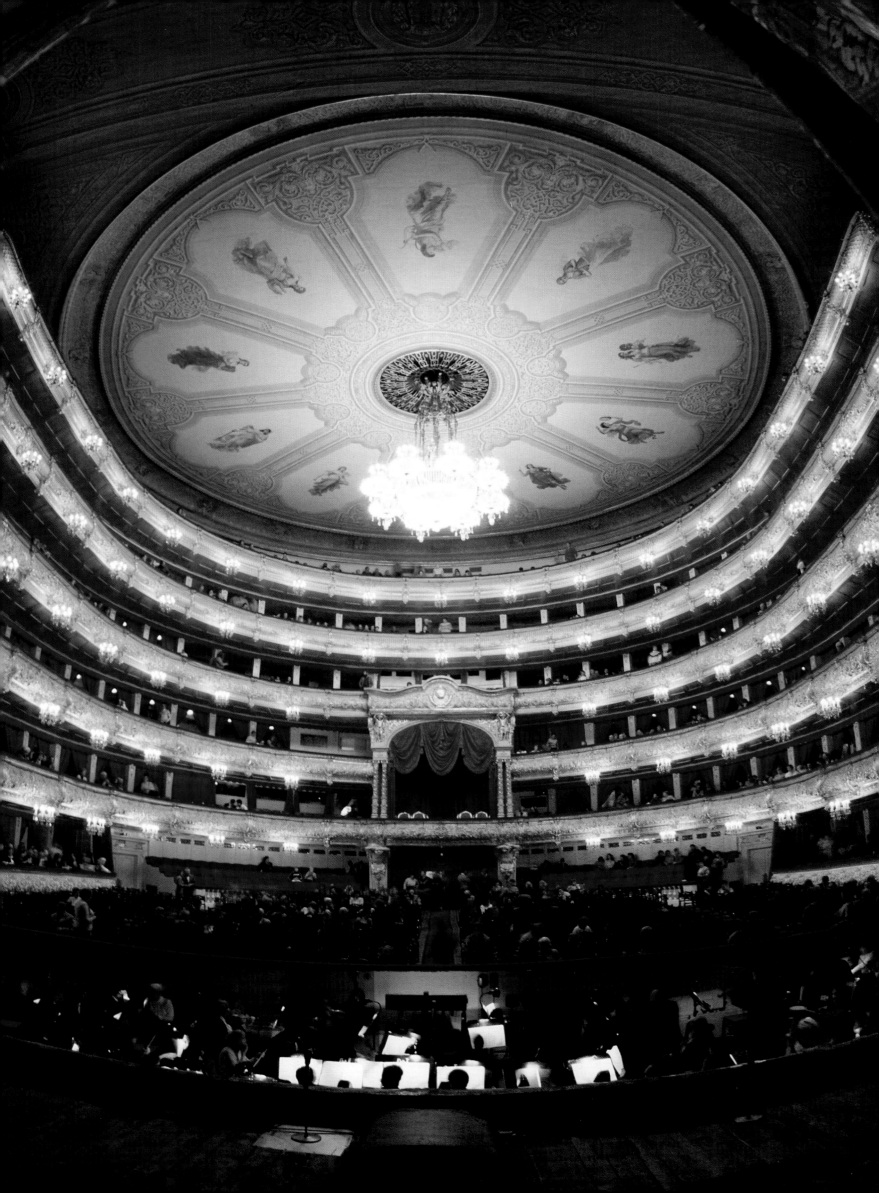

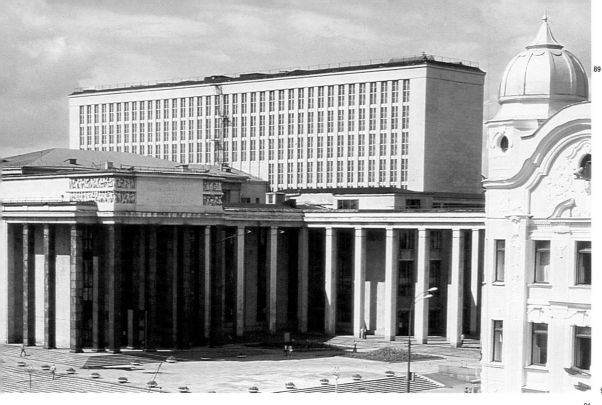

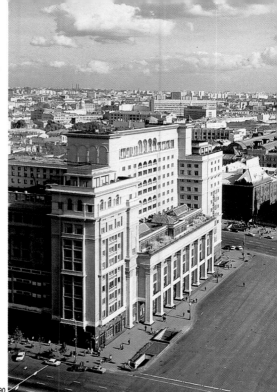

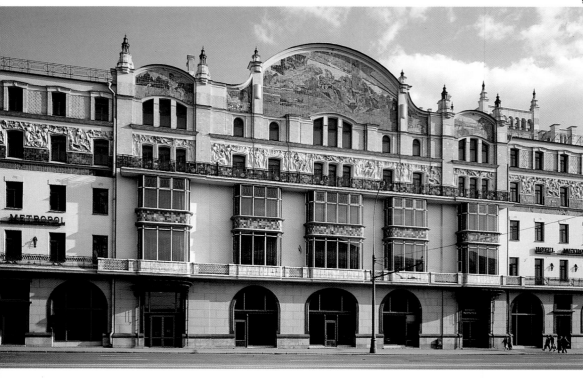

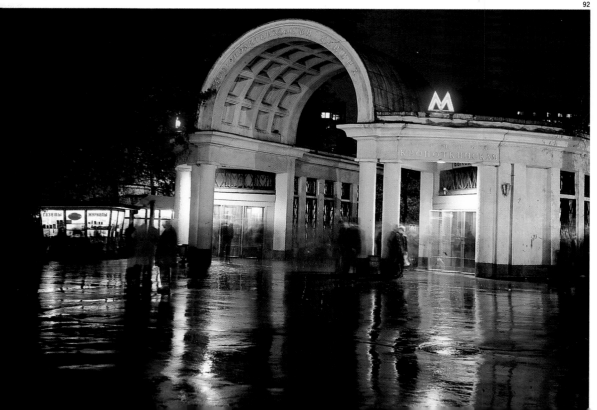

89. The State Library of Russia
*1928–58, architects Vladimir Helfreich,
Valdimir Shchuko and others*

90. Hotel Moskva
*1933–35, architects Alexei Shchusev,
Leonid Savelyev, Osvald Stapran;
1968–77, architects Alexander Boretsky,
Dmitry Solopov, Igor Rozhin*

91. Hotel Metropole
1899–1903, architect William Wallcott

92. Kropotkinskaya Metro station.
The ground-level lobby
1935, architect Samuel Kravets

93. Rozhdestvensky (Nativity) Boulevard

94. Petrovsky (Peter) Boulevard

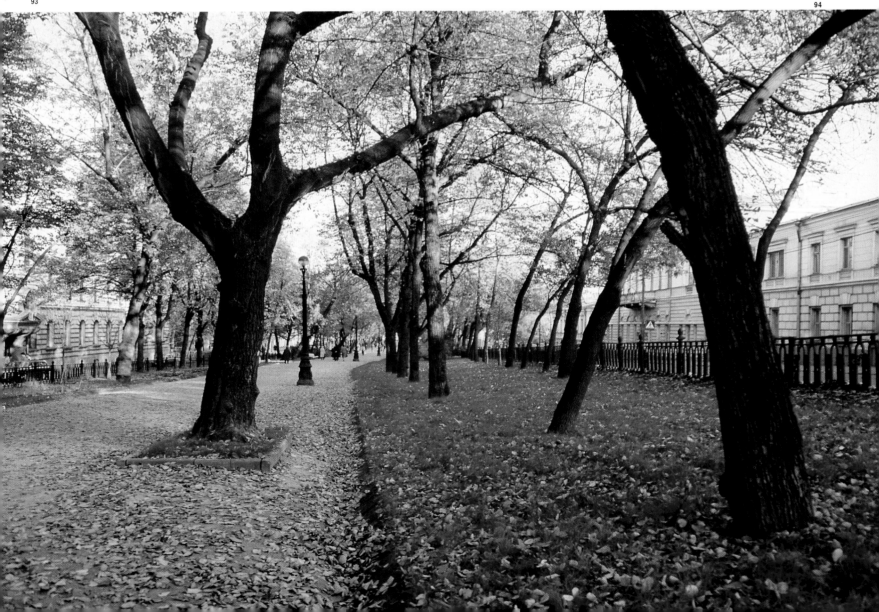

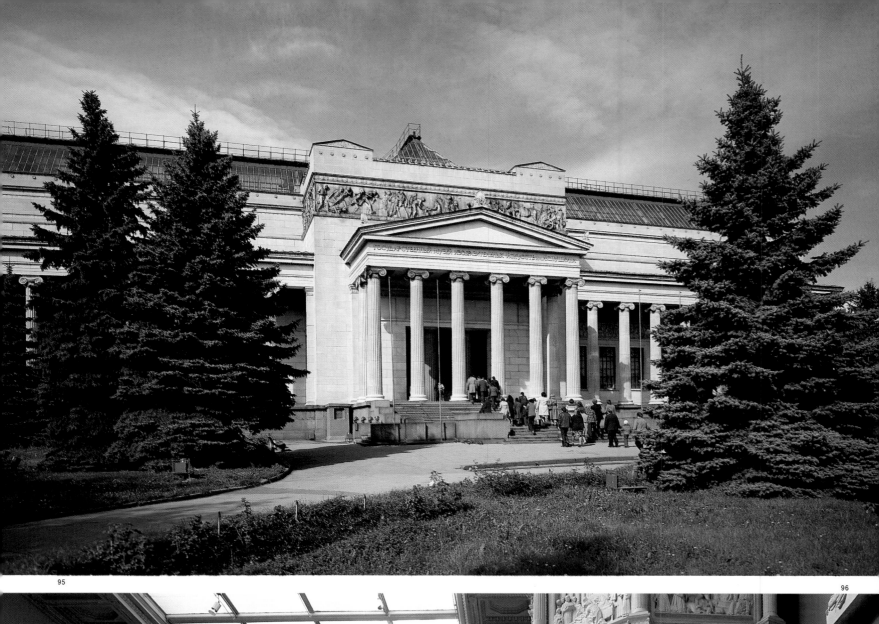

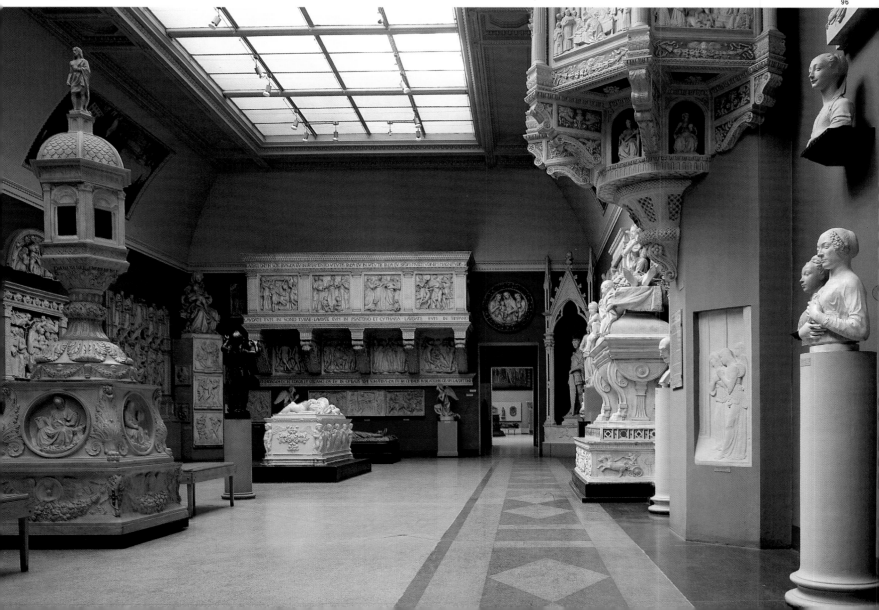

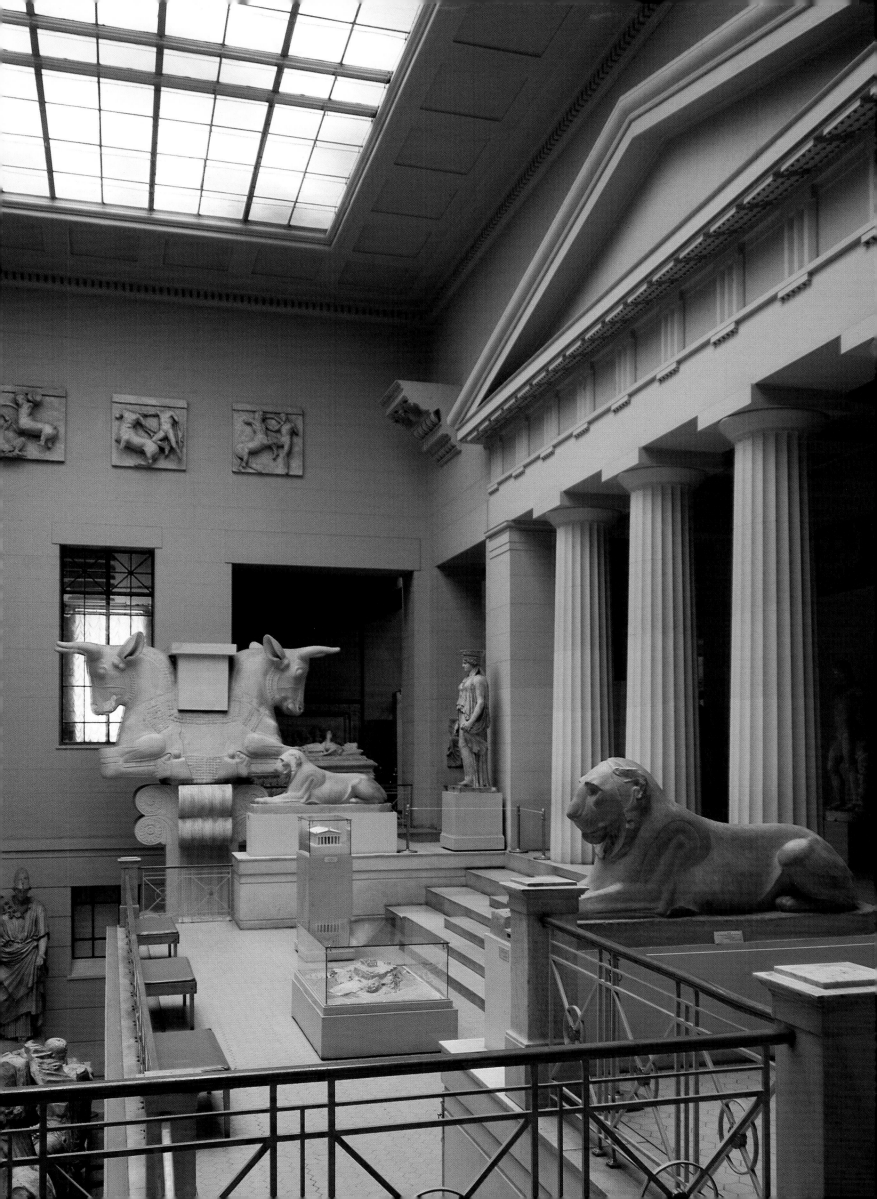

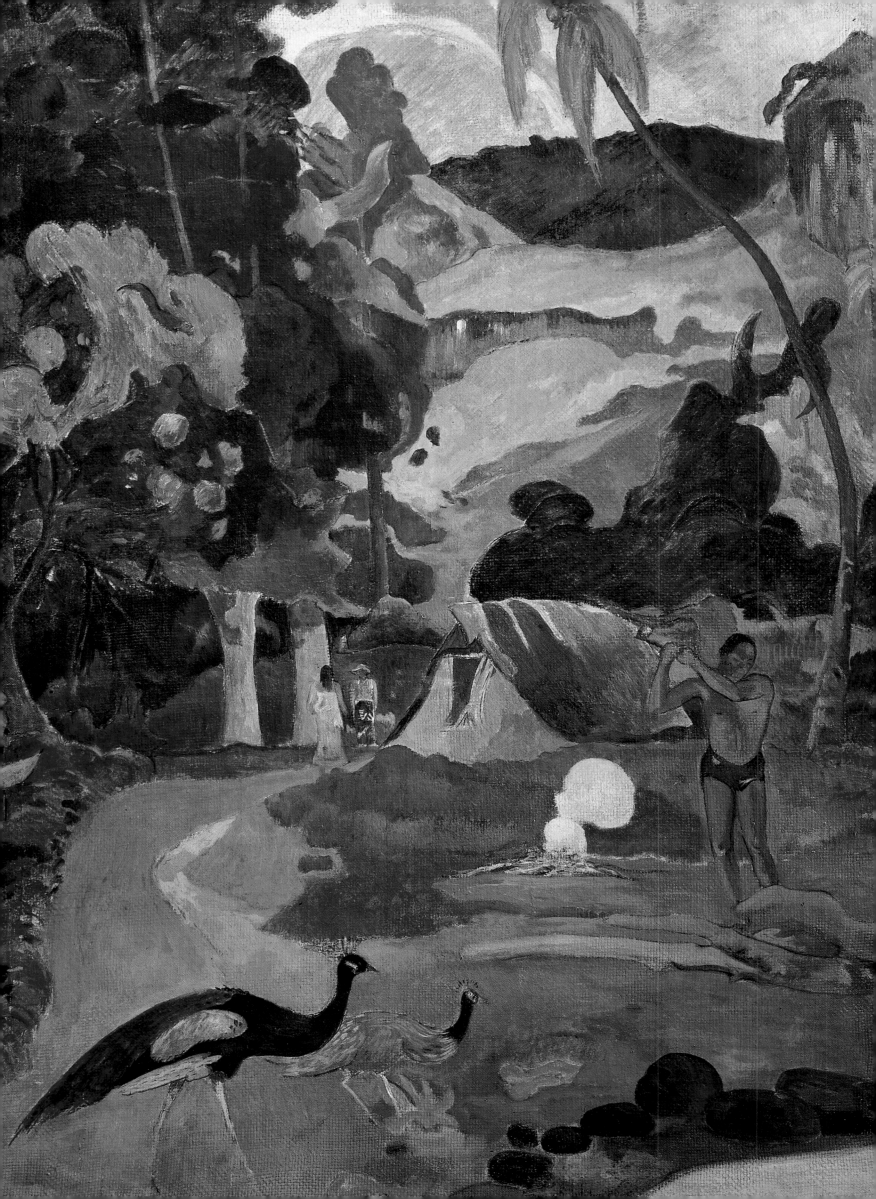

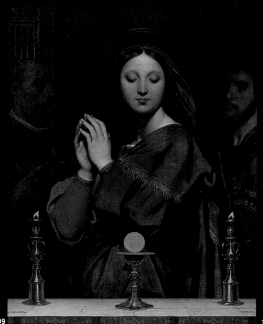

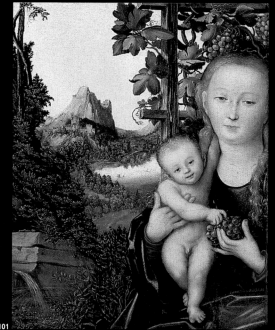

99

100

102

101

95. The Pushkin Museum of Fine Arts
*1898–1912, architect Roman Klein,
sculptor Hugo Zaleman*

96. The Hall of the Italian Renaissance

97. The Hall of Ancient Greek Art

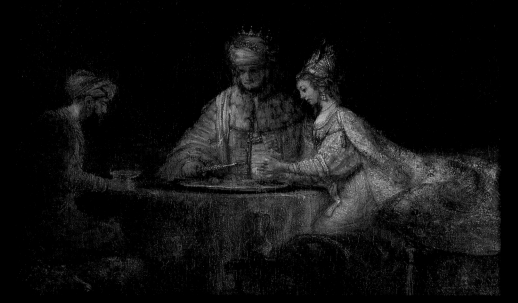

103

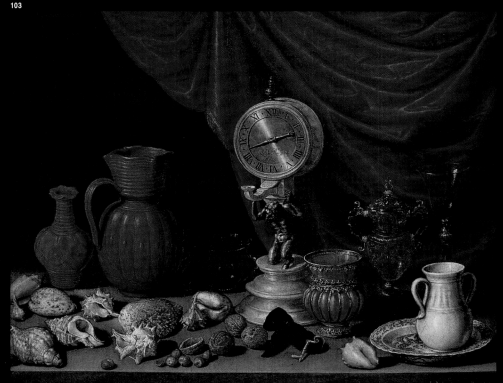

98. Paul Gauguin. 1848–1903
*France
Landscape with Peacocks.* 1892

99. Jean Auguste Dominic Ingres. 1780–1867
France
The Virgin Adoring the Eucharist. 1841

100. Giovanni Battista Tiepolo. 1696–1770
*Italy
Two Saints*

101. Lucas Cranach the Elder. 1472–1553
*Germany
The Virgin and Child*

102. Rembrandt Harmensz van Rijn. 1606–1669
*Holland
Ahasuerus, Haman and Esther.* 1660

103. Antonio Pereda y Salgado. C. 1608–1678
*Spain
Still Life with a Clock*

THE EARTHWORKS CITY

The area of Moscow historically known as the Earthworks City (Zemlianoi Gorod) lies between the present-day Boulevard and Garden Rings. It got its name from the 15-kilometre line of defences around it. The first defences, put up in 1591–92, took the form of a wooden wall with towers and caused an impression for the speed with which they were built. That wall was entirely destroyed by a fire in 1611 and, in the course of the reconstruction of Moscow after the devastating Time of Troubles, in the 1630s an earthwork rampart was erected in its place. Until the middle of the 18th century this was the fiscal boundary of Moscow.

As Moscow grew, the character of the population and building in the Earthworks City changed considerably. In the period around 1600, the area was occupied by *slobody:* separate suburban settlements of *streltsy* (fusiliers), craftsmen and merchants. The boyars and senior clergy rarely lived in the Earthworks City. After the *streltsy* revolted in the late 17th century, Peter the Great removed them and their families from Moscow and the capital's defence was entrusted to units of the newly-created western-style army, stationed for the most part in the Earthworks City. In the 18th century the *slobody* vanished. The area across the River Moskva from the Kremlin was settled mainly by merchants, while in the same period the nobility began to actively buy up land outside the centre and move into the Earthworks City. A particularly large number of noble houses were built between Prechistenka and the Arbat on the site of old stables. In the early 19th century the remnants of the rampart and walls were completely razed and, embracing the city in its place, a road appeared which was flanked by wooden houses with gardens and vegetable patches. The horseshoe shape of this road and its abundant greenery, lost during the reconstruction of the 1930s, suggested a name which has survived to this day — the Garden Ring.

At the square by Kropotkinskaya metro station, which was once the site of a gate-tower in the White City wall, two radial streets, Prechistenka and Ostozhenka, begin, as well as Soimonovsky Lane leading down to the River Moskva. At the start of the lane there is an apartment house built in 1906–10 for a man named Pertsov in imitation of old Russian wooden architecture. The complex configuration and steeply-pitched roof, ceramic representations of the sun, mermaids, exotic animals and plants, an abundance of fruits and flowers and the ornamental design of the banisters, all contribute to the impression that the building has materialized from some fairy-tale.

Prechistenka and neighbouring Ostozhenka, parts of the nobility's Moscow in the late 18th and early 19th centuries, are rich in works of Classical architecture. One true masterpiece is the mansion of the Khrushchev-Seleznev family. Reconstructed in 1817 after the great fire, its complex, free harmony places it in a class of its own among the buildings of the period. Rejecting the customary formal symmetry, the architect managed to combine in a single whole two completely different aspects of the main building: the grand façade with a six-column portico turned to the street and the intimate, private "face" looking onto Khrushchevsky Lane, with a raised terrace and a portico of eight paired columns. The sculptor Ivan Vitali was involved in decorating the façades with exquisite moulded bas-reliefs. Today the buiding houses a branch of the Pushkin Museum of Fine Arts.

On the corner of Spiridonovka and Malaya Nikitskaya Street is one of the finest and best known works of Art Nouveau architecture in Moscow — the former mansion of the millionaire Stepan Riabushinsky (1902). Maxim Gorky lived here for the last five years of his life and it is now a museum to the writer. The building combines precise construction and a convenient, rational layout with picturesque asymmetry.

At the start of Malaya Dmitrovka stands the picturesquely festive edifice of the Church of the Nativity of the Virgin in Putinki. This mid-17th-century building was the last masonry tent-roofed church to be created in Moscow and is a fine example of this architectural type.

The 17th-century noble residence in Bolshoi Kharitonyevsky Lane changed owners several times. It passed from the prominent statesman and diplomat Piotr Shafirov to another close associate of Peter the Great, Grigory Yusupov who participated in the major campaigns of the time and became head of what was effectively the Ministry of War. The opulent limestone decoration of the façades is in the Naryshkin Baroque style.

Barashevsky Lane, which branches off Pokrovka near the boulevard ring, perpetuates the name of a settlement of *barashi* — servants who transported tents for the Tsar during military campaigns. Standing where the lane bends is the single-domed Church of the Presentation (1701), another example of the Naryshkin Baroque style. The church is notable for its bright, festive colour and rich limestone decoration with carefully carved details. Its heavy mass, narrowing towards the top, is balanced by a slender, tiered bell-tower.

104. View of the Krymskaya (Crimea) Embankment

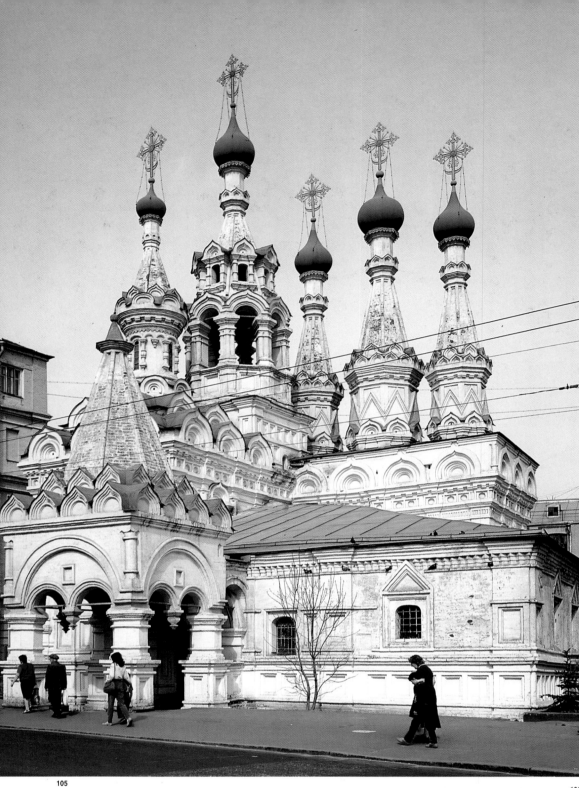

105

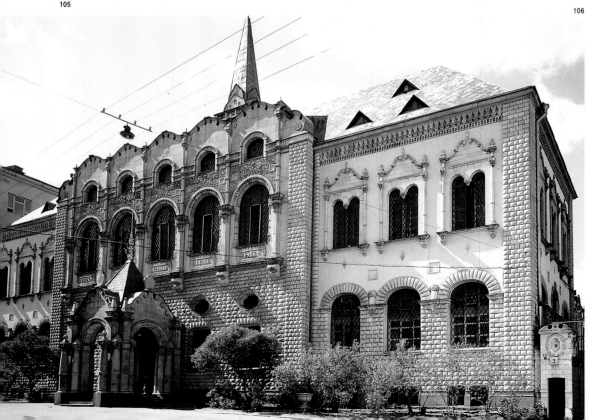

106

107

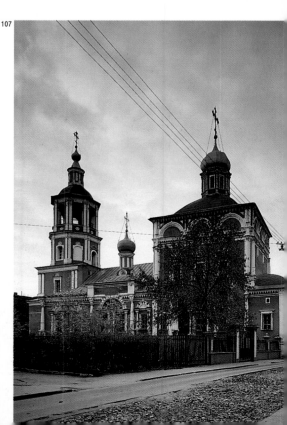

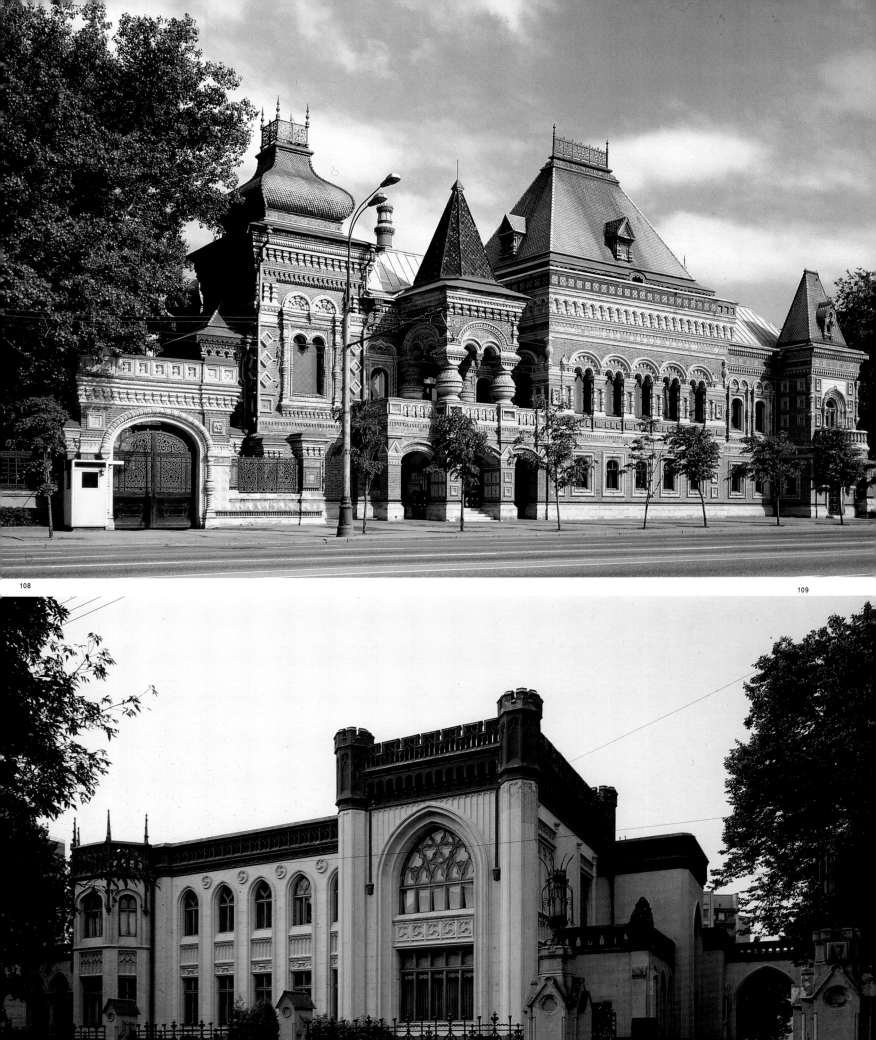

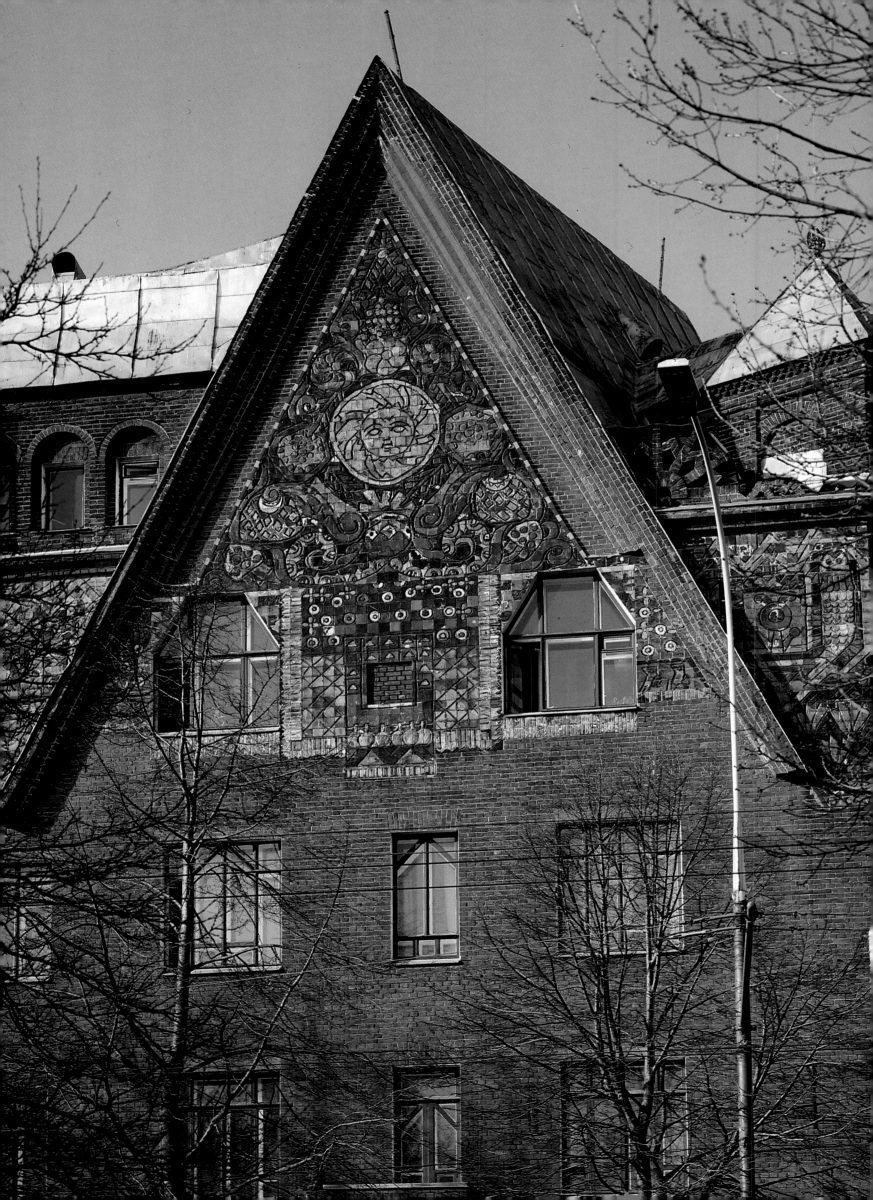

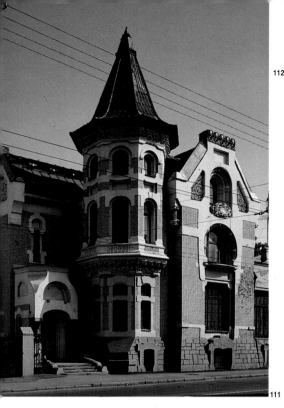

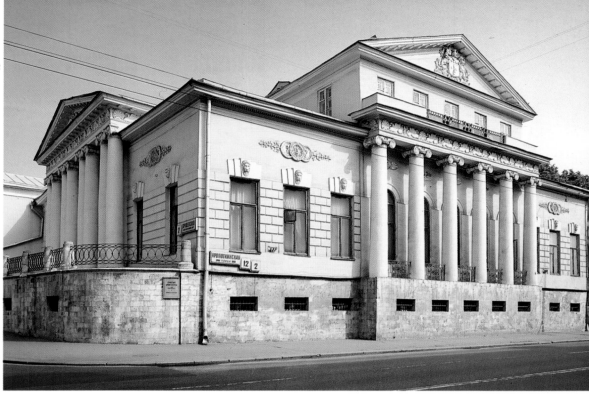

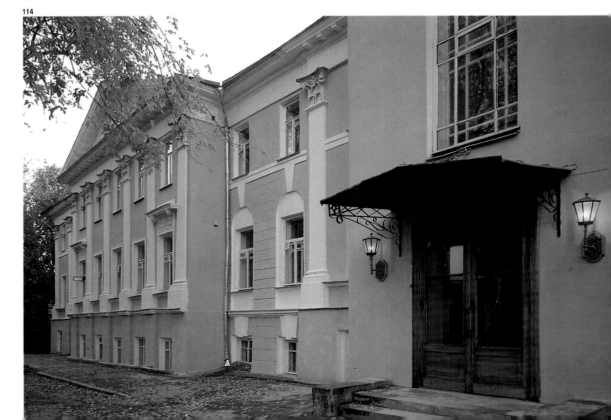

110. The Pertsov Apartment House
1906–10, architect Nikolai Zhukov;
artist Sergei Maliutin

111. Kekusheva's mansion
1900–01, architect Lev Kekushev

112. The town-residence
of the Khrushchev-Seleznev family
1814–16, architect Afanasy Grigoryev;
sculptor Ivan Vitali

113. The Yusupov residence
17th century

114. A town-residence on Tverskoi Boulevard
(the Yakovlev House)
Late 18th – early 19th centuries

115. Riabushinsky's mansion
1900–02, architect Fiodor Schechtel

116. The monument to the composer Piotr
Tchaikovsky by the Conservatoire
1954, sculptors Vera Mukhina, Nina Zelenskaya,
Zinaida Ivanova; architects Alexander Zavarzin,
Dmitry Savitsky

117. The pedestrianized Arbat

118. Riabushinsky's mansion. The grand staircase

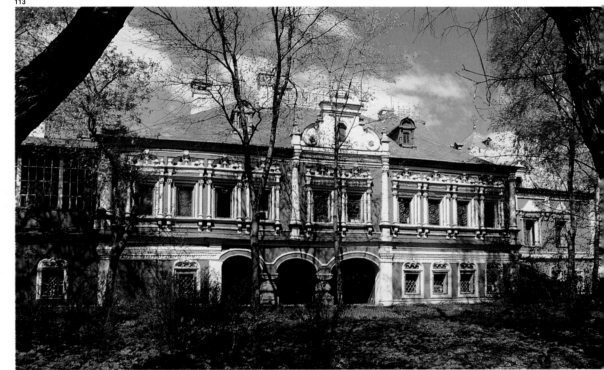

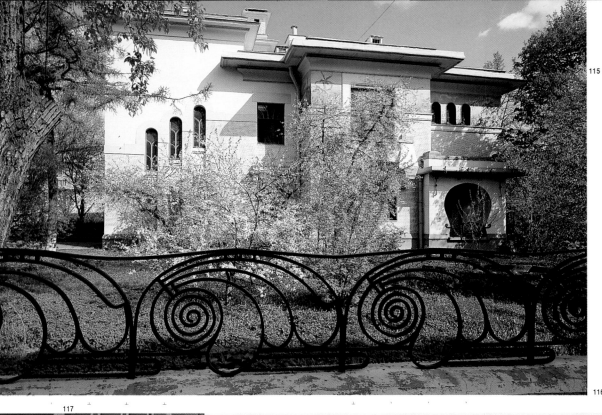

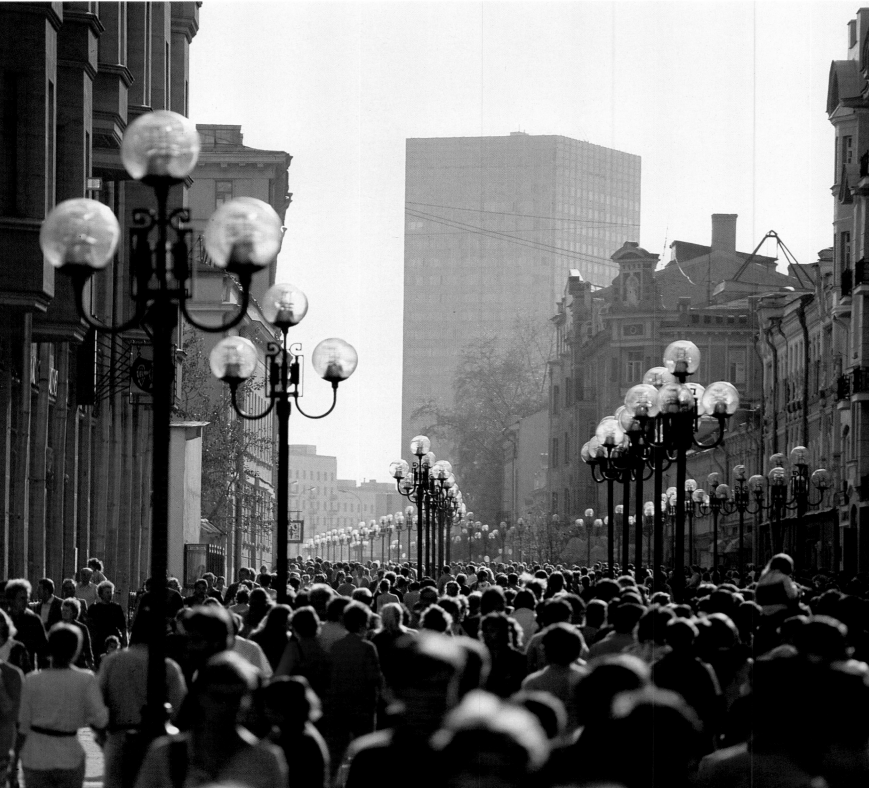

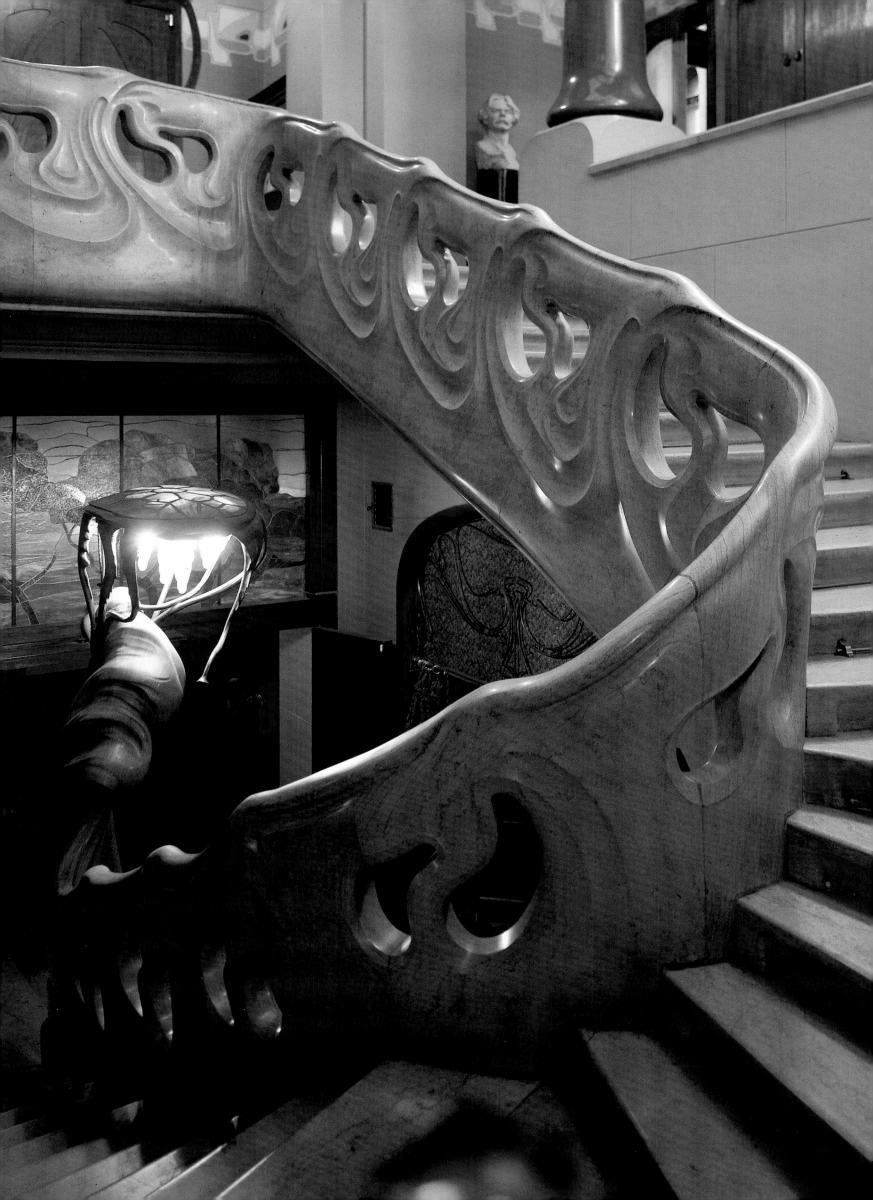

ACROSS THE RIVER MOSKVA

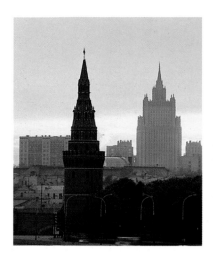

The extensive area between the River Moskva and the southern arc of the Garden Ring is known as Zamoskvorechye, literally "beyond the River Moskva". The first mention of a similar name came in 1365 when Moscow was already the capital of a grand principality. Both the proximity of the river, which periodically flooded and turned this low-lying bank into a bog, and the danger of attack by the Tatar nomads (the road to their territory ran through the district) left their marks on the history and layout of Zamoskvorechye. From present-day Serpukhovskaya Square three main thoroughfares ran through this part of the city back towards the centre: Bolshaya Polianka, Bolshaya Ordynka and Pianitskaya Street. The construction of the Drainage Canal in the late 18th century turned the area closest to the river into an island.

From early times settlements of *streltsy* and Cossacks were located on the southern fringe of the city. In Peter the Great's reign, such *slobody* rapidly disappeared. The merchants became predominant in Zamoskvorechye and imposed their distinctive way of life on the area. To this day, the appearance of the streets here is chiefly determined by numerous churches, old retail buildings and squat dwelling houses. Extending picturesquely along the Bersenevskaya Embankment of the Moskva is the one-time residence of the senior official Averky Kirillov. This unique ensemble includes a masonry mansion and the Church of St Nicholas. The three-part layout of the mansion derives from that of the *izba,* the traditional dwelling of the ordinary Russian people. The side façades bear the imprint of the 17th century, while the richly decorated façade overlooking the river dates from the 1700s. Its composition is reminiscent of the first triumphal arches to appear in Moscow. Rich decoration also marks the five-domed church which was once connected to the mansion by a covered passage. This is the only residence in Moscow to have survived almost in its entirety from the 17th century.

The Kadashevskaya Embankment of the Drainage Canal and the adjoining streets were once the home of the coopers who made barrels for the grand princes. In the 17th century weavers settled here. We can still see some of their houses and the Church of the Resurrection — a first-class example of the Naryshkin Baroque.

The Church of St Nicholas "in Pyzhi" is situated on Bolshaya Ordynka. It was constructed by an unknown architect in 1672 and paid for by the men of a *streltsy* unit commanded by a man named Pyzhov. The tent-roofed bell-tower is one of the finest structures of its kind in Moscow.

A remarkable architectural ensemble is the nearby Martha and Mary Convent. It was founded by Yelizaveta Fiodorovna, the widow of Grand Duke Sergei Alexandrovich who was assassinated in the Kremlin in 1905. She herself was shot in 1918, like other members of the royal family.

The convent's single-domed Church of the Intercession with its austere decoration, massive walls, narrow windows, resembling arrow-slits, and powerful semicircles of the apses is reminiscent of the ancient edifices of north-western Russia. But this was no more than a skilful imitation of the architecture of Novgorod and Pskov.

The most impressive Baroque creation in Zamoskvorechye is the Church of St Clement. It was constructed in 1774 and there is no other building like it in Moscow. Its exultant style and combination of large volumes create the impression of some royal palace. Only the mighty arrangement of five domes, a prominent landmark in the district, betrays the building's religious purpose.

The Church of St John the Warrior was built in 1713 when Peter the Great had transferred the capital to St Petersburg and forbidden masonry construction in Moscow. The traditional compositional arrangement for Russian churches — church, refectory and bell-tower with a tiered structure — is here combined with architectural innovations typical of Peter's time: semicircular pedestals and decorative pilasters, balustrades, scrolls and pyramids.

Zamoskvorechye is also the location of one of Moscow's main cultural centres, the world-famous Tretyakov Gallery. In front of the building is a monument to its founder, the wealthy merchant who in 1892 donated his unique collection of art to the city. The main façade is worked in white and red in keeping with age-old tradition. The decoration of the outside of the building, by the artist Victor Vasnetsov, was inspired by Old Russian book illumination. The ornate calligraphy of the dedicatory inscription fills a frieze; the Moscow coat-of-arms (St George slaying the dragon) appears in an ogival frame. The gallery possesses over 57,000 works of Russian art. It boasts extremely rich collections of Old Russian icons and later portraits, paintings by the "Itinerants" and works by artists of various late-19th- and 20th-century movements. In the early 1990s, a large museum complex was created around the original gallery, including a depository and ancillary buildings as well as exhibition, lecture and conference halls.

119. The Kotelnicheskaya
Embankment of the River Moskva

70

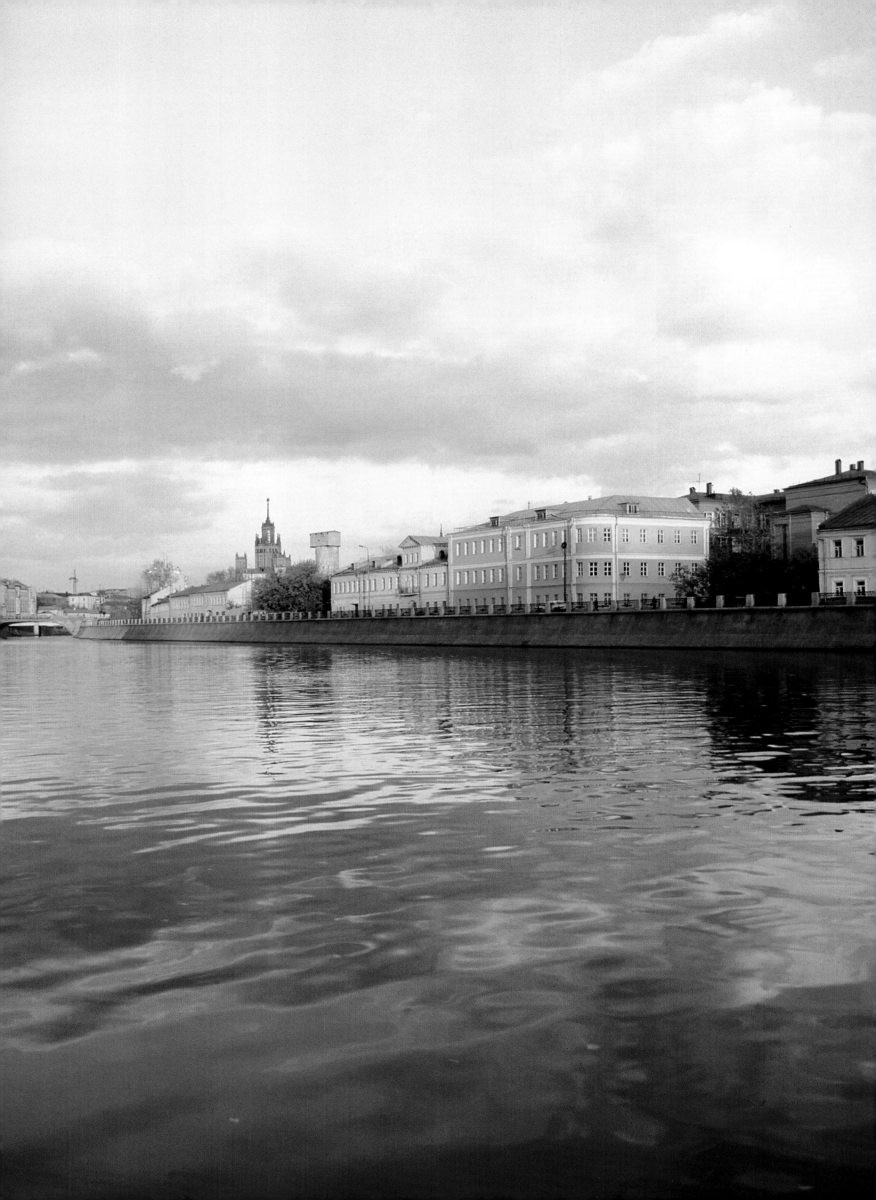

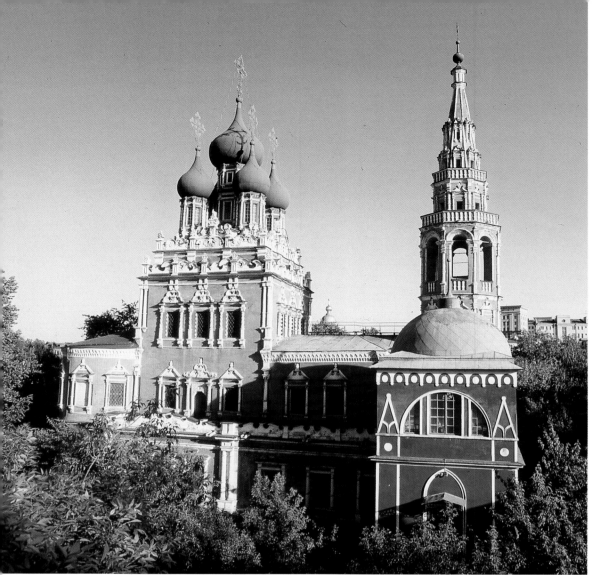

120. The Church of the Resurrection in Kadashi
1657; 1687–1713, architect Sergei Turchaninov

121. Bridge over the Drainage Canal

122. The Church of the Intercession of the Virgin
the Martha and Mary Convent
1908–12, architect Alexei Shchusev

123. The Church of St Clement
1754–74

124. Footbridge over the Drainage Canal

125. The bell-tower of the Church of St Sophia on
the Sofiyskaya (St Sophia's) Embankment
1868, architect Nikolai Kozlovsky

126. The Church of the Virgin of All Sorrows
*Refectory and bell-tower: 1783–91, architect
Vasily Bazhenov;
rotunda church: 1828–33, architect Osip Bove*

127. The Church of St Nicholas in Pyzhi
1672

128. The Church of St John the Warrior
1709–13, architect Ivan Zarudny

129. The residence of Averky Kirillov
1656–57; 18th century

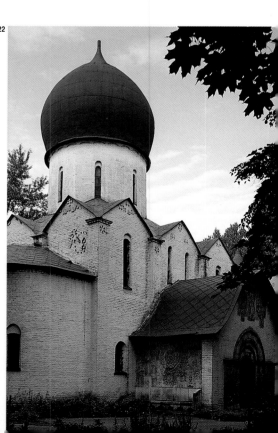

120

121

122

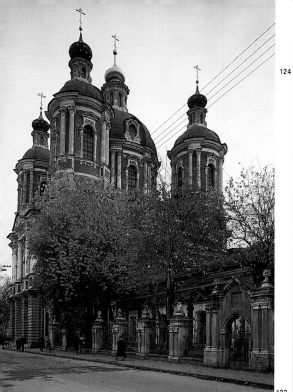

124

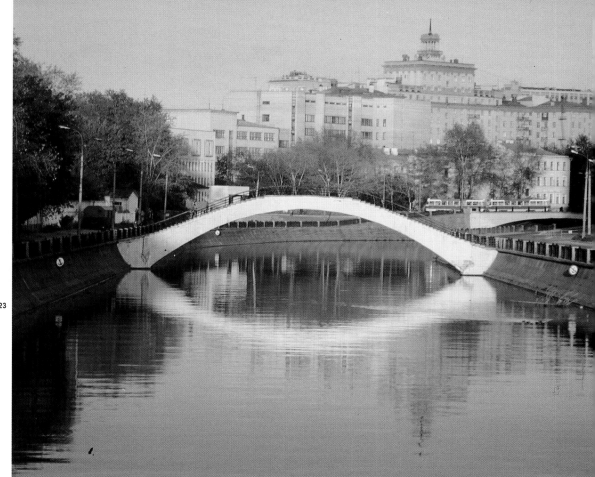

123

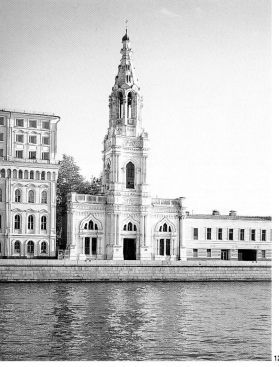

126

125

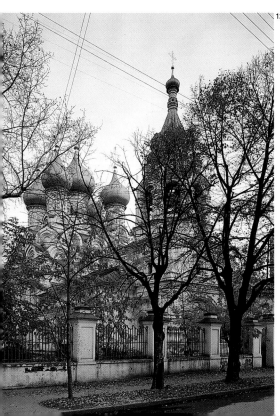

127

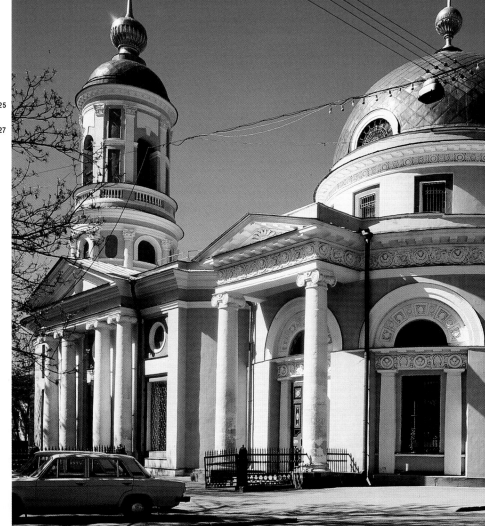

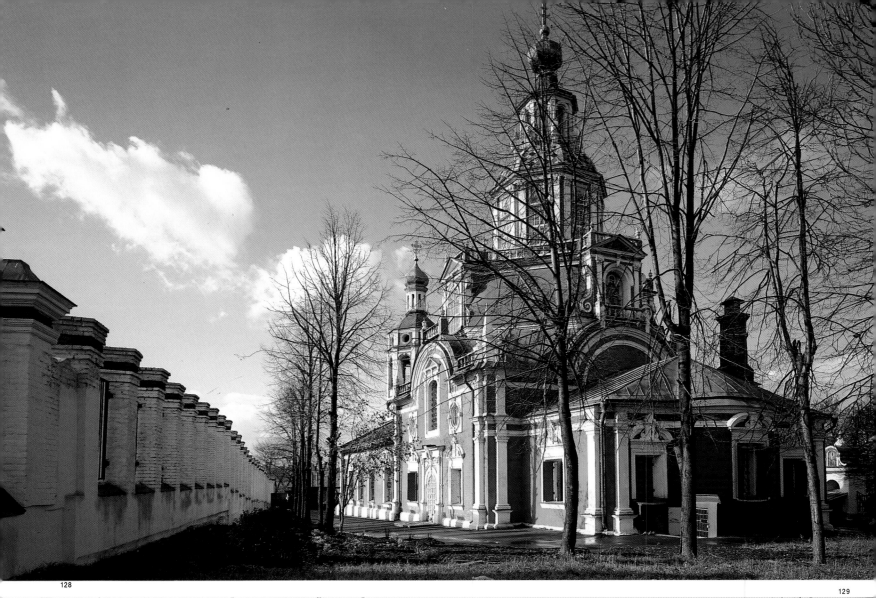

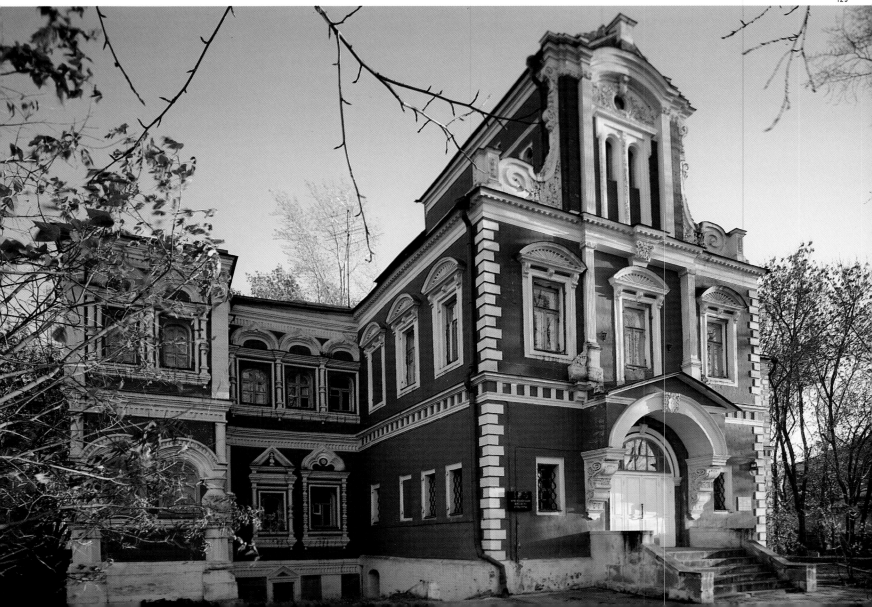

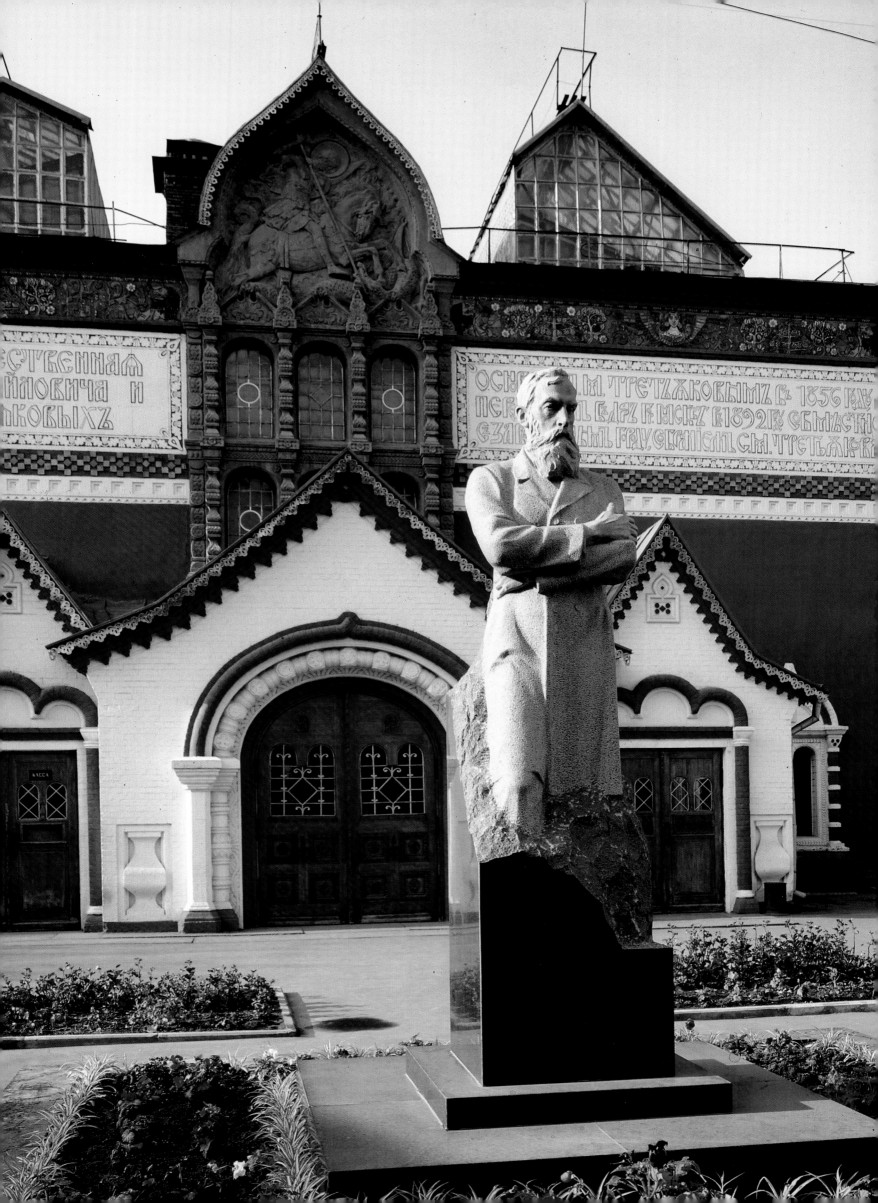

131

133

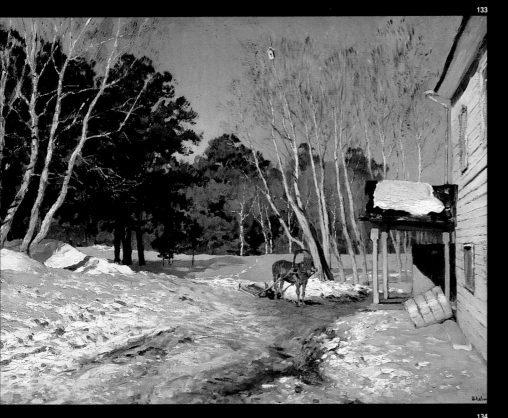

134

130. The Tretyakov Gallery
1902. Main façade designed by the artist Victor Vasnetsov

Monument to Pavel Tretyakov
1980, sculptor Alexander Kibalnikov; architect Igor Rozhin

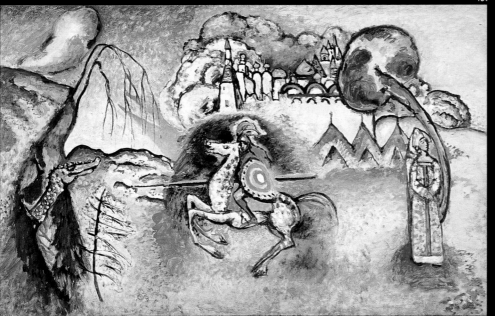

131. Konstantin Korovin. 1861–1939
Paper Lanterns. 1898

132. Mikhail Vrubel. 1856–1910
Demon. 1890

133. Isaac Levitan. 1860–1900
March. 1895

134. Wassily Kandinsky. 1866–1944
Horseman. St George

135. Karl Briullov. 1799–1852
Rider. 1832

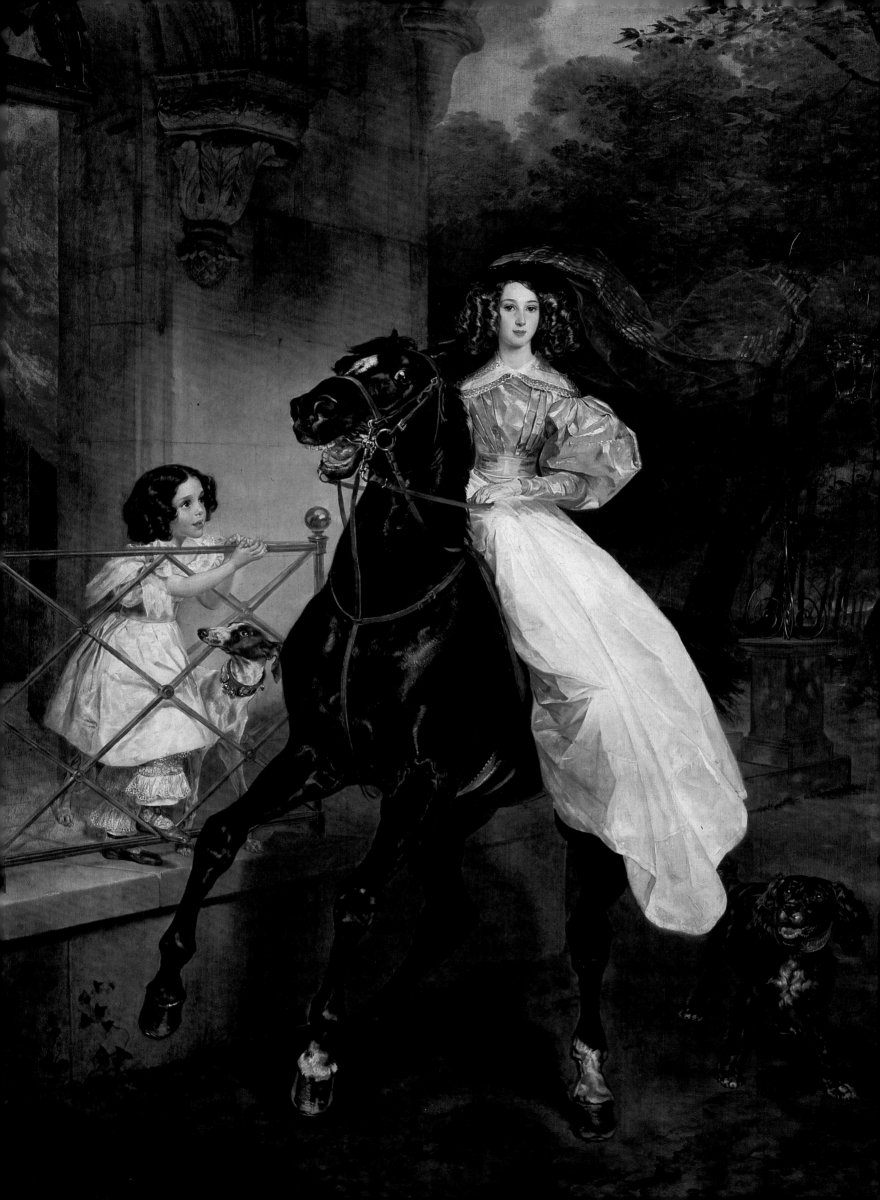

OUTSIDE THE GARDEN RING

The Earthworks City fortifications did not remain the boundary between city and suburbs for long. Moscow was growing rapidly. In 1742 it was enclosed by the Kamer-Kollezhsky Rampart, 37 kilometres long with a ditch and controlled entry points. It became the fiscal and then the judicial border of Moscow. This rampart was in existence for about a century before it was levelled. The size of the city remained almost unchanged until the 20th century when at last, in 1960, it acquired a new precise boundary in the form of the Moscow Circular Highway, a boundary which, however, it quickly over-stepped. Six "arms" extending beyond the highway were incorporated into the capital and the settlements and villages they contained soon became the focus for large, urban housing areas: Kurkino, Mitino, Novokosino, Yuzhnoye Butovo, Solntsevo, Peredelkino and others. Nevertheless, the Moscow hinterland still retains little islands of genuine Russian landscape with its gentle beauty. The surrounding countryside has a long history of enhancing the capital. It gave Moscow ancient monasteries and convents enclosed by fortified walls, luxurious palaces, austere architectural ensembles betokening talent and artistic taste, and other fine masterpieces.

The Novodevichy, or New Maiden, Convent, was founded by Grand Prince Vasily III to commemorate the recovery of Smolensk from the Poles. It also served as a stronghold guarding the south-western approach to Moscow. The surviving 16th- to 18th-century architectural ensemble is one of the most interesting in Moscow. The main cathedral, dedicated to the icon of the Virgin of Smolensk, was completed in 1525. The 16th century also saw the construction of the Church of St Ambrose and the palace of Tsarina Irina Godunova; the 17th — fortified walls with 12 towers and two gate-churches: the five-domed Church of the Transfiguration in Naryshkin Baroque style (1687–88) and the three-domed Church of the Intercession (1683–88). The same period produced the colossal refectory incorporating the Church of the Dormition (1685–87) and later, in 1689–90, the magnificent, six-tiered bell-tower, richly decorated with carved limestone. The Museum of History and Art located in the convent buildings displays unique examples of painting and decorative art. Adjoining the convent to the south is the most famous cemetery in Moscow.

The Andronikov Monastery was founded about 1360 on the south-eastern approaches to Moscow as a defensive post against Tatar raids. Its Saviour Cathedral (1420–27) is the oldest building in Moscow outside the Kremlin and marked a break with Byzantine tradition and the transition to a new, national Russian style of architecture. In a garden close to the monastery is a monument to the great icon-painter Andrei Rublev. He was a monk of the Andronikov Monastery and is probably buried there.

The Don Monastery was founded in 1591. The oldest building in it is the Small Cathedral of 1593. The Large Cathedral, constructed between 1584 and 1616, displays some features of the Naryshkin Baroque. Rising above the monastery's northern gate is the astonishingly finely-proportioned Church of the Virgin of Tikhvin (1713–14). The monastery cemetery is the oldest still existing in Moscow.

The history of Kolomenskoye — a personal manor of the rulers of Moscow in the 15th to 17th centuries — goes back into the depths of time. The earliest building to survive today is the Church of the Ascension. One of the first, and also the best known tent-roofed church, it was put up in 1532 to celebrate the birth of Vasily III's long-awaited heir — the future Ivan the Terrible. In 1995 UNESCO included the church among its list of monuments of world significance. The Kolomenskoye complex also includes the bell-tower-church of St George (16th century), the Water-Tower and the Church of the Virgin of Kazan, masonry chambers and two masonry gate-houses (all 17th century) and, in nearby Dyakovo, the 16th-century Church of John the Baptist. The territory of the estate is now used to display examples of Russian wooden architecture.

A unique architectural and artistic ensemble was created at Ostankino in the late 18th century as a suburban residence and place of amusement for Count Nikolai Sheremetev. The wooden theatre-palace was built in 1791–98 in the mature Classical tradition. Galleries linked it to the Egyptian and Italian Pavilions which contained concert and banquet halls. The palace is the only building from the period to have completely retained typical late-18th-century interiors. Adjoining it is a regular park decorated with sculptures and various lesser buildings. Today the Ostankino Palace houses the Museum of Serf Art.

Izmailovo lay to the east of Moscow. In olden times it was a royal manor with agricultural lands, a menagerie and also a village belonging to the royal household. Peter the Great spent his childhood at Izmailovo and here he learnt to sail in the little boat which became known as "the grandfather of the Russian navy". The island in the Round Pond is noted for the 17th-century architectural ensemble of the Royal Court.

The Kuskovo estate was formed between the 1740s and 1770s as a suburban residence for Count Piotr Sheremetev. Still surviving are: the wooden palace, the church, Italian- and Dutch-style houses, a "hermitage" and an orangery, all set in a regular park with ponds and canals. The collection of ceramics in the museum here is one of the richest in the country.

The Church of the Intercession in Fili is a perfect embodiment of the Naryshkin Baroque style. It was constructed on the bank of the Moskva at the expense of Lev Naryshkin, a relative of Peter the Great.

136. Hotel Cosmos
1979, a joint project by Russian and French architects

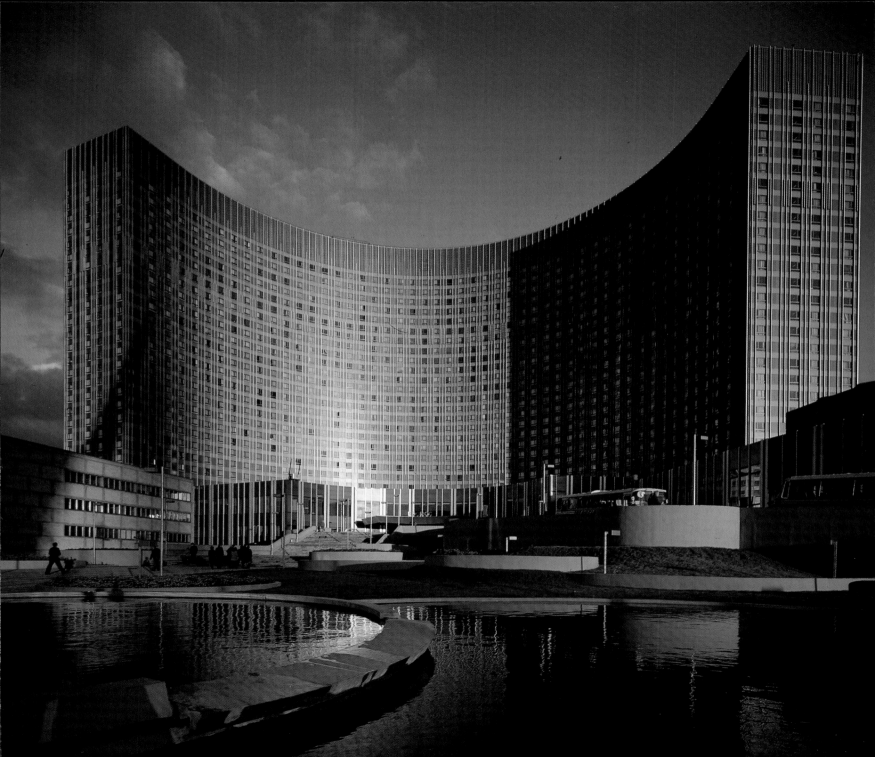

137

138

139

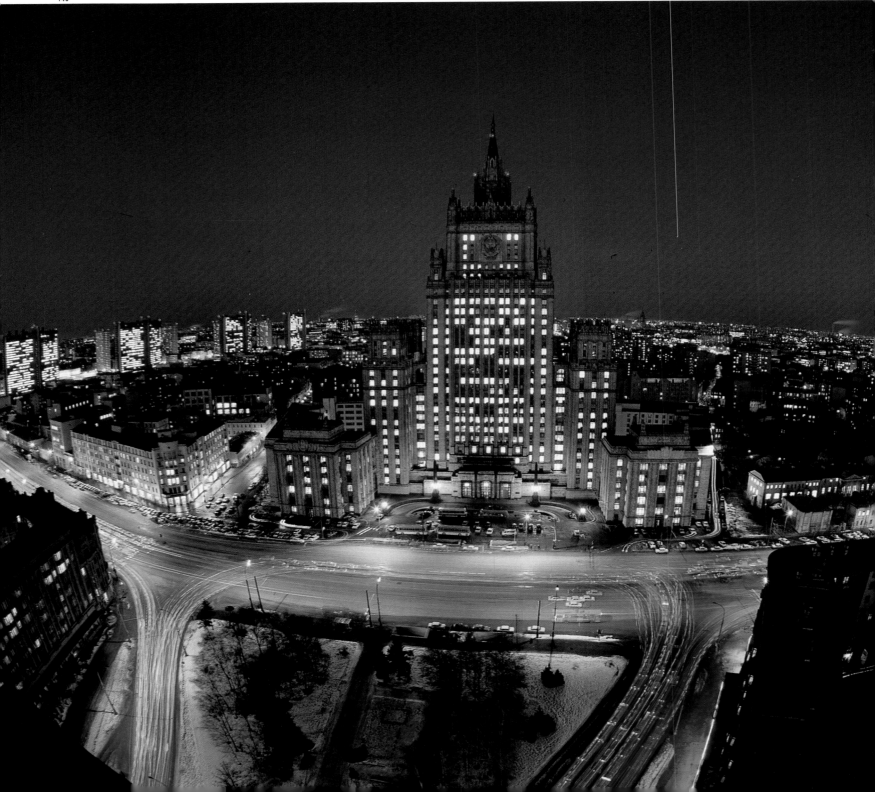

140

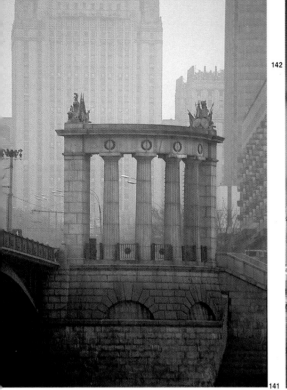

142

141

144

143

146

145

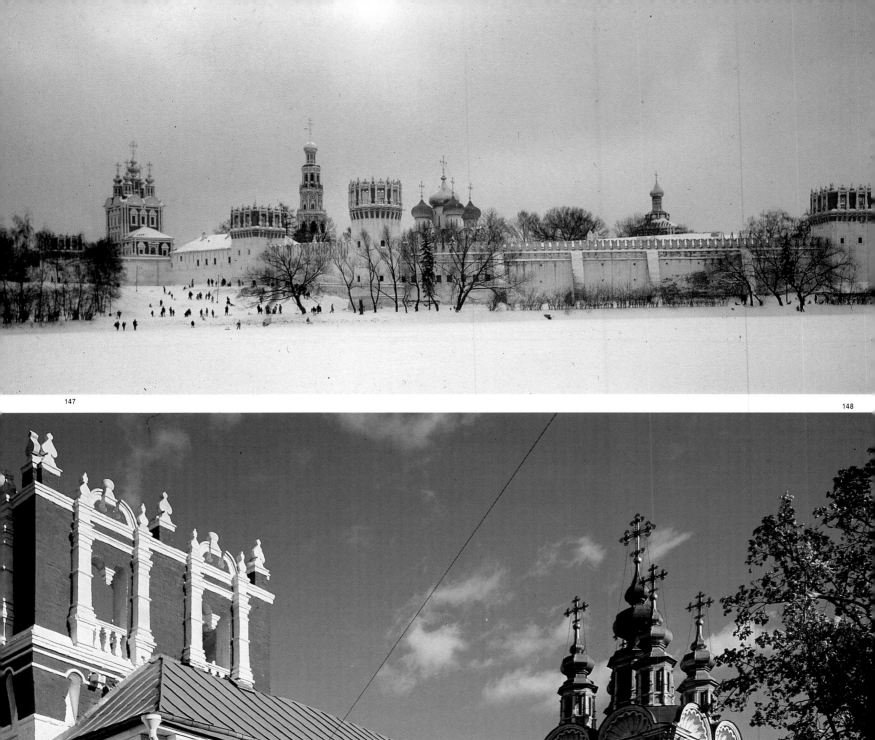

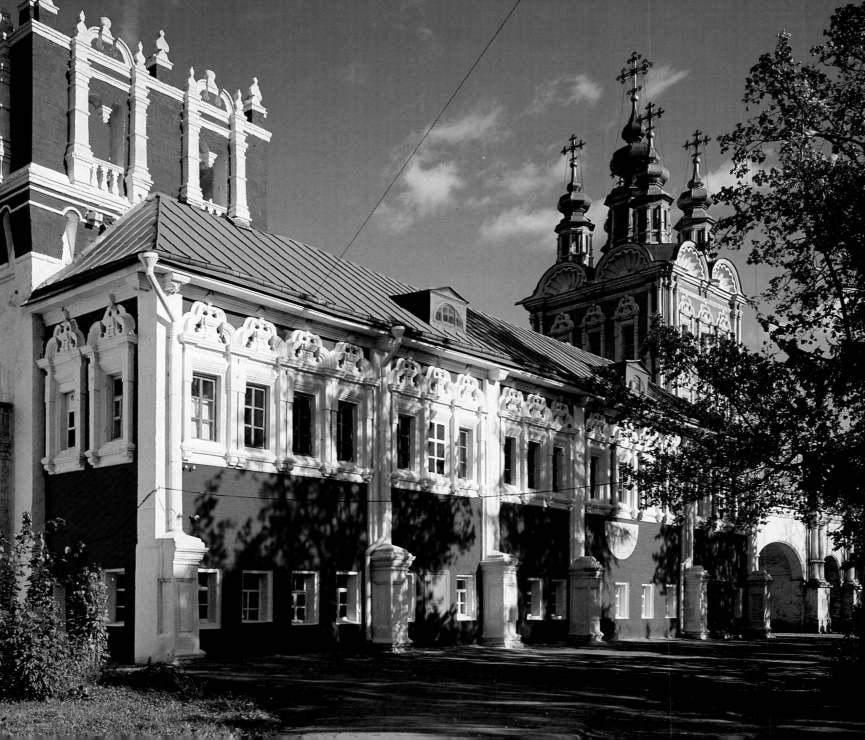

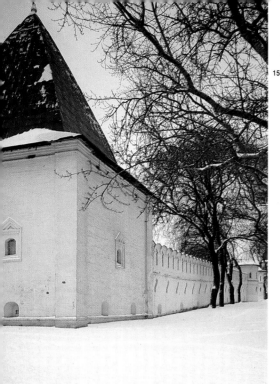

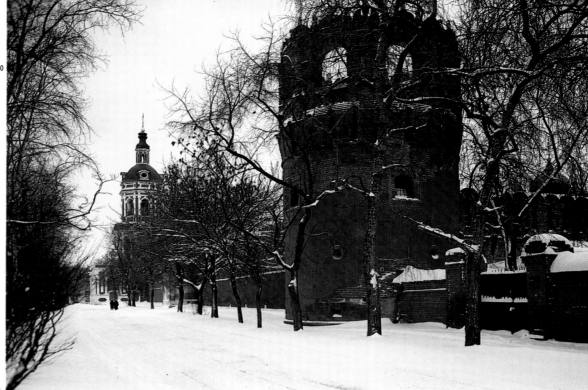

150

149

151

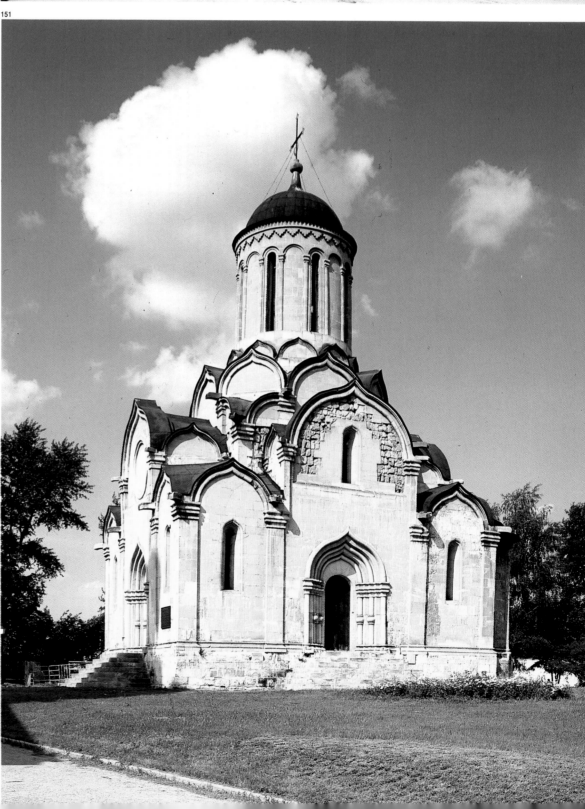

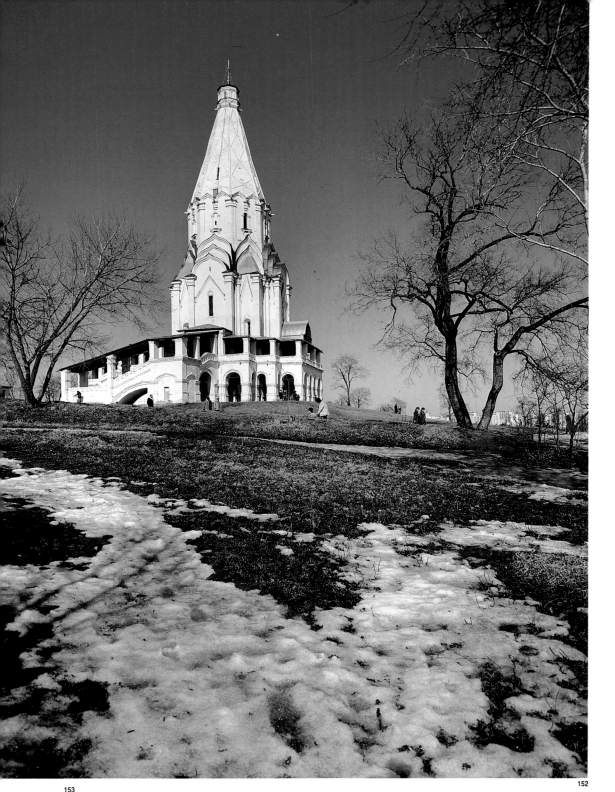

153

152

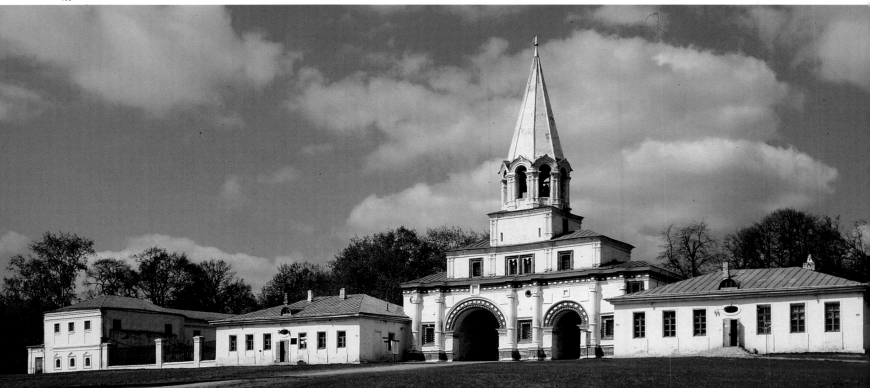

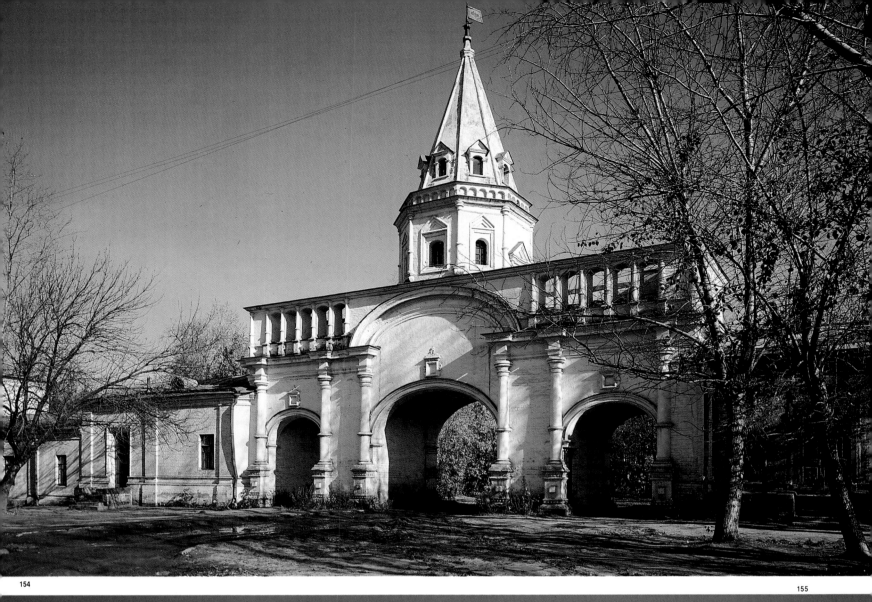

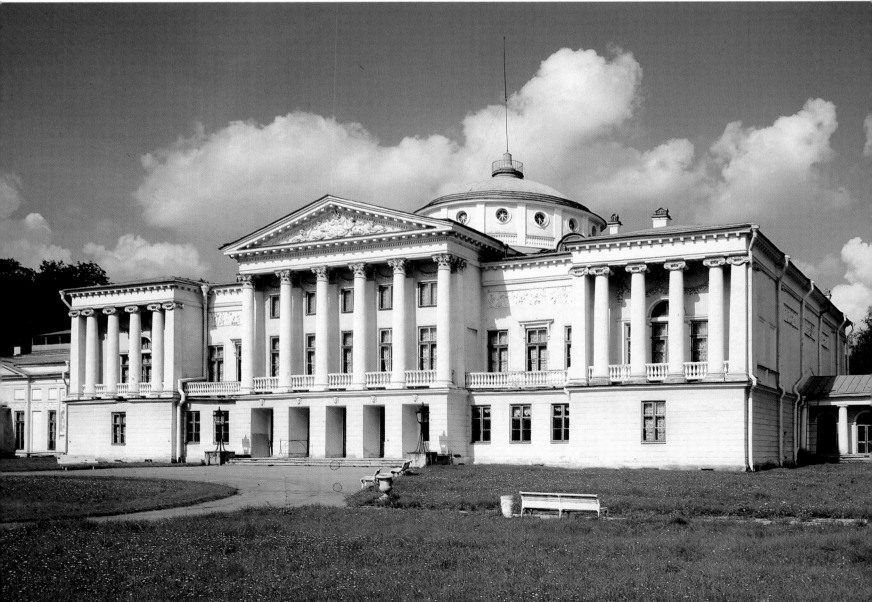

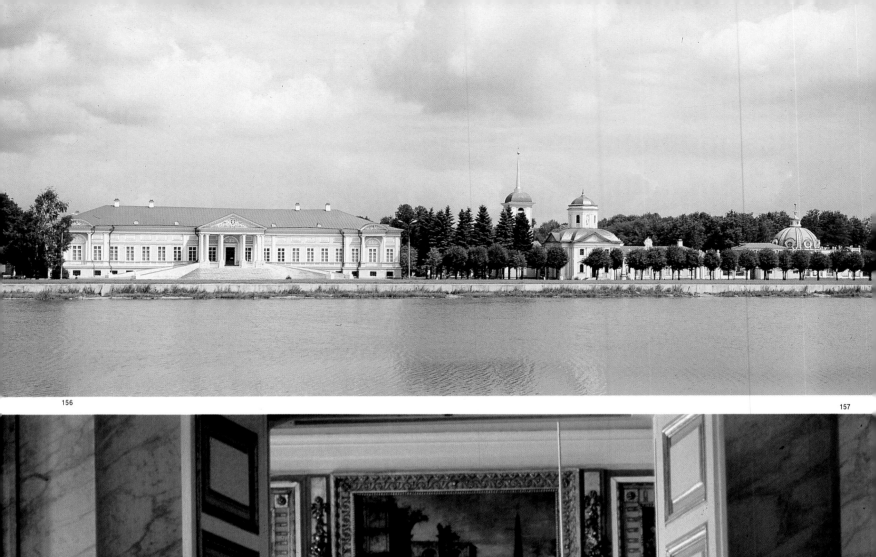

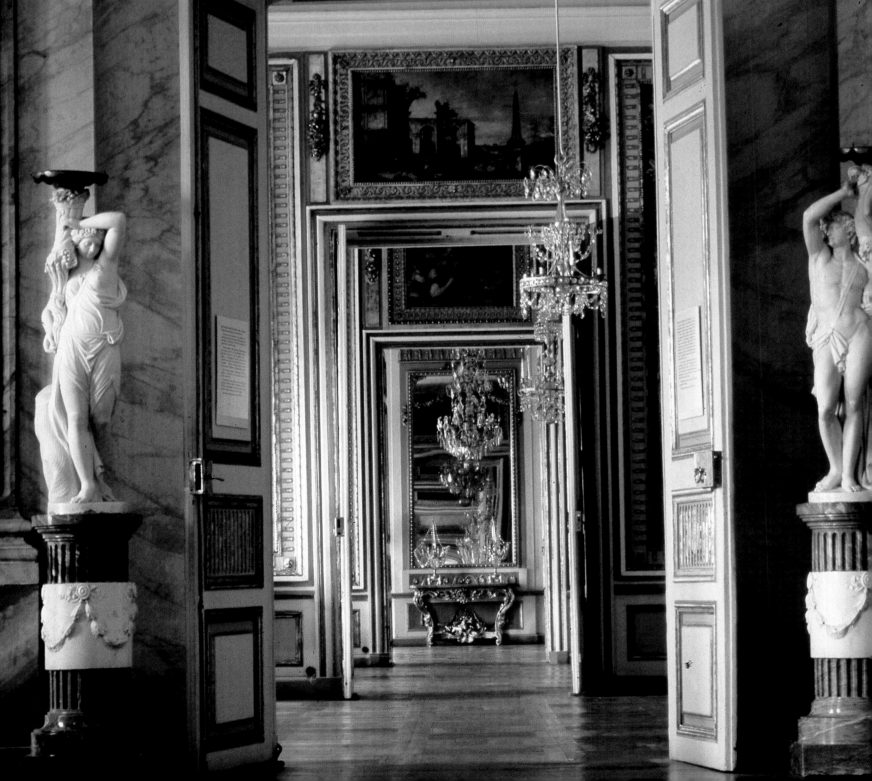

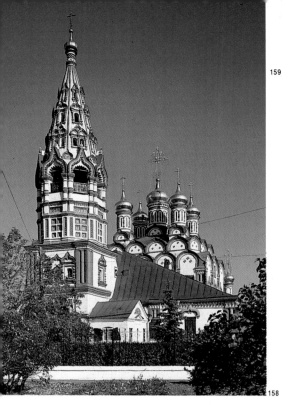

158

159

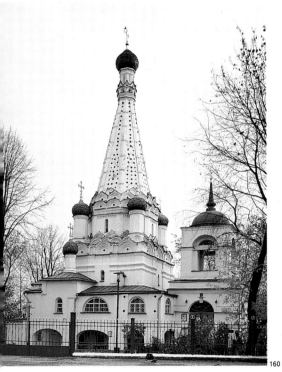

160

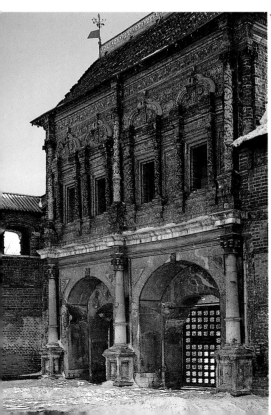

162

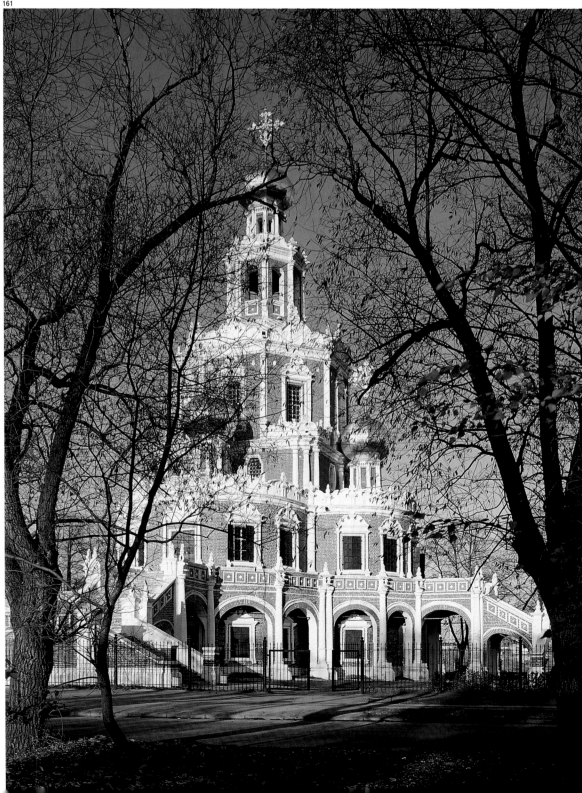

161

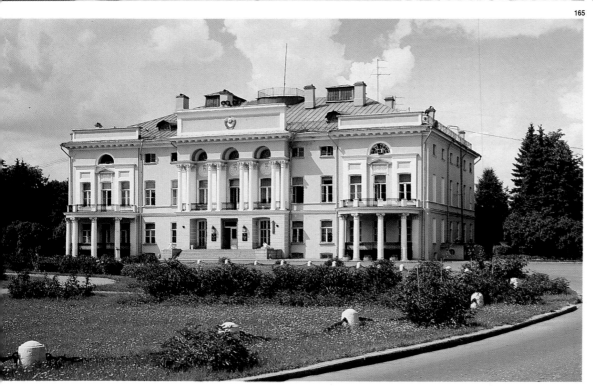

163. The Fiodor Chaliapin Memorial Museum
Mansion of the late 18th century

164. The Musin-Pushkin house on Razguliay
Square
*Late 18th – early 19th centuries,
architect Matvei Kazakov*

165. The "Neskuchnoye" (Pleasure) estate. The
Alexandrinsky Palace
*1756, architect Wilhelm Jest;
1830s, architect Yevgraf Tiurin*

166. The Lefortovo (Menshikov) palace. The main
entrance
1707–08, architect Giovanni Mario Fontana

167. The Petrovsky (Peter) Way Palace
1776–96, architect Matvei Kazakov

168. The Shchukin mansion on Malaya
Gruzinskaya Street
1892–95, architect Boris Freudeberg

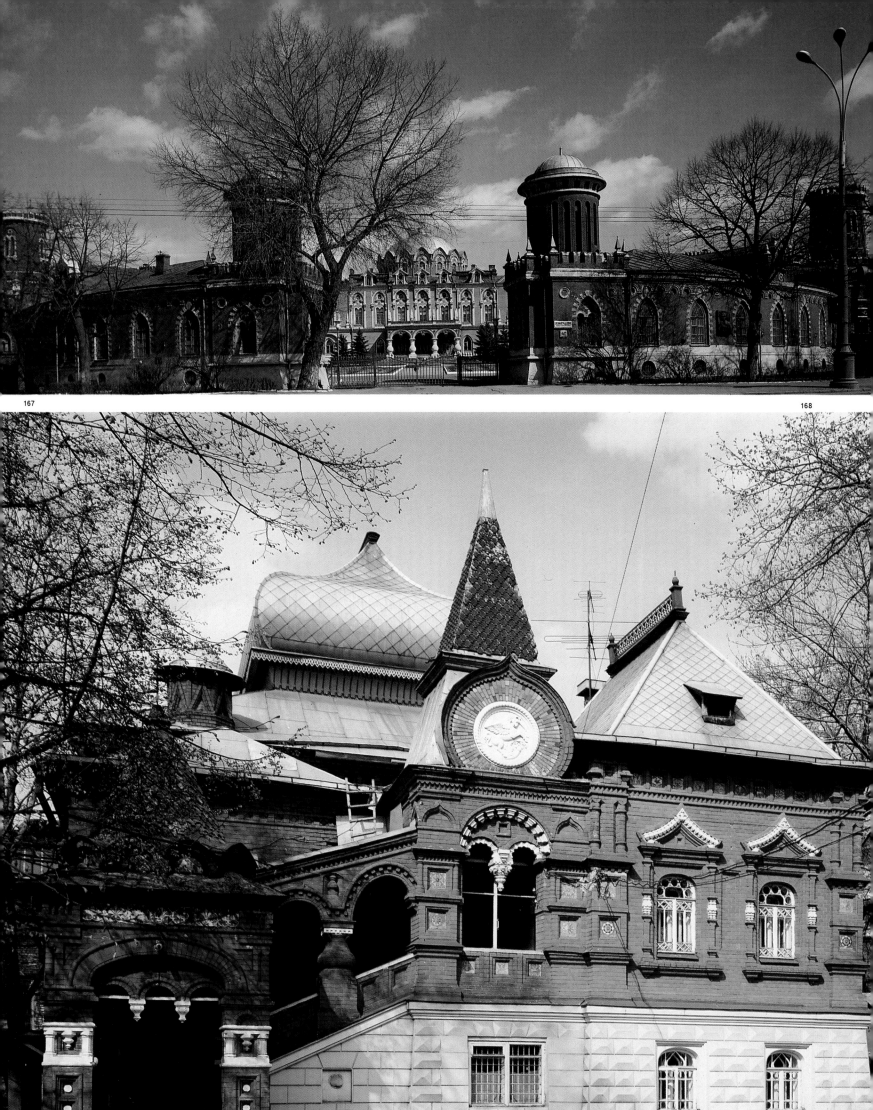

169. The Arkhangelskoye Estate
Museum. The supporting wall
of the lower terrace and the grotto
1790s, architect Giacomo Trombaro

Suburban residences, estates and religious centres always spring up around any capital or notable city. They reflect the history of the country and changes in artistic tastes.

The estate of Arkhangelskoye, which belonged to two noble families — the Golitsyns and then the Yusupovs, is a monument of Russian culture in the years around 1800. The Classical-style palace contains a splendid enfilade of state rooms. Especially elegant is the columned Oval Hall. The palace contains works by Western painters, ancient sculpture, antique furniture, carpets, Russian and foreign ceramics, and a unique library. The park is a fine example of landscape architecture. Two terraces link the palace to the parterre of the regular park which is decorated with almost 200 marble statues.

The Trinity–St Sergius Monastery, founded in 1337–40, is a *lavra,* one of the main religious centres in the country. The celebrated ensemble is one of the gems of Russian architecture. Although the complex we see today was created over a period of four centuries, and therefore contains buildings of different styles, it nevertheless has the feel of a single artistic whole. The oldest edifice — the Trinity Cathedral (1424) — is an example of early Moscow architecture. Its walls were frescoed in 1425–27 by the celebrated Russian icon-painters Ivan Rublev and Daniil Cherny, who also created the original icons (including Rublev's famous *Old Testament Trinity,* now in the Tretyakov Gallery). The fortified walls with eleven towers built in the mid-16th century after the pattern of the Kitai-Gorod wall in Moscow, enabled the monastery to withstand a 16-month siege by Polish and Lithuanian forces in the early 17th century. The design of the monumental Dormition Cathedral, erected in 1559–85 on the orders of Ivan the Terrible, drew heavily on its namesake in the Moscow Kremlin. It still retains a 17th-century iconostasis and frescoes. That century also saw the construction of the Chapel over the Well, the infirmary, a refectory in the Naryshkin Baroque style incorporating the Church of St Sergius and the Tsar's Chambers. The 18th century added the Baroque Smolensk Church and the elegant five-tier bell-tower. In 1920 a museum was opened within the monastery to display its treasures: 14th- to 17th-century icons, embroidery, articles of gold and silver, lace, enamel, painting and graphic art, glass and crystal items, and works of folk art.

Zvenigorod — one of the oldest towns in Russia, as old as Moscow — lies in a picturesque area. It can boast unique historical and cultural monuments. The Dormition Cathedral "in the Gorodok" (1399–1401) was constructed on the tall hill of the Zvenigorod kremlin, the earth ramparts of which still survive. It is the most ancient building to have come down to us in the area of the capital and is in early Moscow style. Later reconstructions have distorted the appearance of this highly important piece of architecture, giving it a four-pitched roof. The façades of the cathedral are richly decorated. To the west stands a two-tier 19th-century belfry. The elegant, finely proportioned majestic cathedral is similar, researchers believe, to the Cathedral of the Nativity in the Moscow Kremlin, one of the earliest Moscow churches, only part of which now exists.

The Resurrection New Jerusalem Monastery was founded by Patriarch Nikon in 1656 as his residence outside Moscow. The ensemble formed between then and the 19th century. The Resurrection Cathedral (1658–85) is an example of Russian Baroque, although the prototype for it, in keeping with Nikon's extravagant concept, was a 12th-century church in Jerusalem. The infirmary and the refectory, both incorporating churches, date from the late 17th century. The masonry walls and towers were erected in 1690–94 under the direction of the master-builder Yakov Bukhvostov. The towers were named after the towers and gates of ancient Jerusalem: Gethsemane, Damascus and so on. An elegant tiered gate-church was constructed above the main entrance. In 1941 the museum located in the monastery was plundered, and the cathedral was blown up as German forces withdrew from the area. In 1995 restoration work, which lasted for many years, was completed. The monastery, for long the home of the Moscow Regional Local History Museum, has been returned to the Russian Orthodox Church.

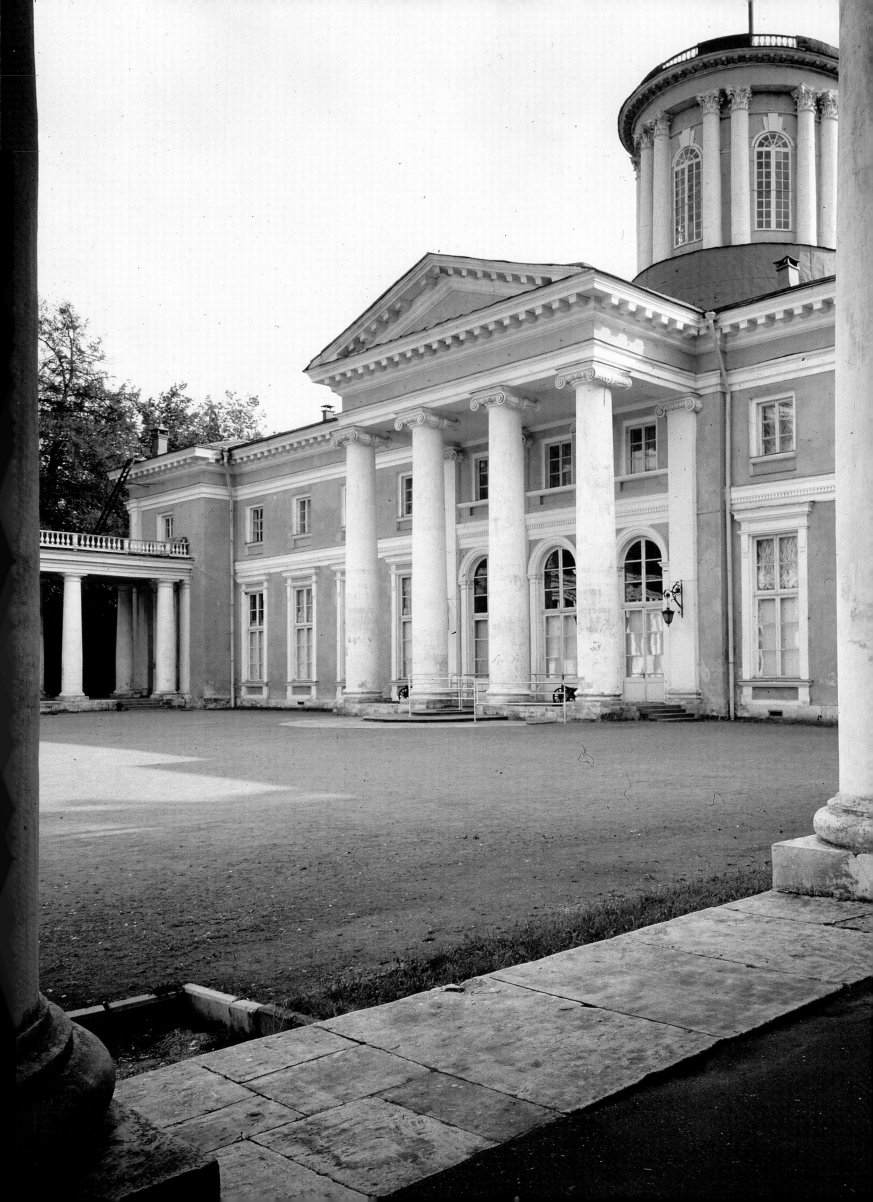

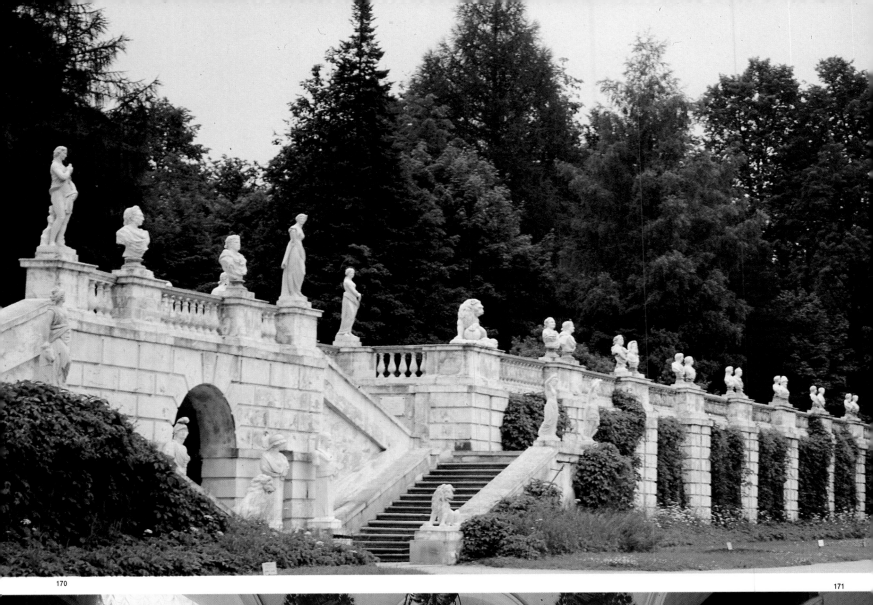

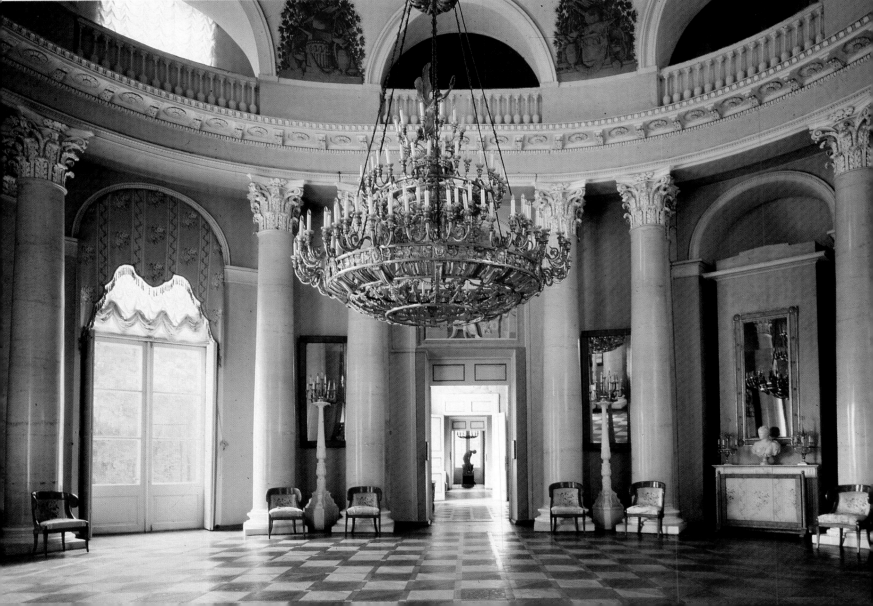

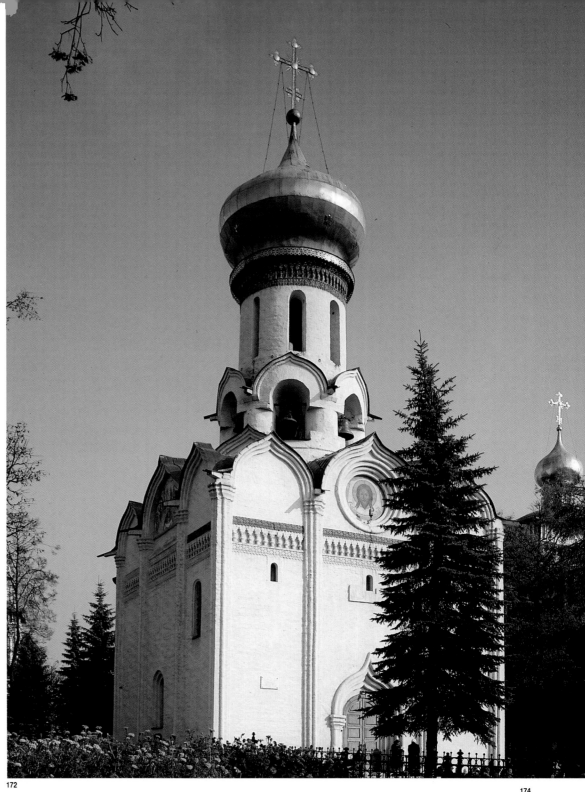

172

173

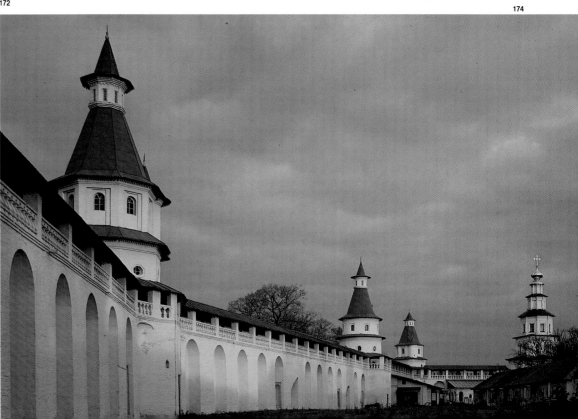

174

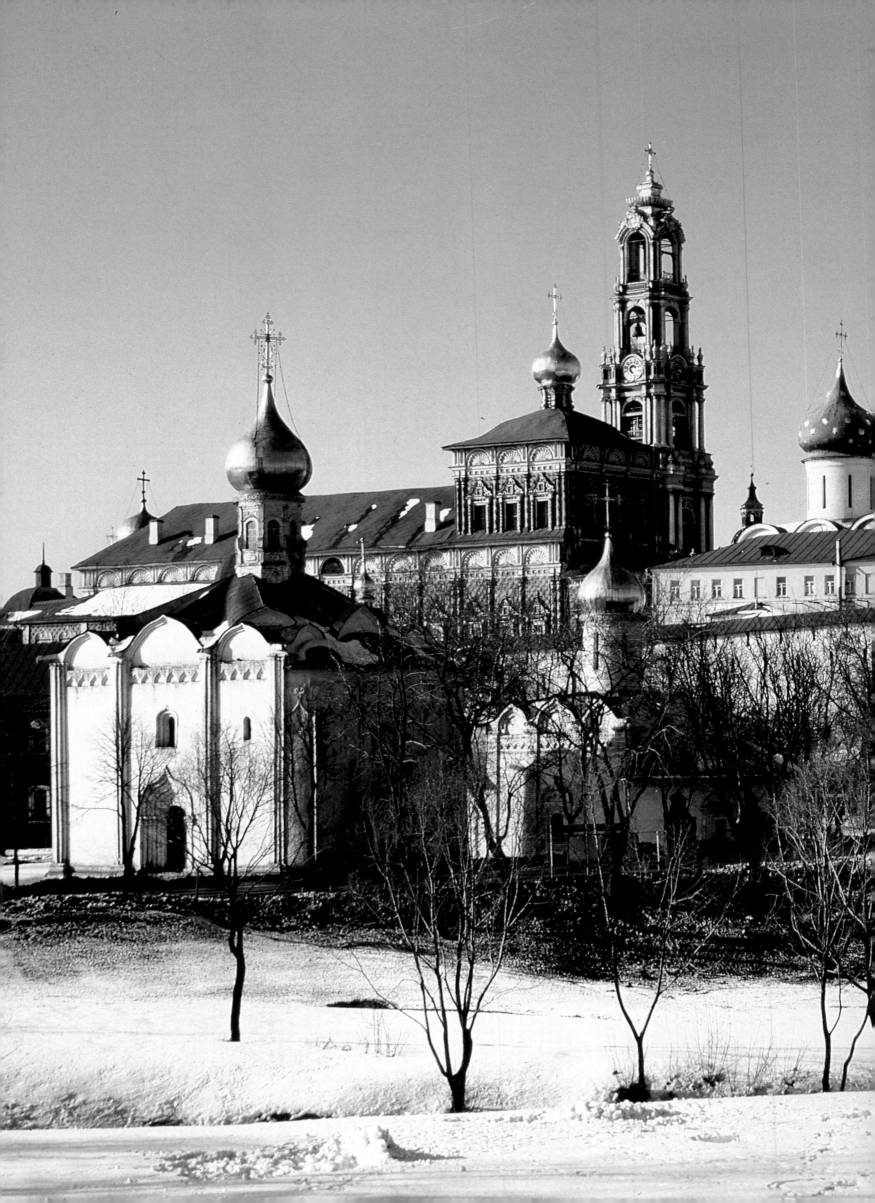

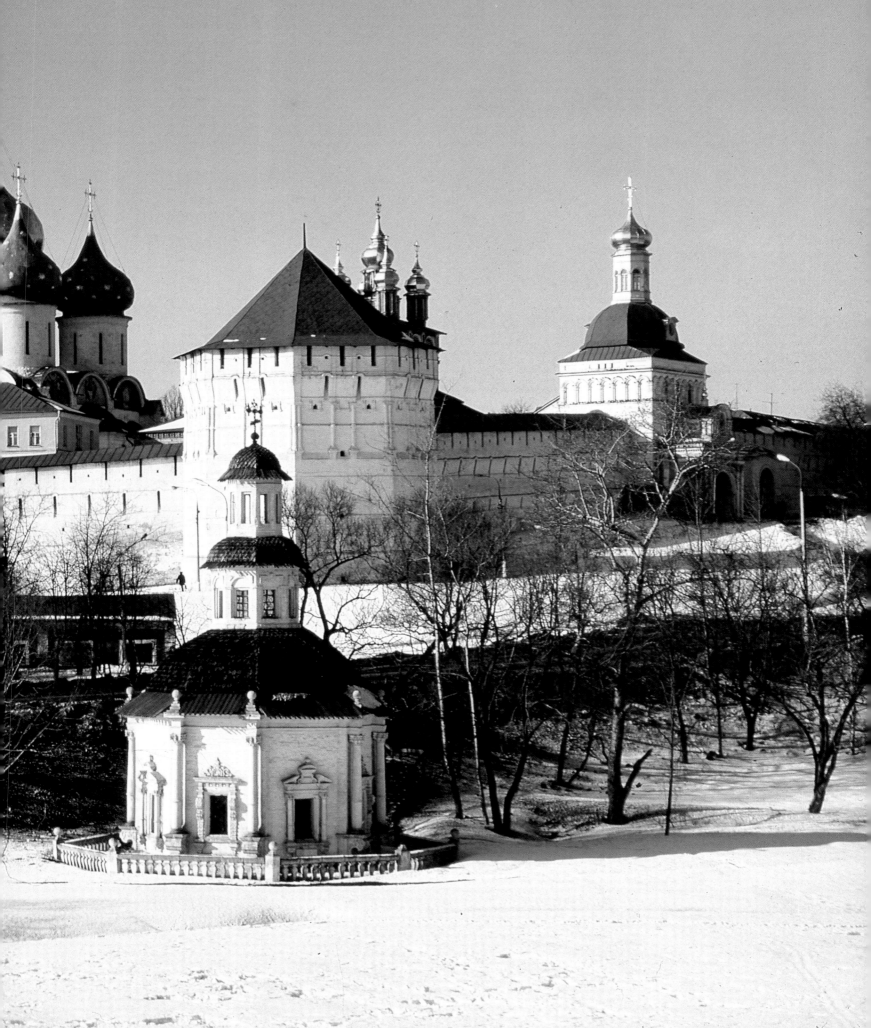

Москва
Альбом (на английском языке)

Издательство «Аврора». Санкт-Петербург. 1996
ЛР № 010131 от 27.11.91. Изд.№ 2833

Printed in France by SAGER Paris

M $\frac{490202000-2824}{023(01)-96}$ без объявления

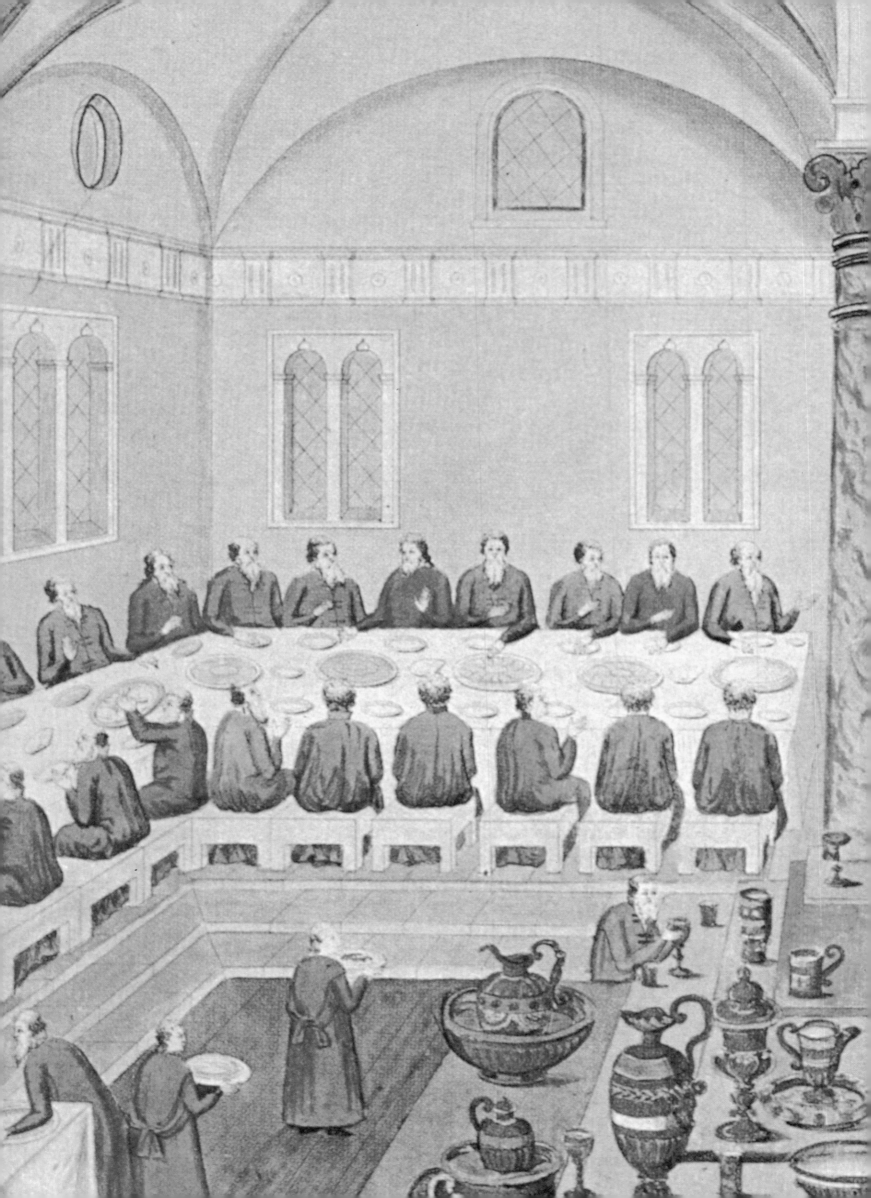